CW01390308

new indoorpool design

daab

A-Cero Estudio de Arquitectura y Urbanismo | A Coruña/Madrid, Spain
House in Madrid
Madrid, Spain | 2001

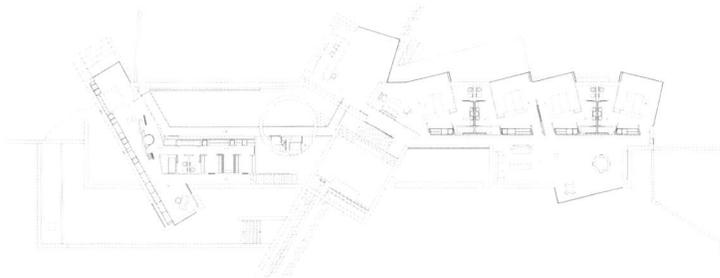

Seit dem Altertum schon betrachtet man das Wasser als ein grundlegendes Element für das Leben und die Entwicklung des Menschen. Im Laufe der Geschichte stoßen wir auf viele Beispiele für das Zusammenspiel dieses flüssigen Elementes und der Lebensweise des Menschen. Bereits in der Zeit der Römer entstand die *domus*, die sich um einen Hof mit einem kleinen Teich erstreckte. Dieser Bereich wurde zum Zentrum des Hauses. Im Laufe der Zeit wurde deren ursprünglichen Funktion, das Auffangen des Regenwassers, in eine noch viel ansprechendere Funktion umgewandelt, die die Lebensqualität der Bewohner erhöhte. Schwimmbäder, und vor allem die, die sich im Inneren eines Hauses befinden wie die, die wir im folgenden zeigen, sind zu einer interessanten Herausforderung für Architekten und Raumgestalter geworden. Die Gestaltung dieser Räume ist oft ein Bestandteil besonders anspruchsvoller architektonischer Planungen.

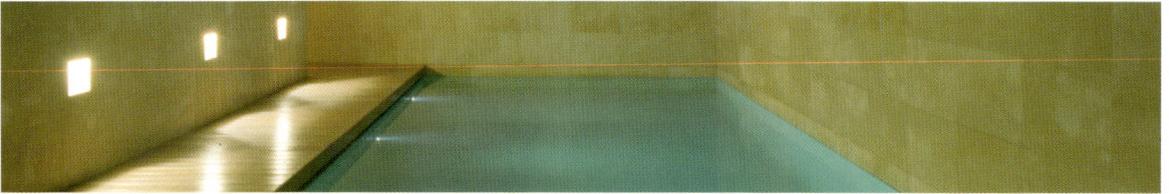

For many years, water has been an essential element for life and for the evolution of man. Countless examples throughout history present an interaction between this liquid element and man's way of life. In Roman times, the *domus* was built around a patio with a small pool, which became the centre of the house. However, with the passing of time, its original function as a place to collect rainwater has given way to another much more thought-provoking one, which contributes to improving people's quality of life. Swimming pools, especially those found inside the home, such as the ones in this book, have become a popular feature for architects and designers, who see the creation of these spaces as a great ally for their most innovative architectural projects.

Desde la Antigüedad, el agua ha sido un elemento esencial para la vida y la evolución del ser humano; a lo largo de la historia son muchos los ejemplos en los que este elemento líquido interactúa con la forma de vivir del hombre. Ya en la época de los romanos, la *domus* se distribuía alrededor de un patio con un pequeño estanque, espacio que se convertía en el centro de la casa. Sin embargo, con el paso del tiempo su función original como lugar donde se recogían las aguas pluviales ha dado paso a otra mucho más sugerente y que contribuye a aumentar la calidad de vida de sus moradores. Las piscinas, y principalmente las que se encuentran en el interior de una vivienda, como las que se muestran a continuación, se han convertido en un importante reclamo para arquitectos y diseñadores, que ven en la creación de estos espacios un gran aliado para sus proyectos arquitectónicos más innovadores.

Dès l'Antiquité, l'eau a été un élément essentiel pour la vie et l'évolution de l'être humain ; au fil de l'histoire, les exemples abondent d'interactions entre cette substance liquide et le mode de vie des hommes. Déjà pour les Romains, le *domus* était agencé autour d'un patio proposant un petit étang, espace qui se convertissait en centre de la maison. Pour autant, avec le passage du temps, sa fonction originelle de lieu de collecte des eaux pluviales a laissé la place à un autre rôle, davantage séduisant, et qui contribue à accroître la qualité de vie de ses occupants. Les piscines, et principalement celles rencontrées au cœur d'une demeure comme nous les présentons à la suite, sont devenues un attrait important pour les architectes et designers qui perçoivent la création de ces espaces comme un grand allié de leurs projets architecturaux les plus novateurs.

Sin dall'antichità, l'acqua è stata un elemento essenziale per la vita e l'evoluzione dell'essere umano; nel corso della storia molti sono gli esempi in cui si riscontra un'interazione tra questo elemento liquido e il modo di vivere delluomo. Già in epoca romana, la *domus* veniva disposta attorno ad un patio con un laghetto, spazio che si trasformava nel centro della casa. Col passare degli anni, comunque, la sua funzione originaria di luogo utilizzato per la raccolta dell'acqua piovana si è evoluta assumendo delle caratteristiche più ludiche, proprie di uno spazio di benessere che contribuisce ad aumentare la qualità di vita dei suoi abitanti. Le piscine e soprattutto quelle che si trovano all'interno di una abitazione, come quelle mostrate qui di seguito, sono diventate un importante richiamo per gli architetti e i designer che vedono nella realizzazione di questi spazi un grande alleato per i loro progetti abitativi più innovativi.

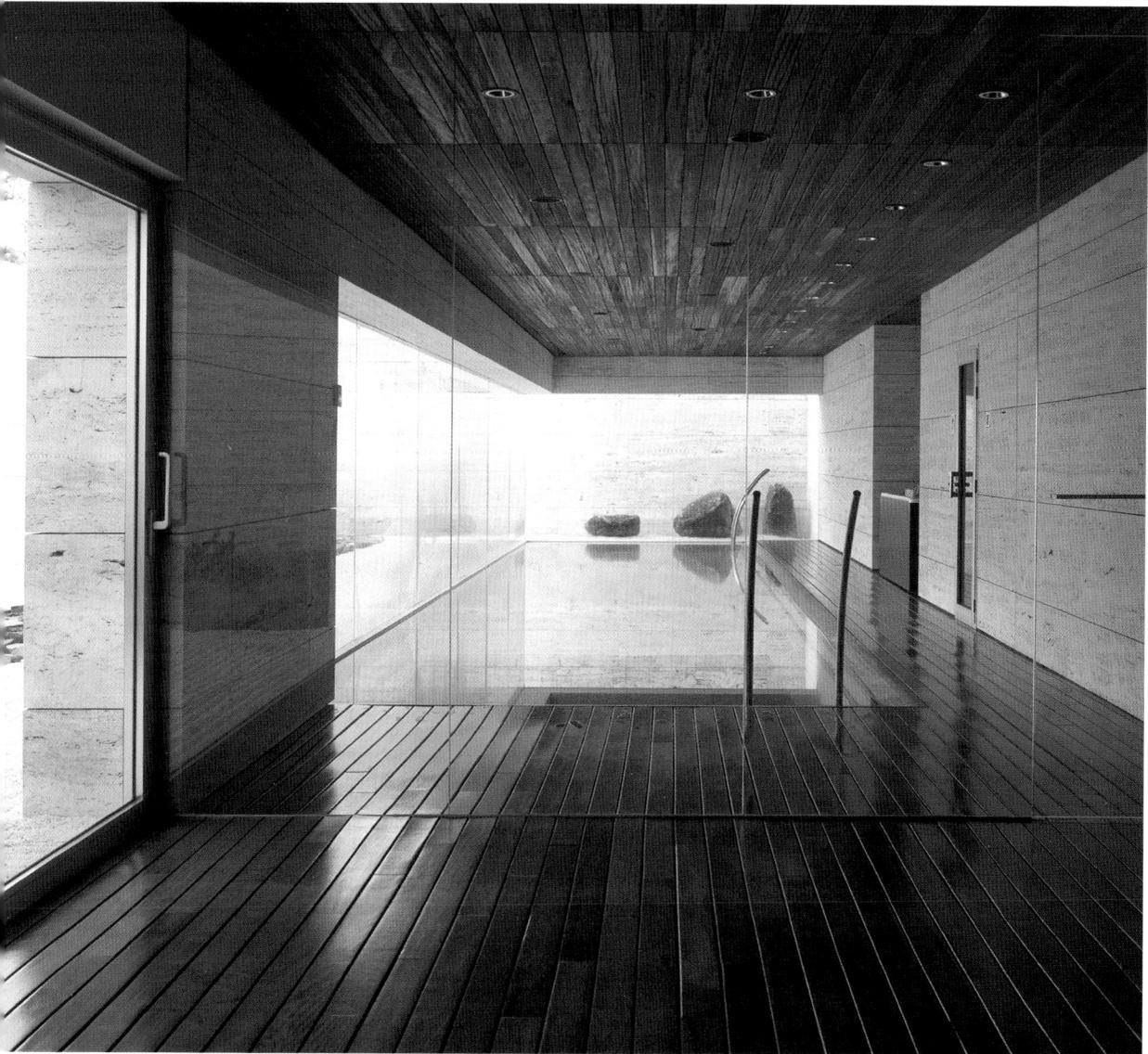

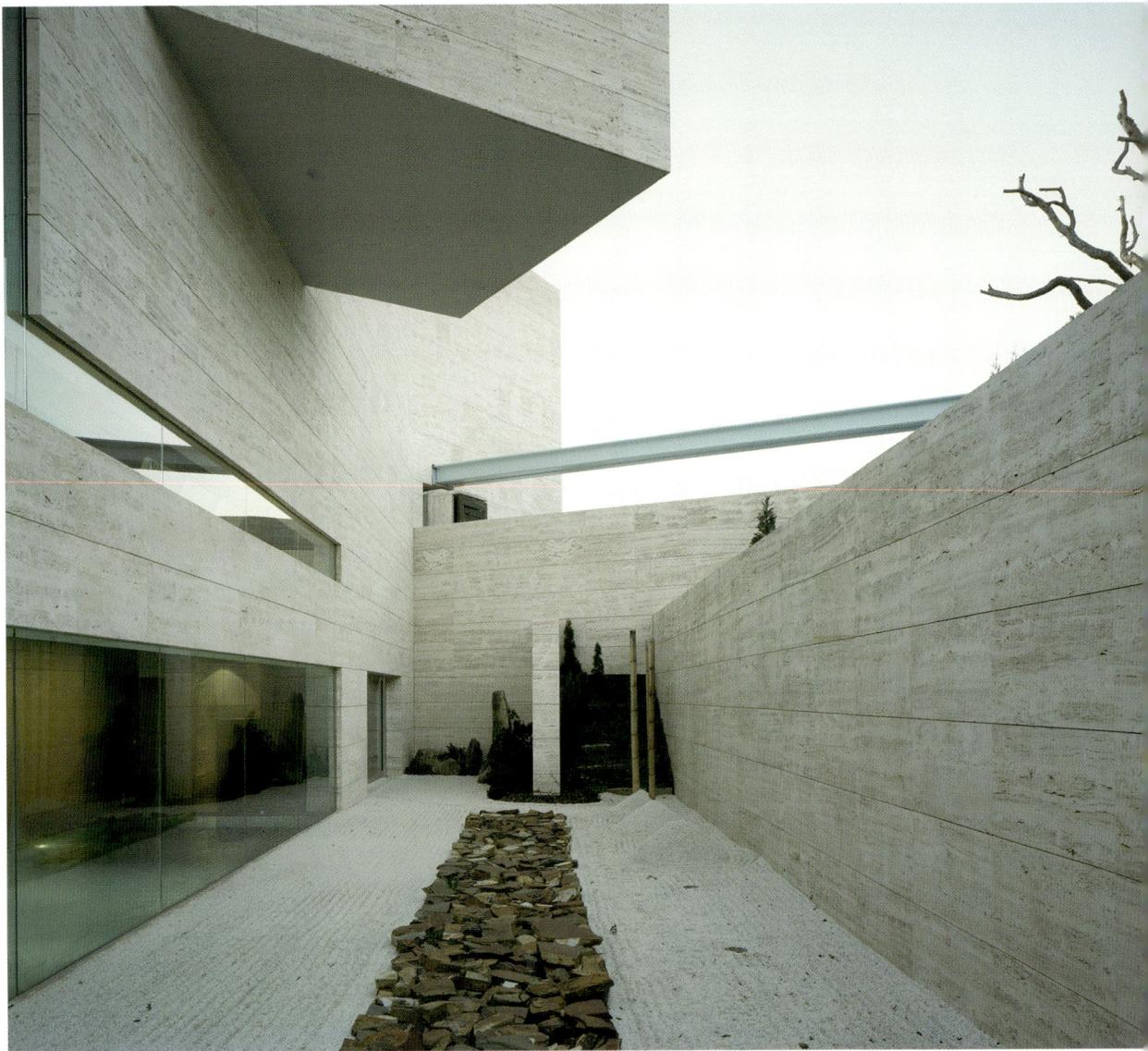

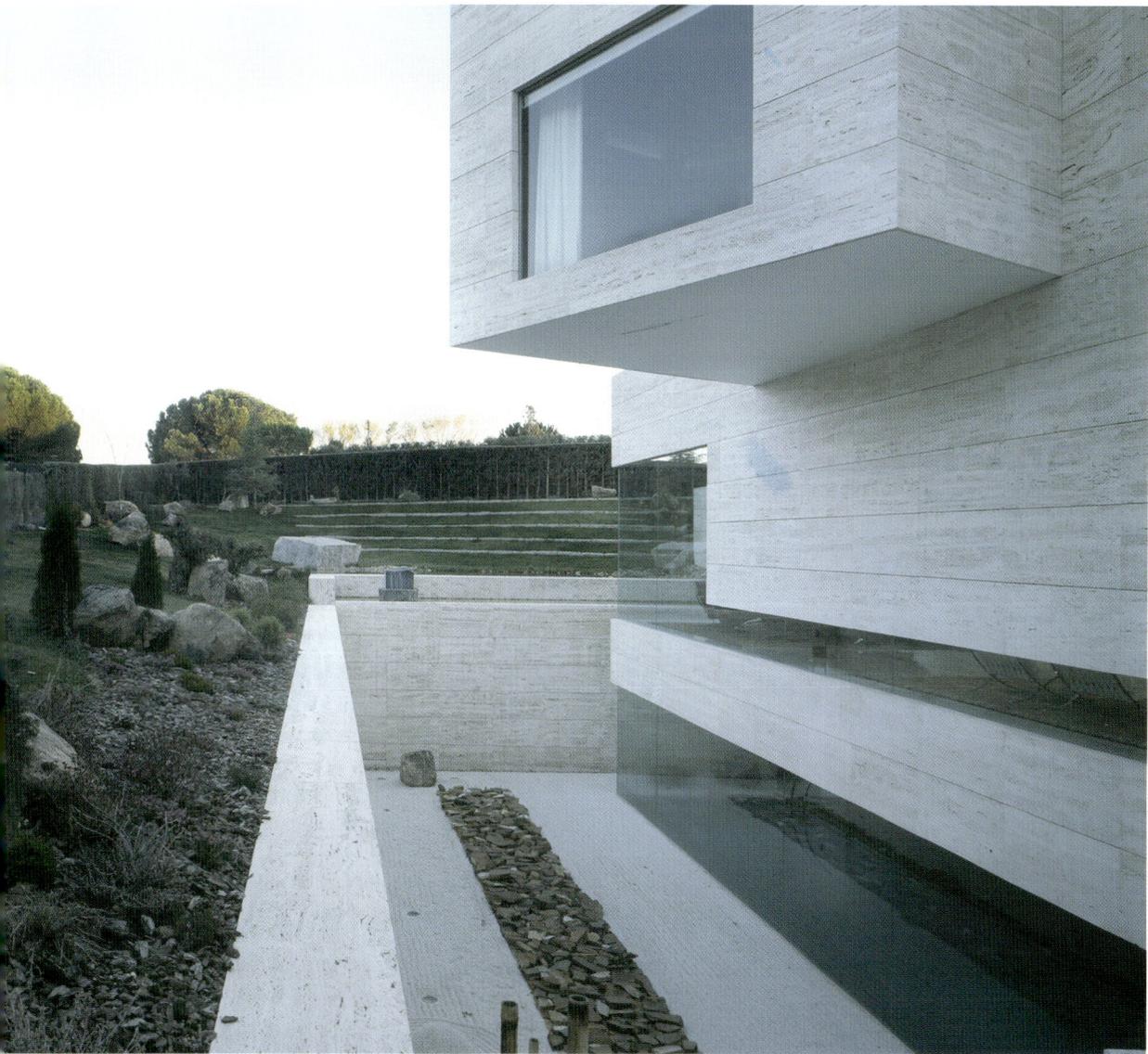

A-LDK–Anabela Leitao, Daiji Kondo | Lisbon, Portugal/Tokyo, Japan
Beloura House
Sintra, Portugal | 2004

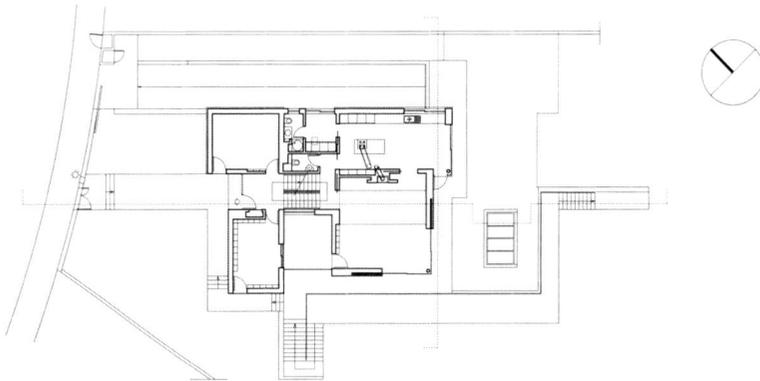

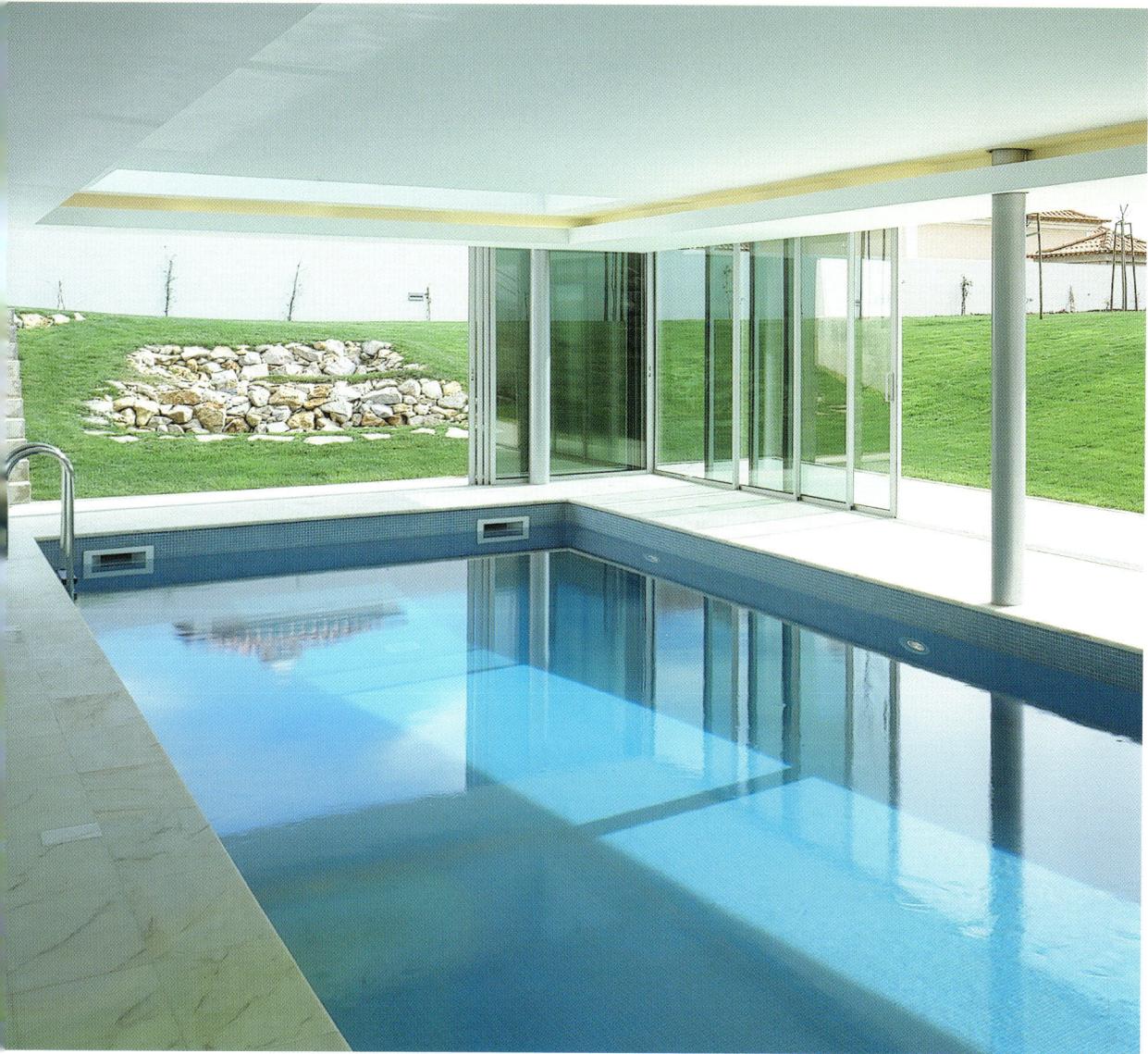

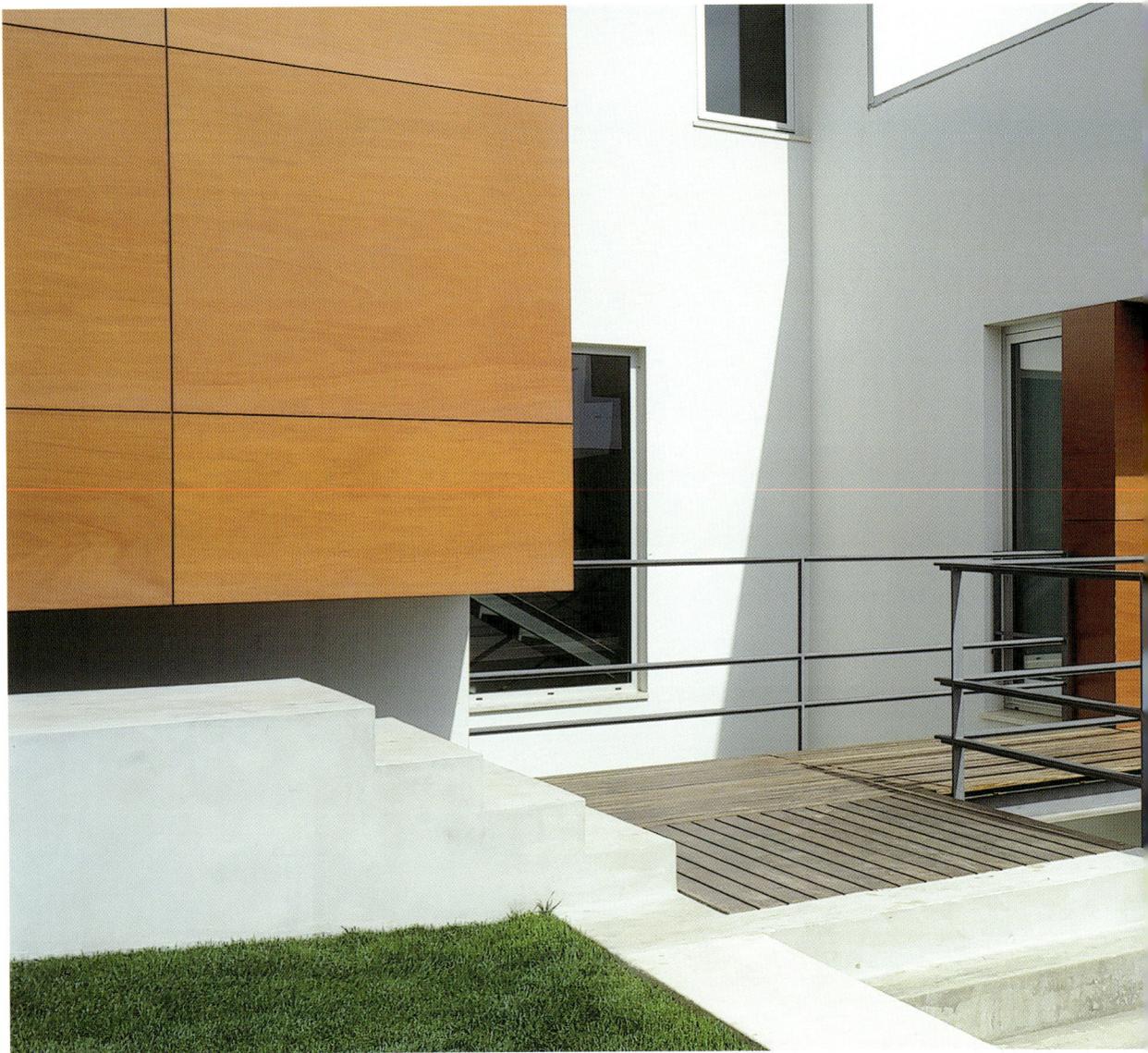

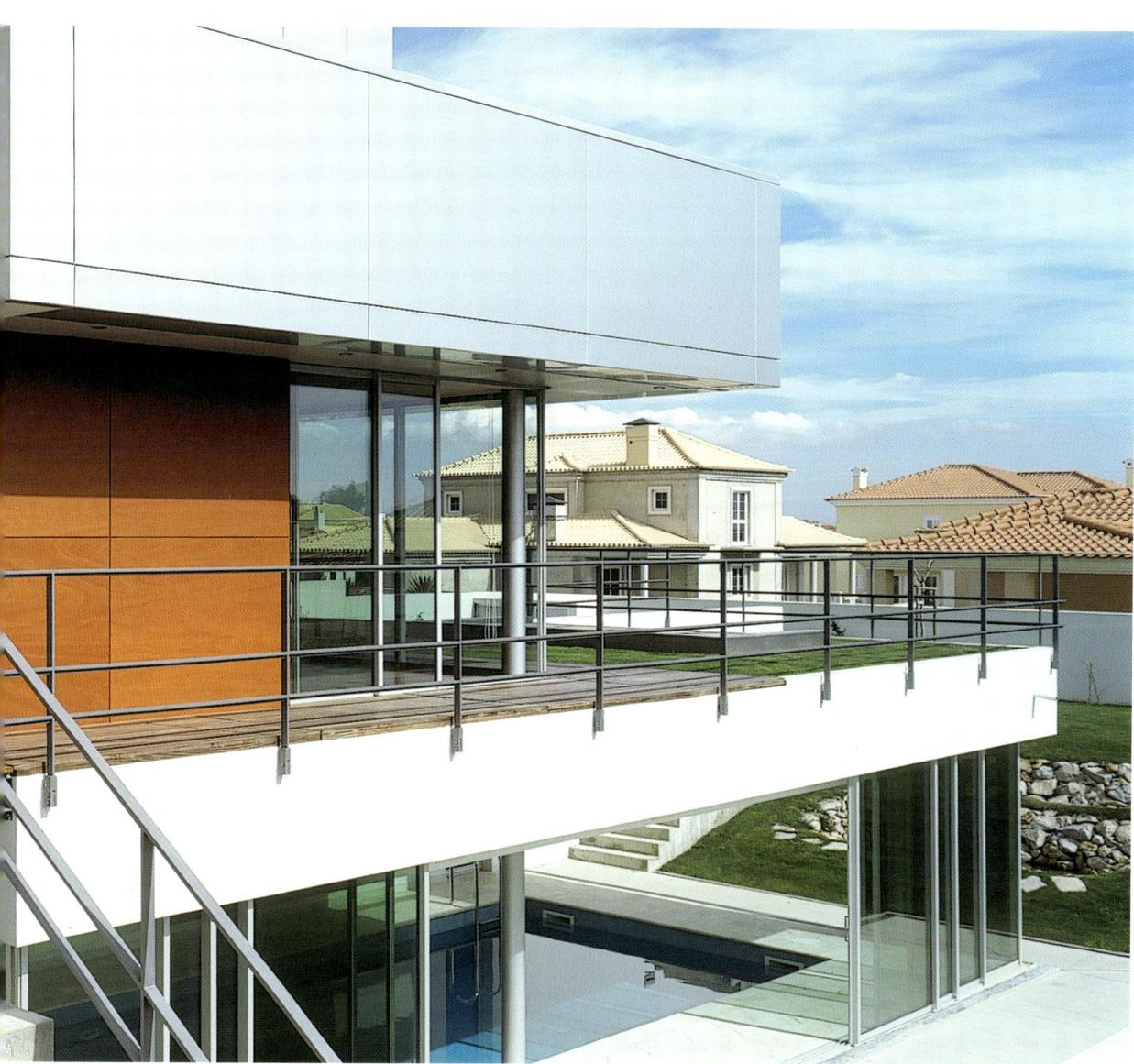

Alonso Balaguer y Arquitectos Asociados | Barcelona, Spain
Modernist House
Barcelona, Spain | 2000

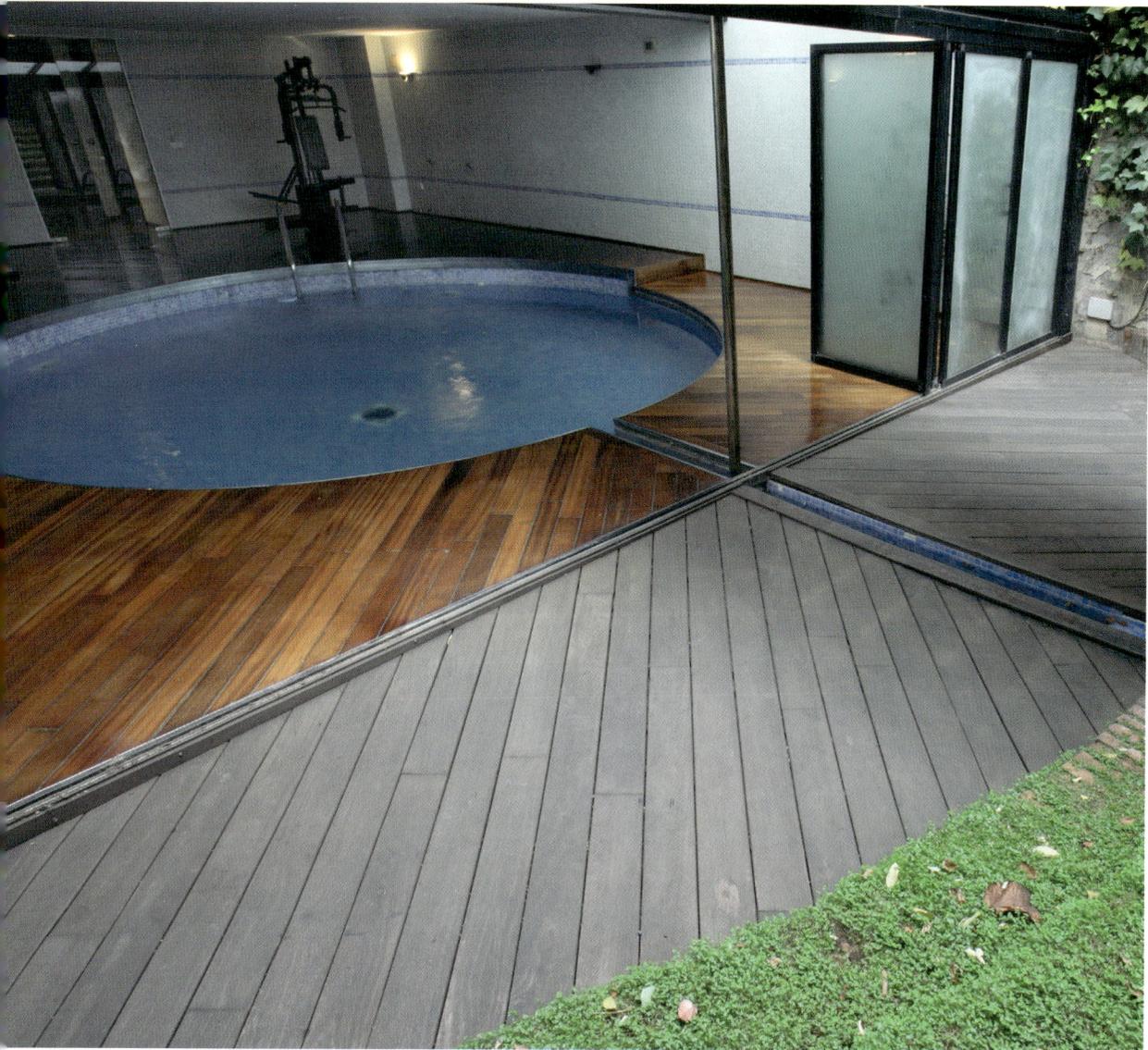

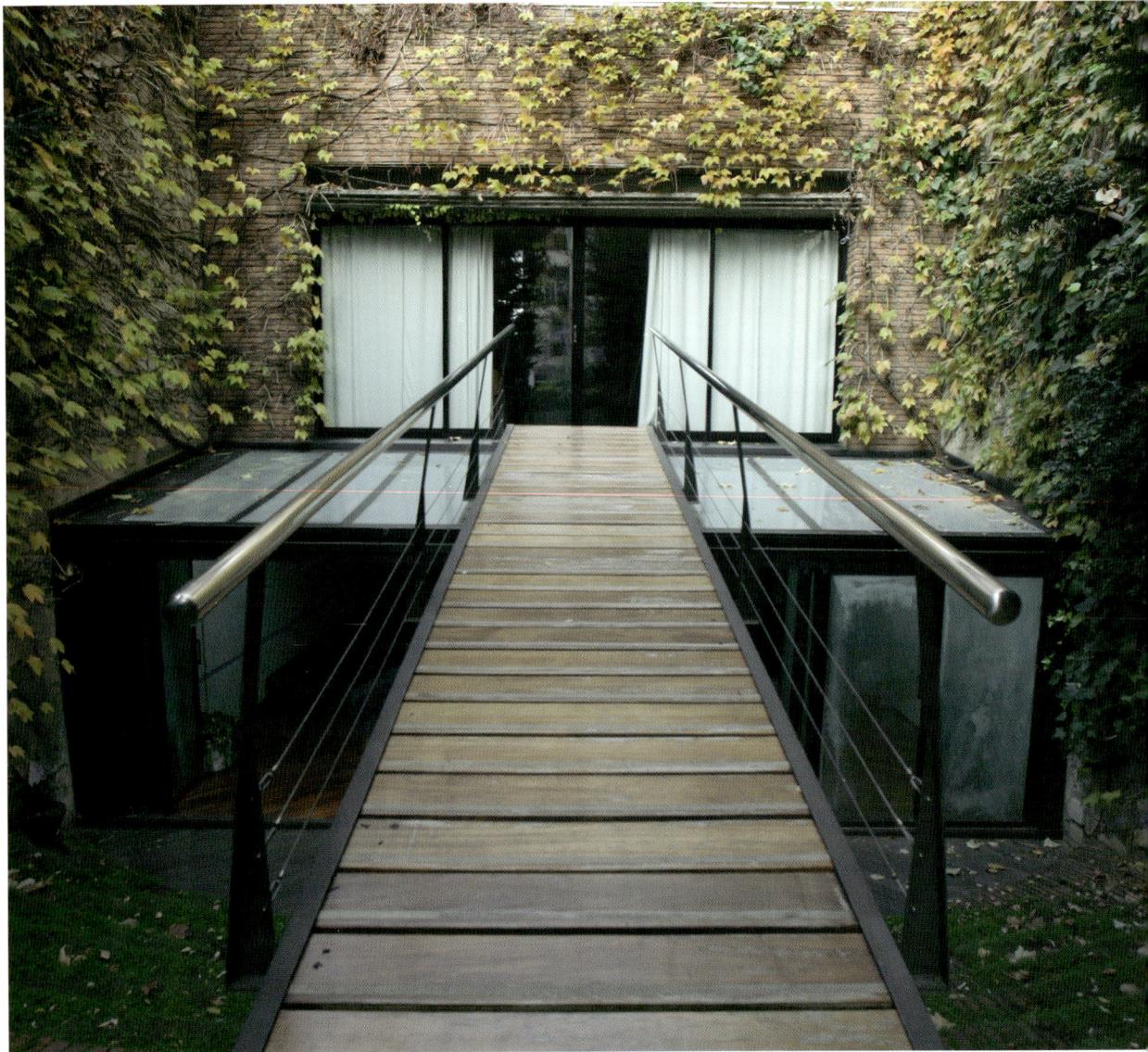

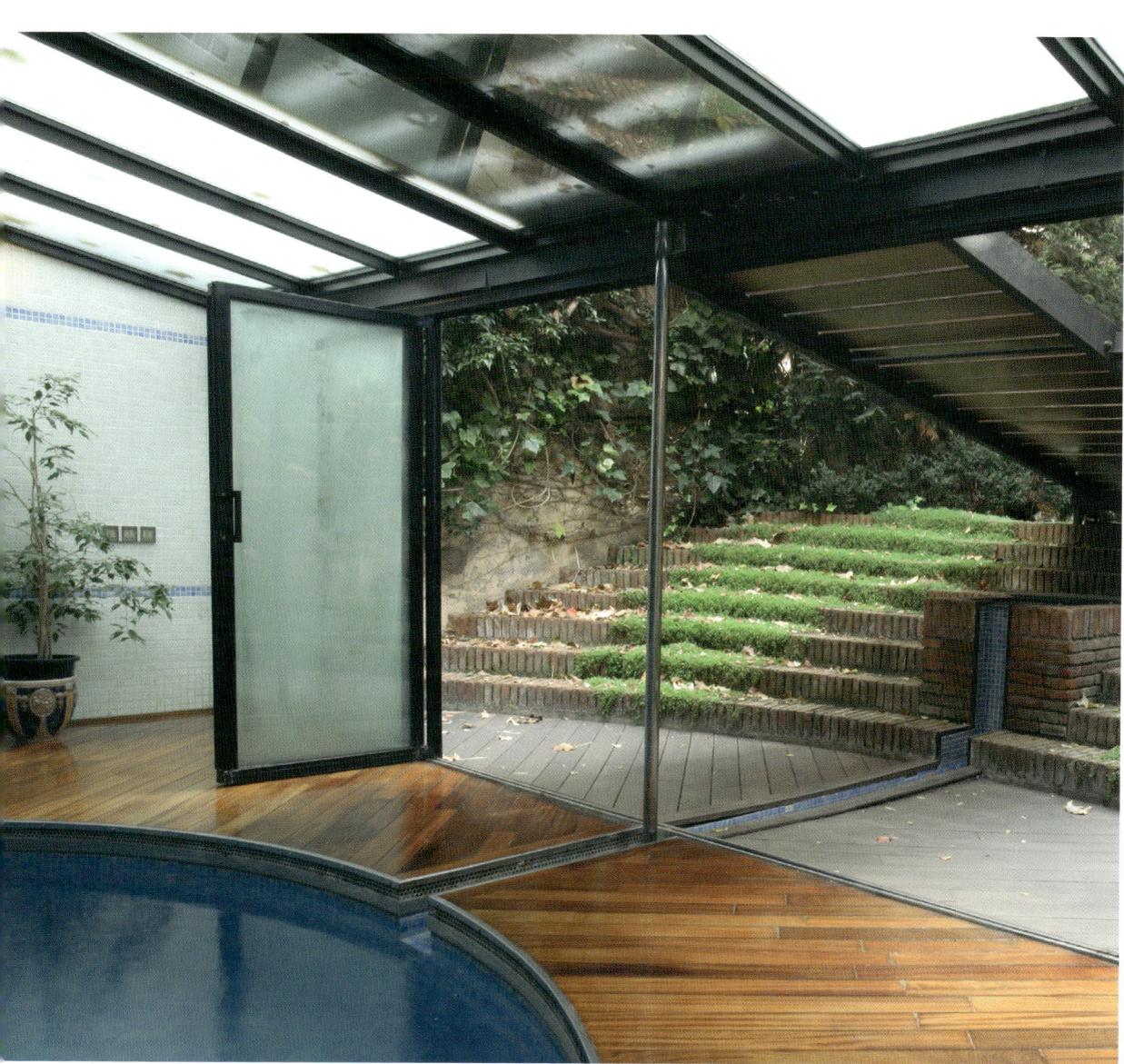

Alonso Balaguer y Arquitectos Asociados | Barcelona, Spain
Musitu Residence
Barcelona, Spain | 2005

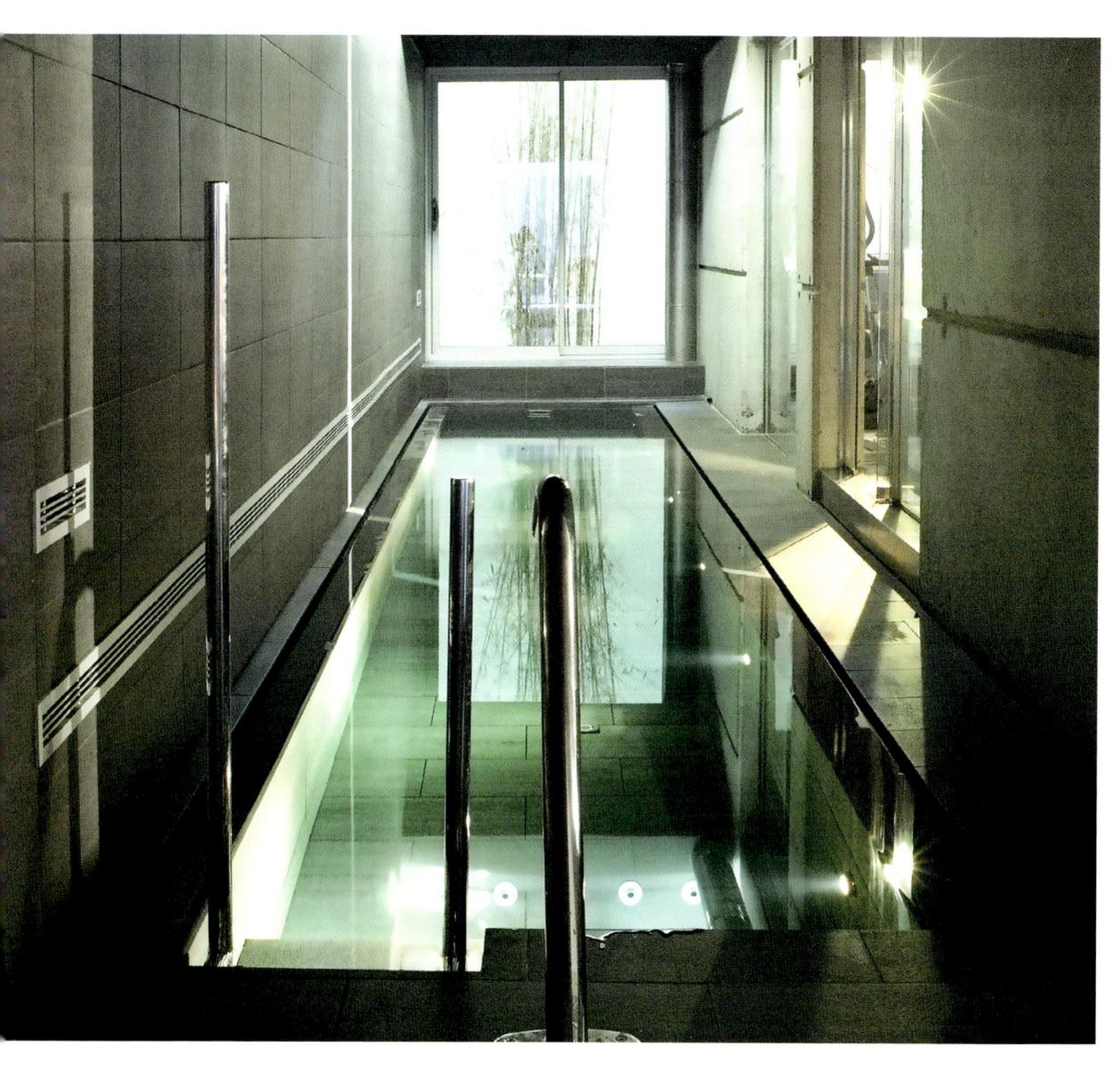

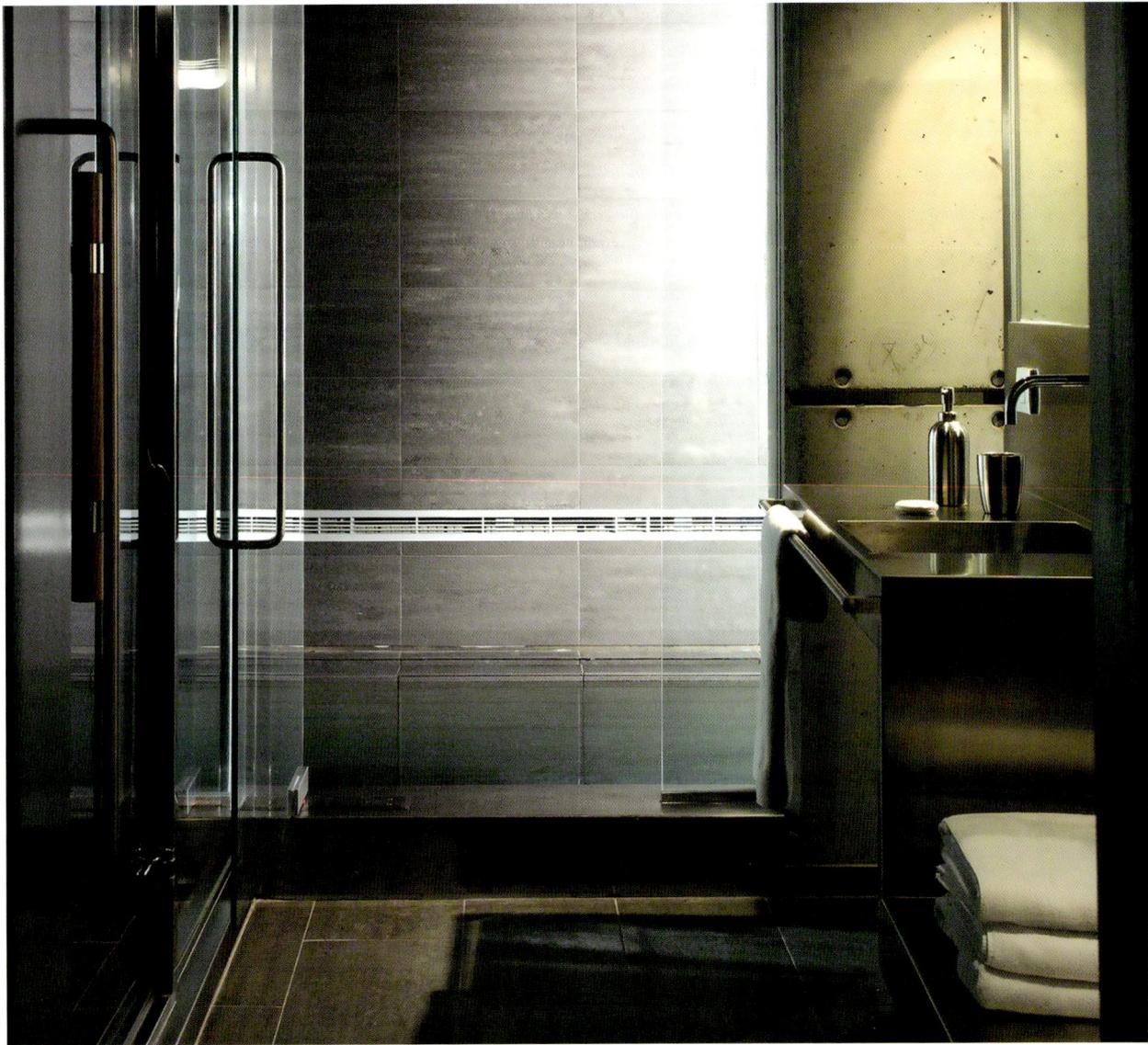

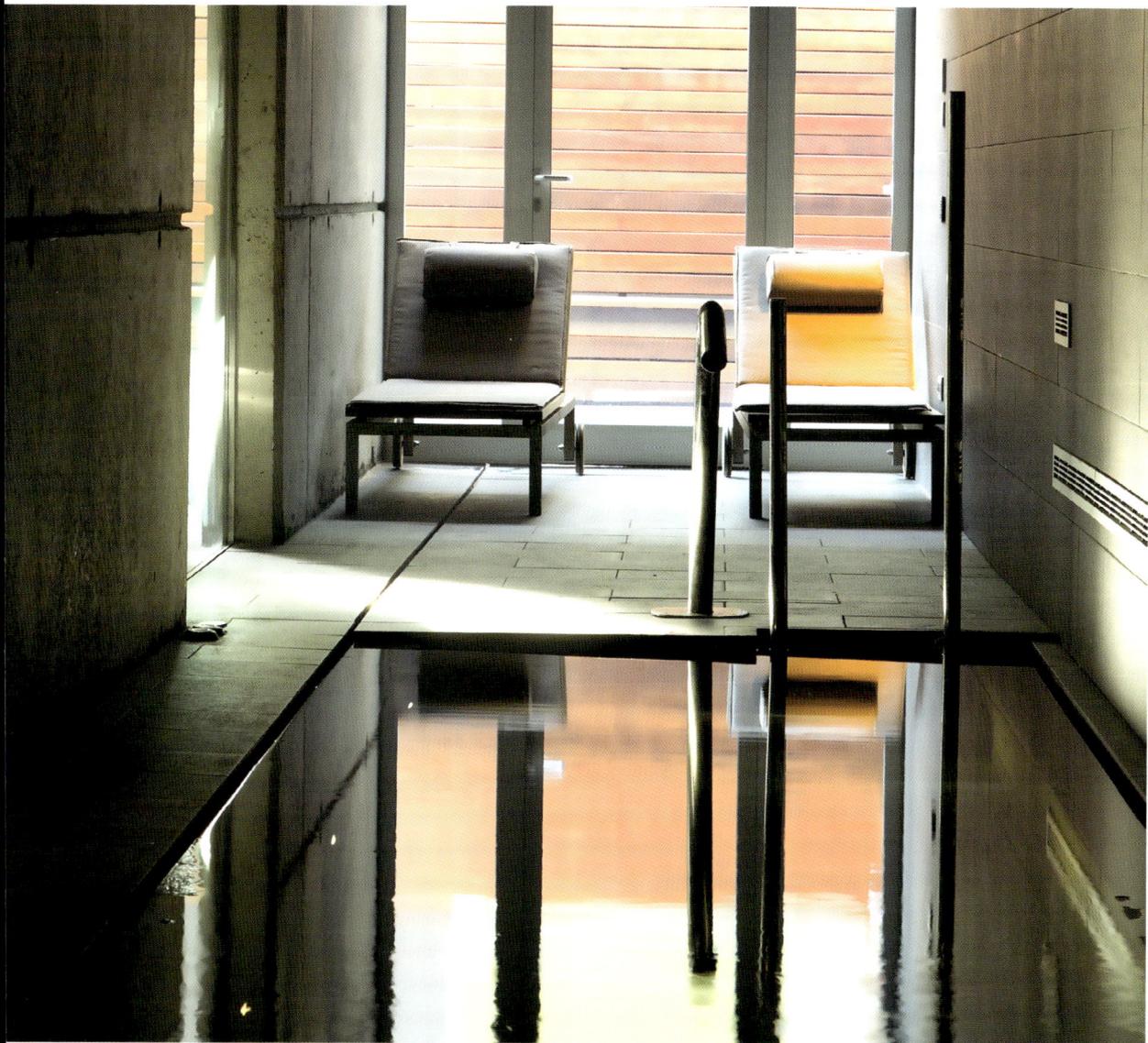

Álvaro Siza | Porto, Portugal
Quinta Santo Ovidio
Douro, Portugal | 1999

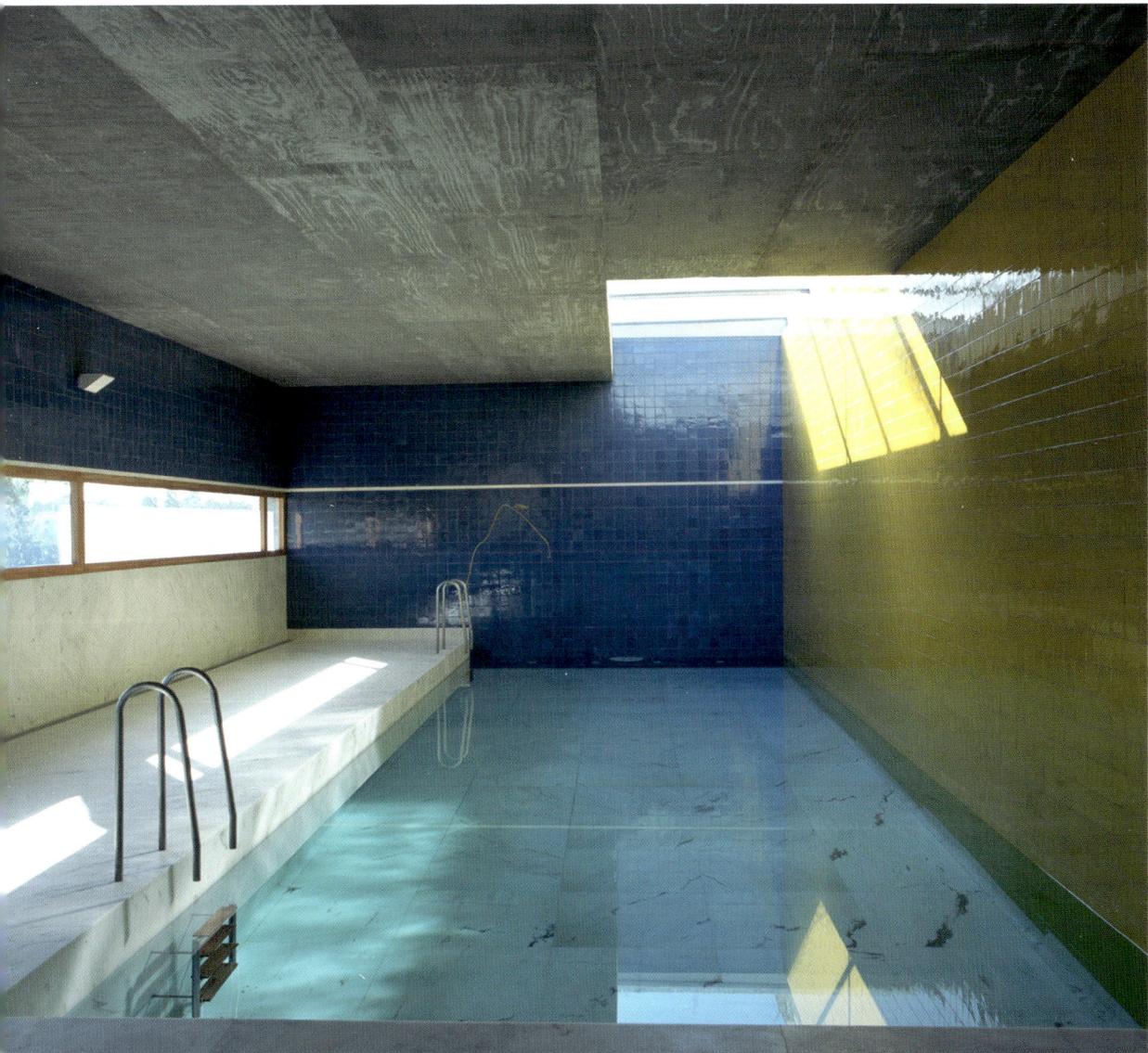

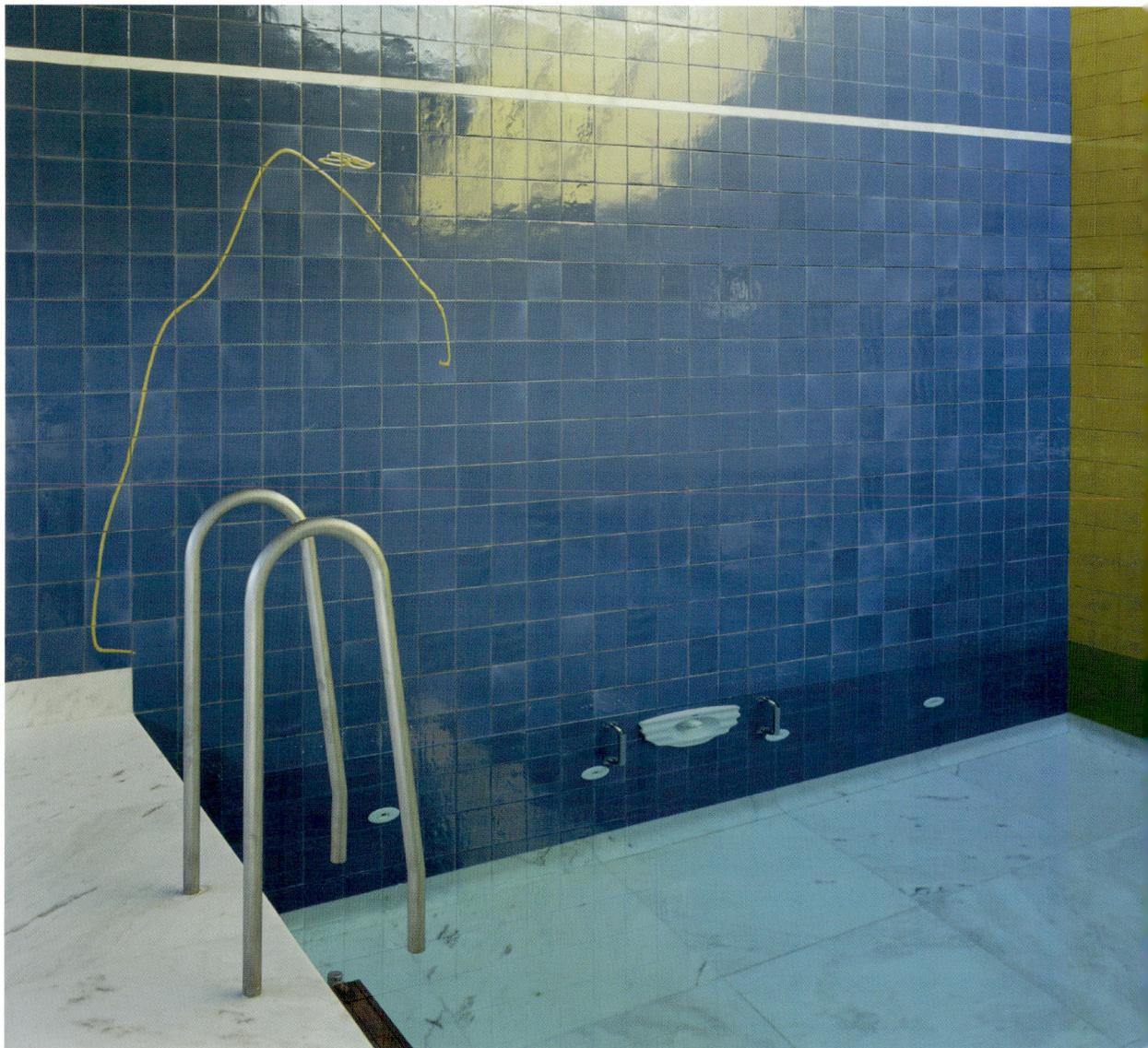

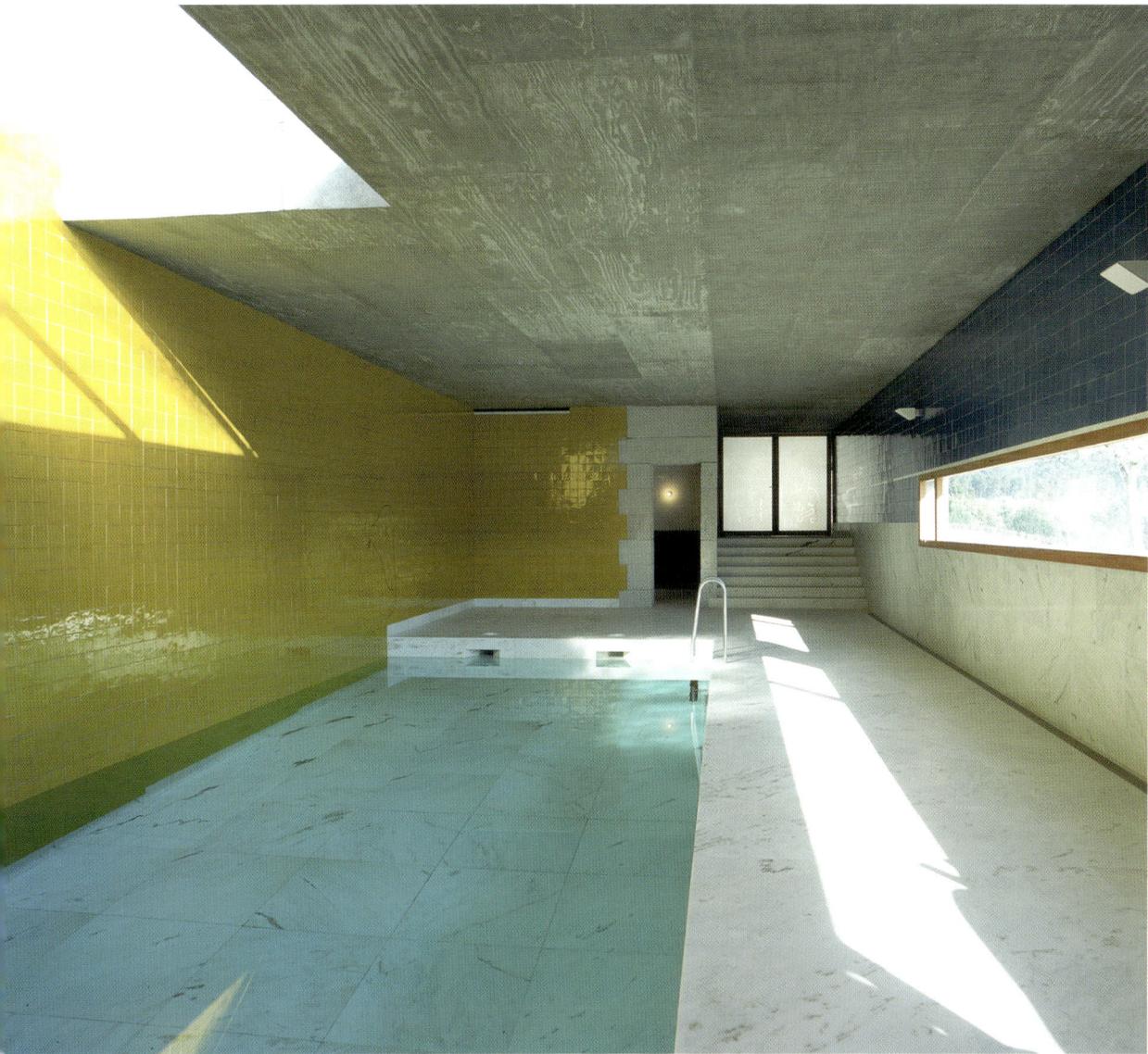

Architectenbureau Paul de Ruiter | Amsterdam, Netherlands
Villa Deys
Rhenen, Netherlands | 2002

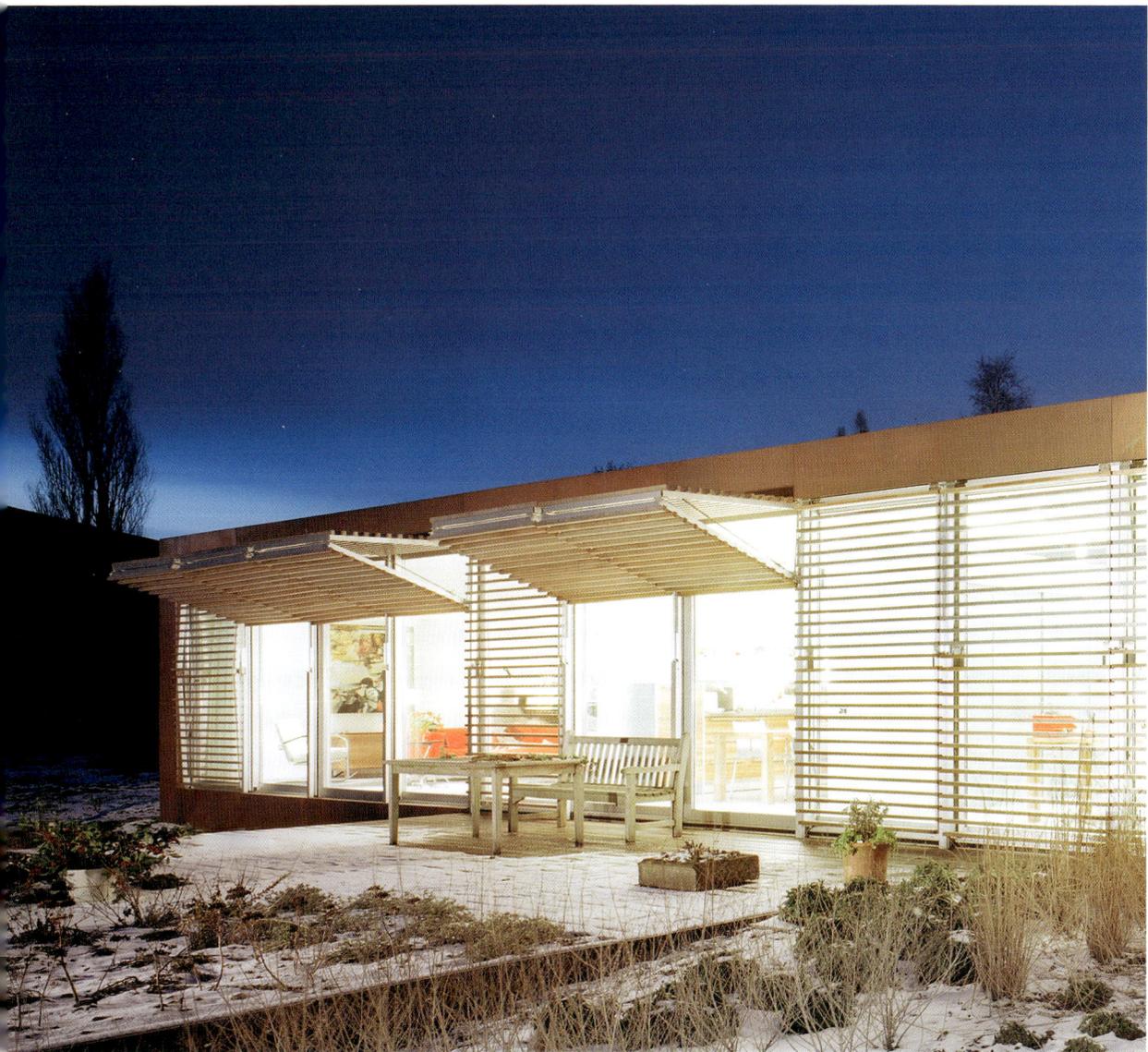

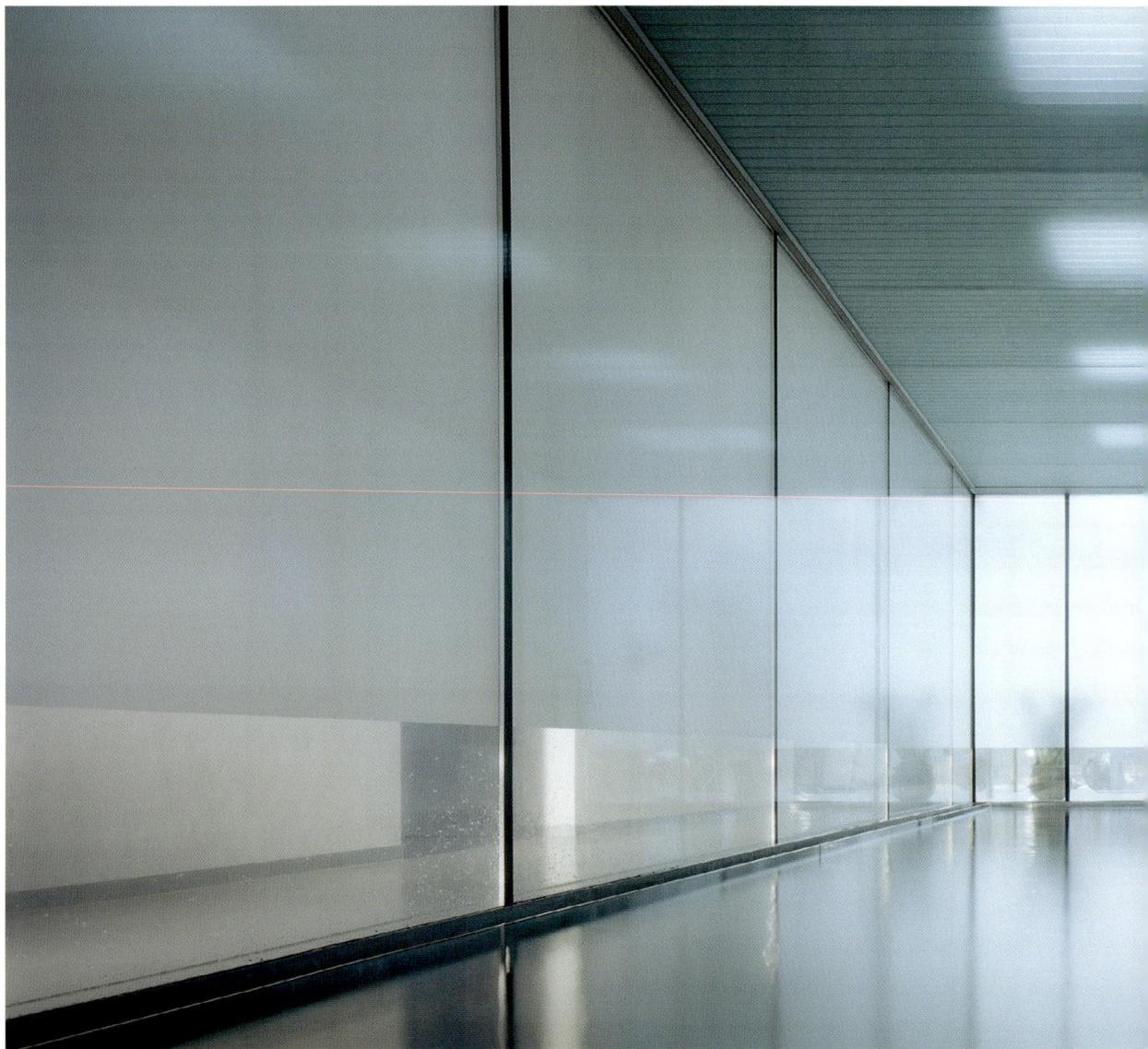

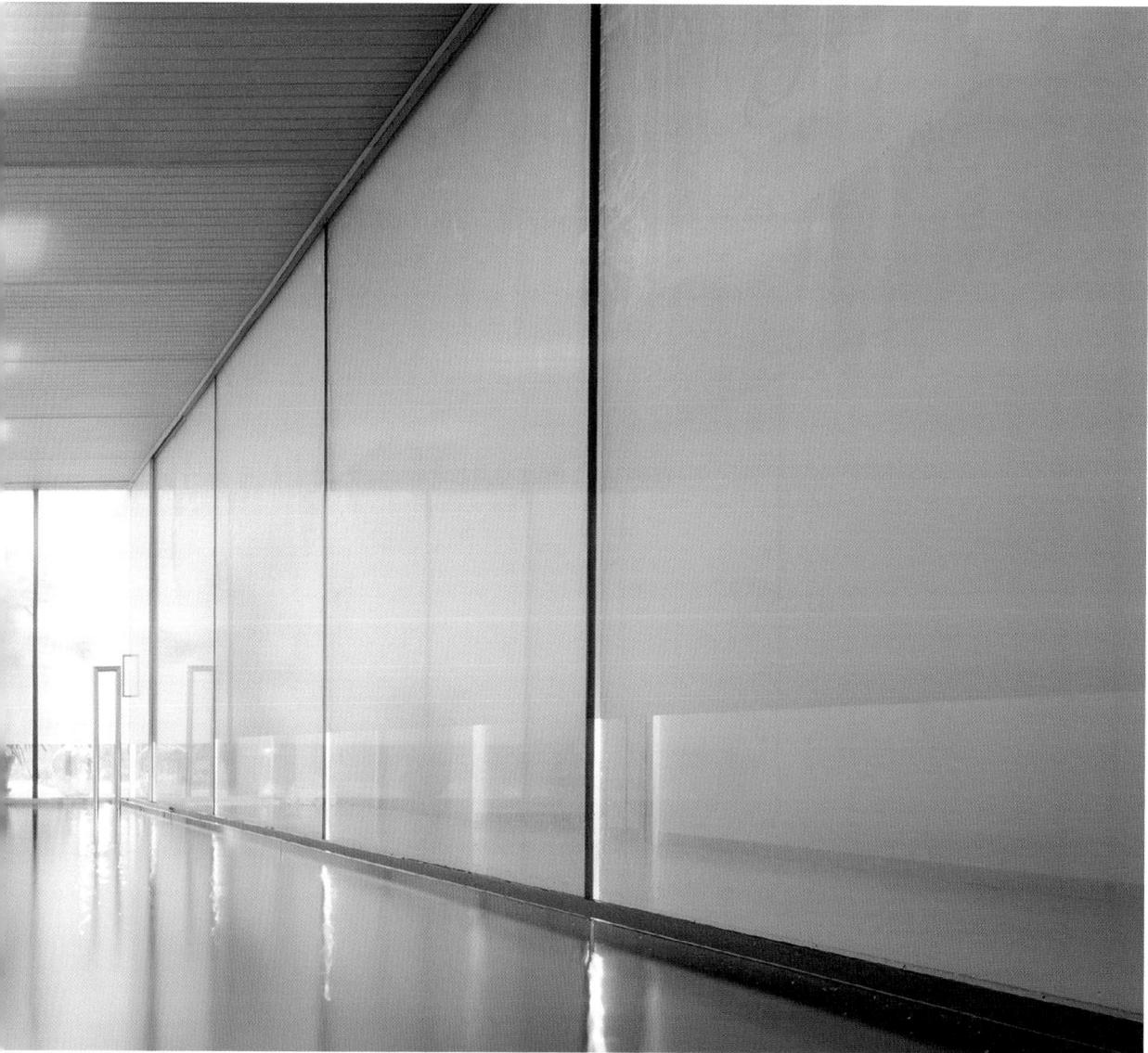

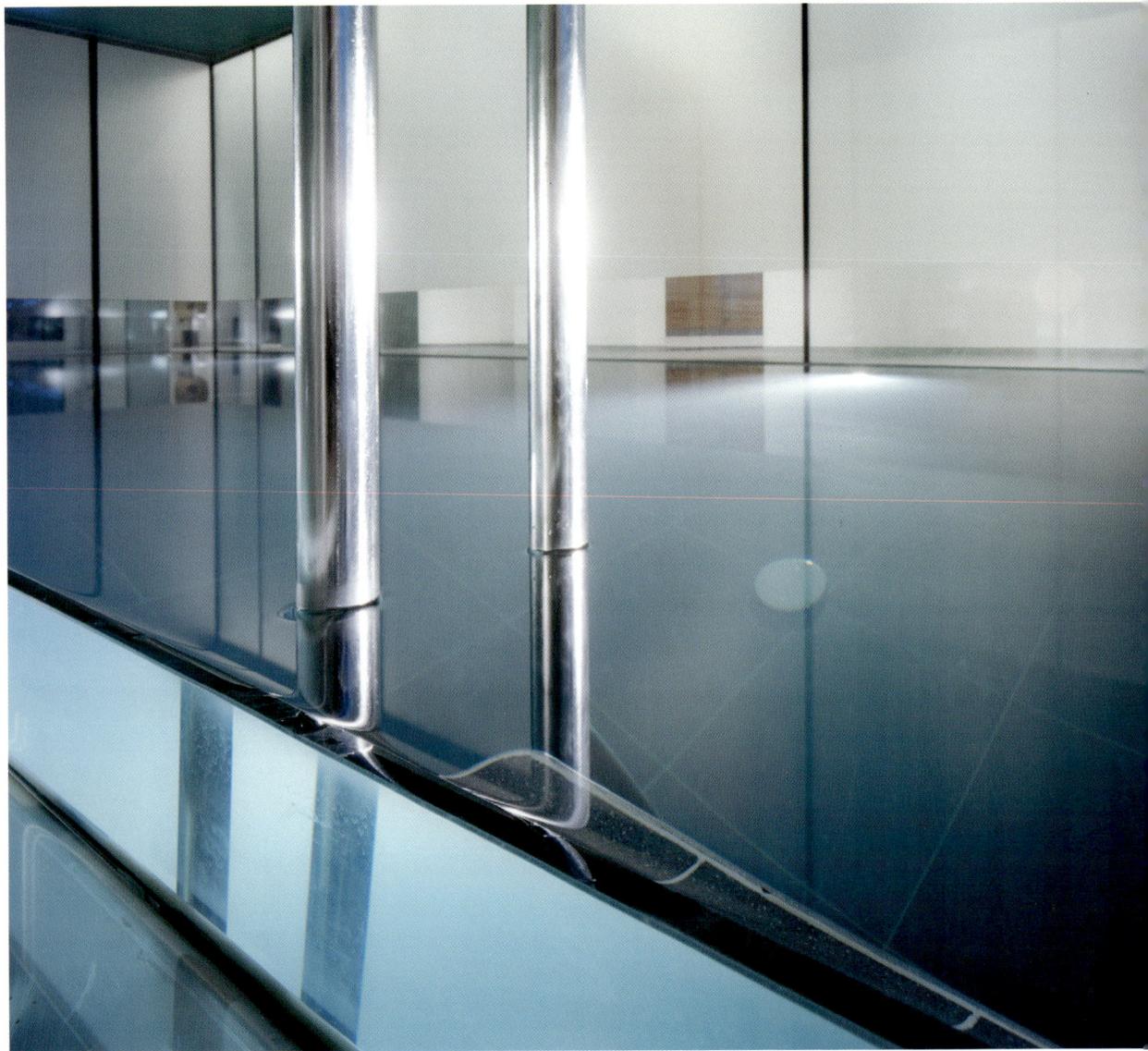

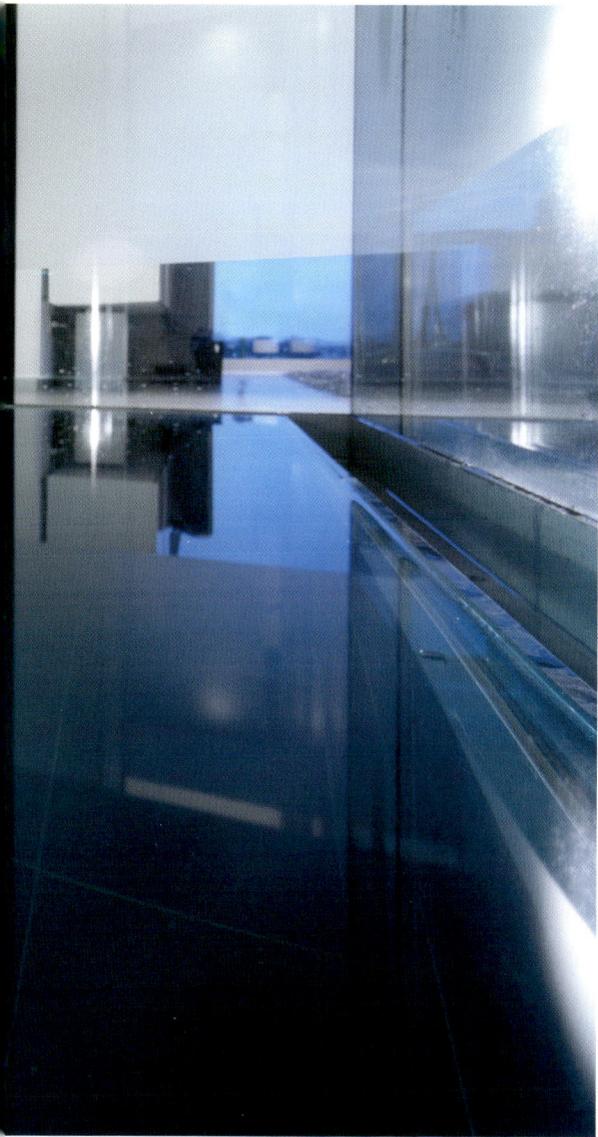

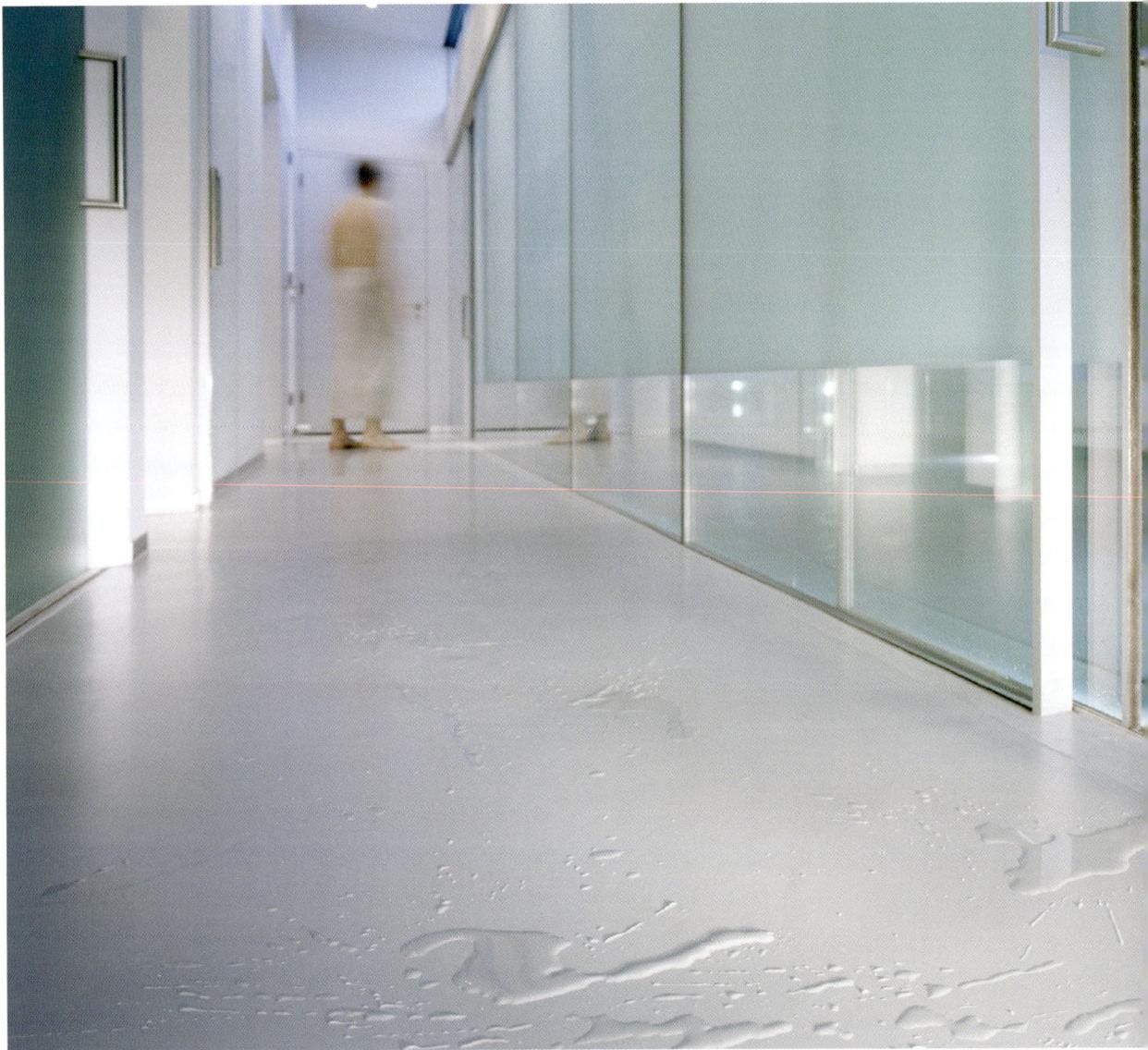

Architektur Consult/Hermann Eisenköck | Graz, Austria
Pool Lannach
Lannach, Austria | 2000

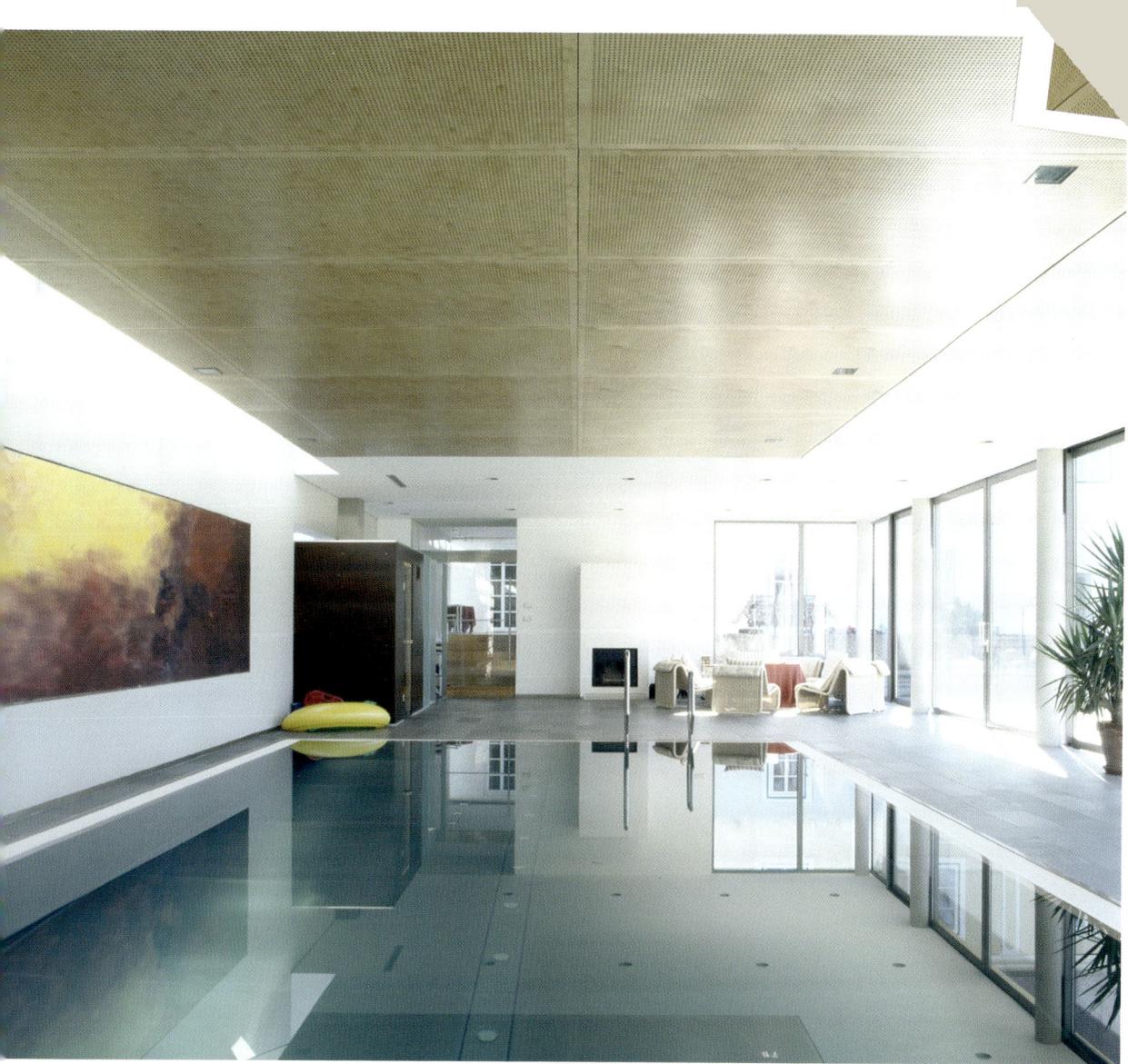

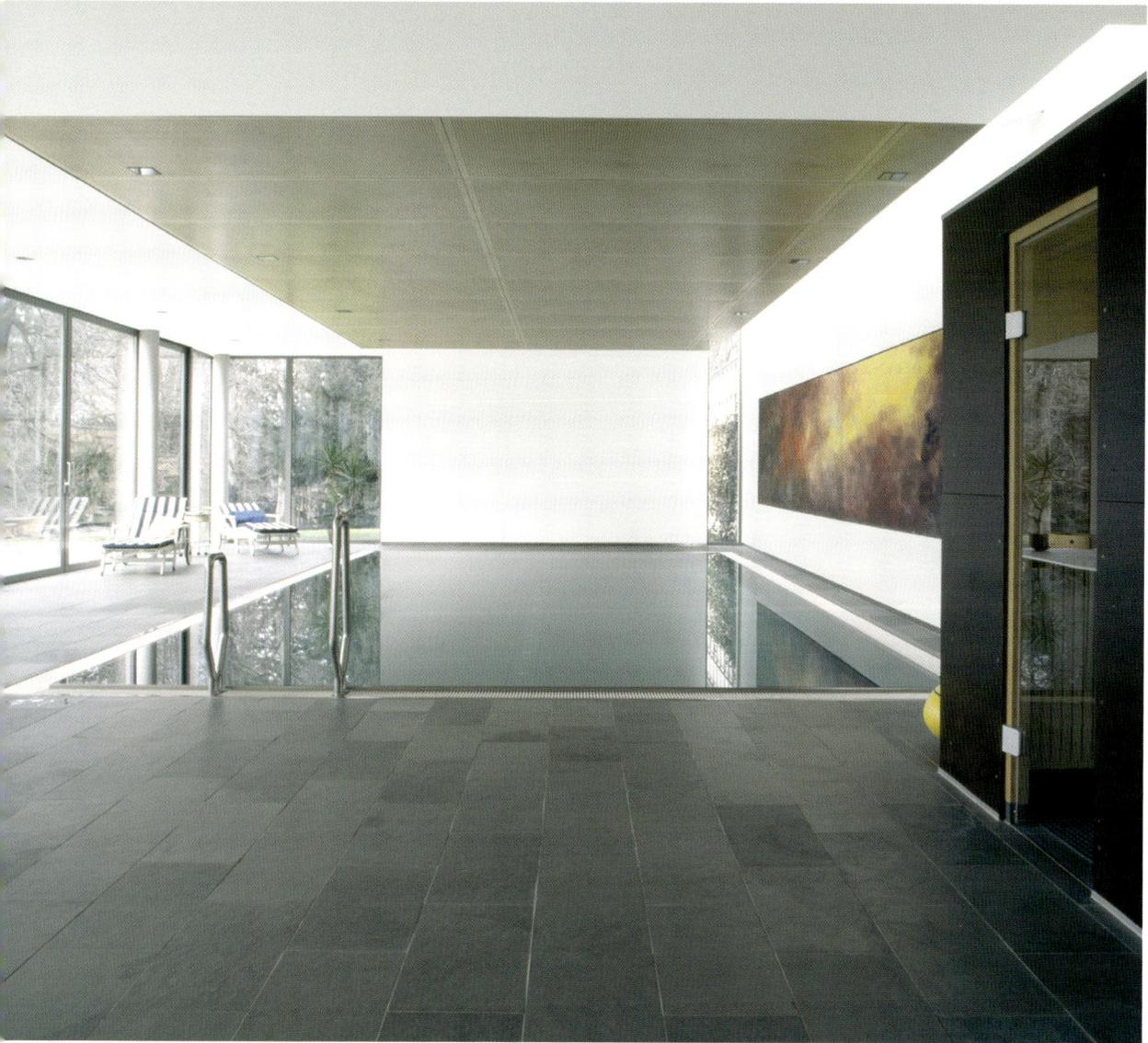

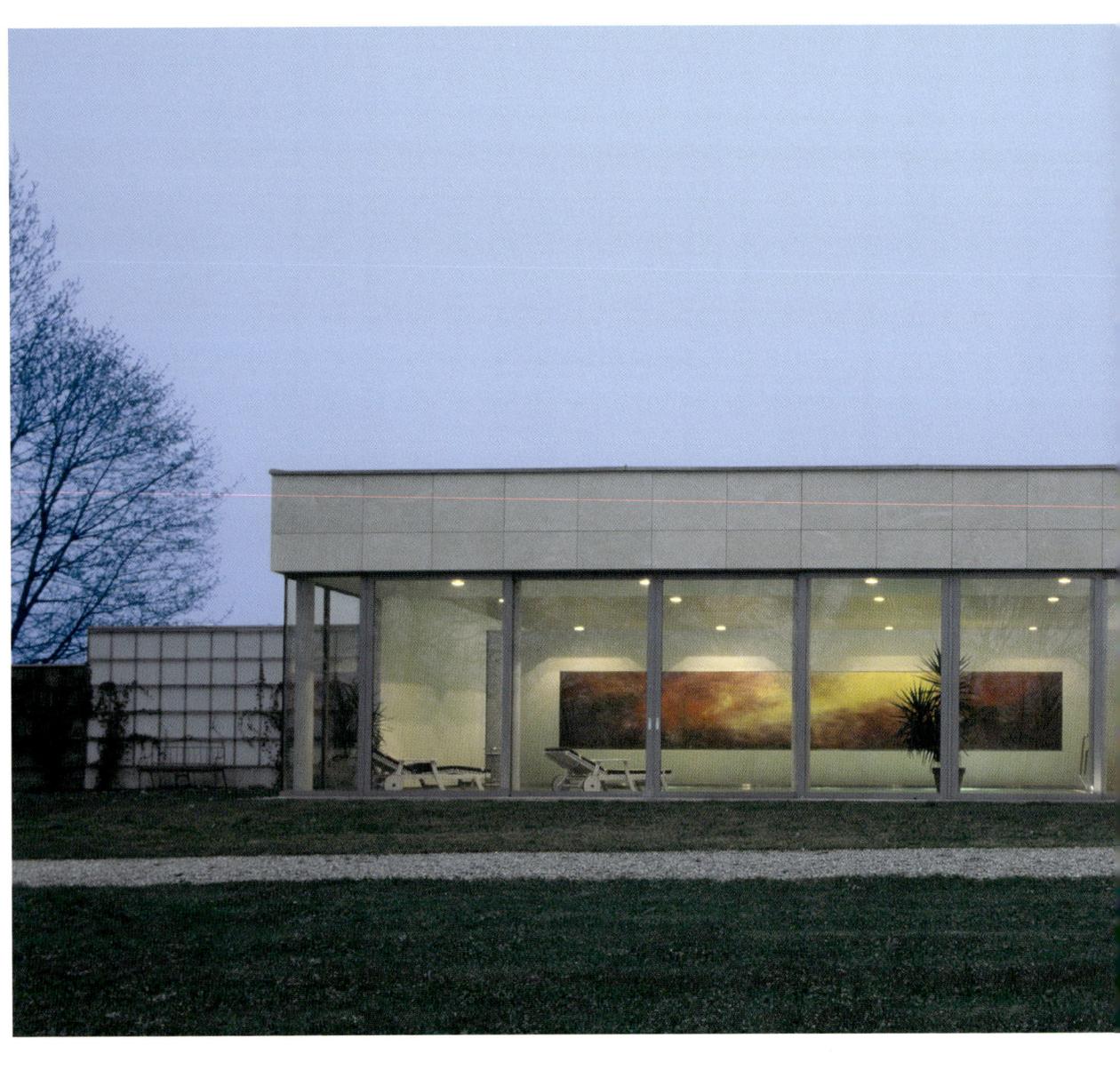

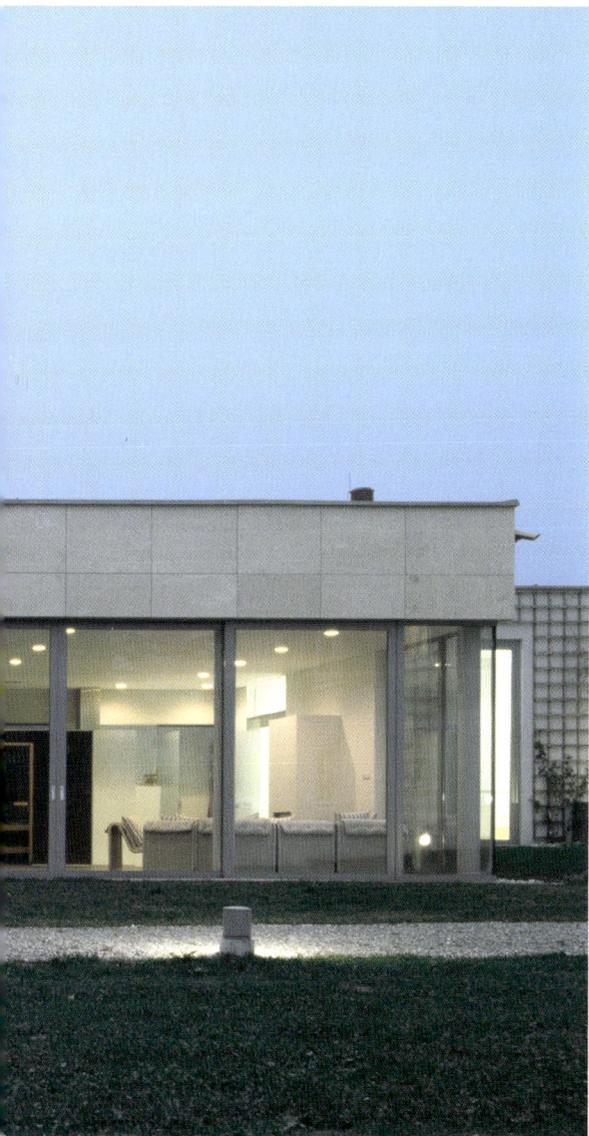

Arthur Casas Arquitetura e Design | São Paulo, Brazil
P. M. Home
Rio de Janeiro, Brazil | 2001

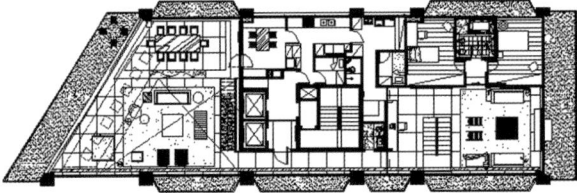

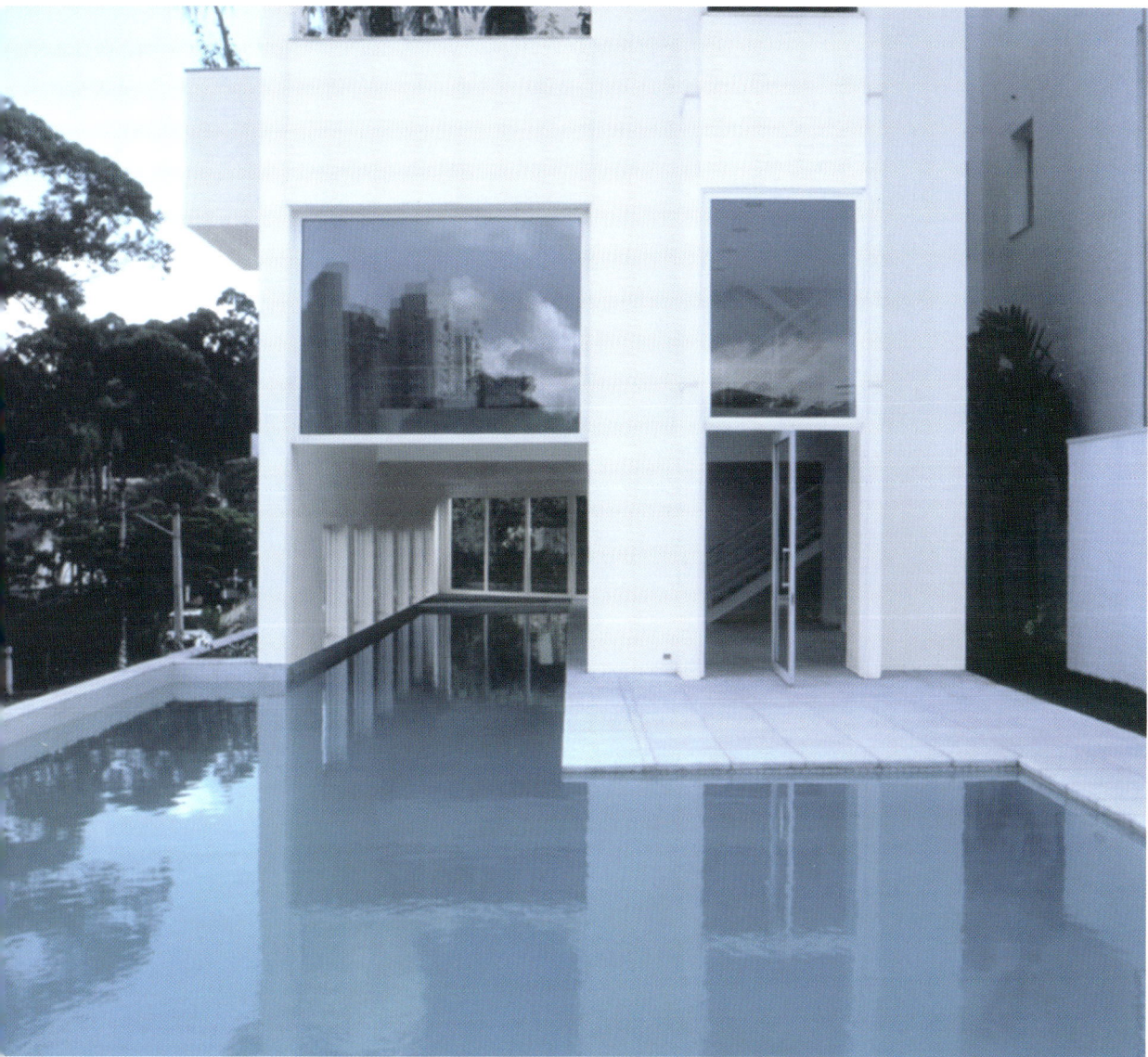

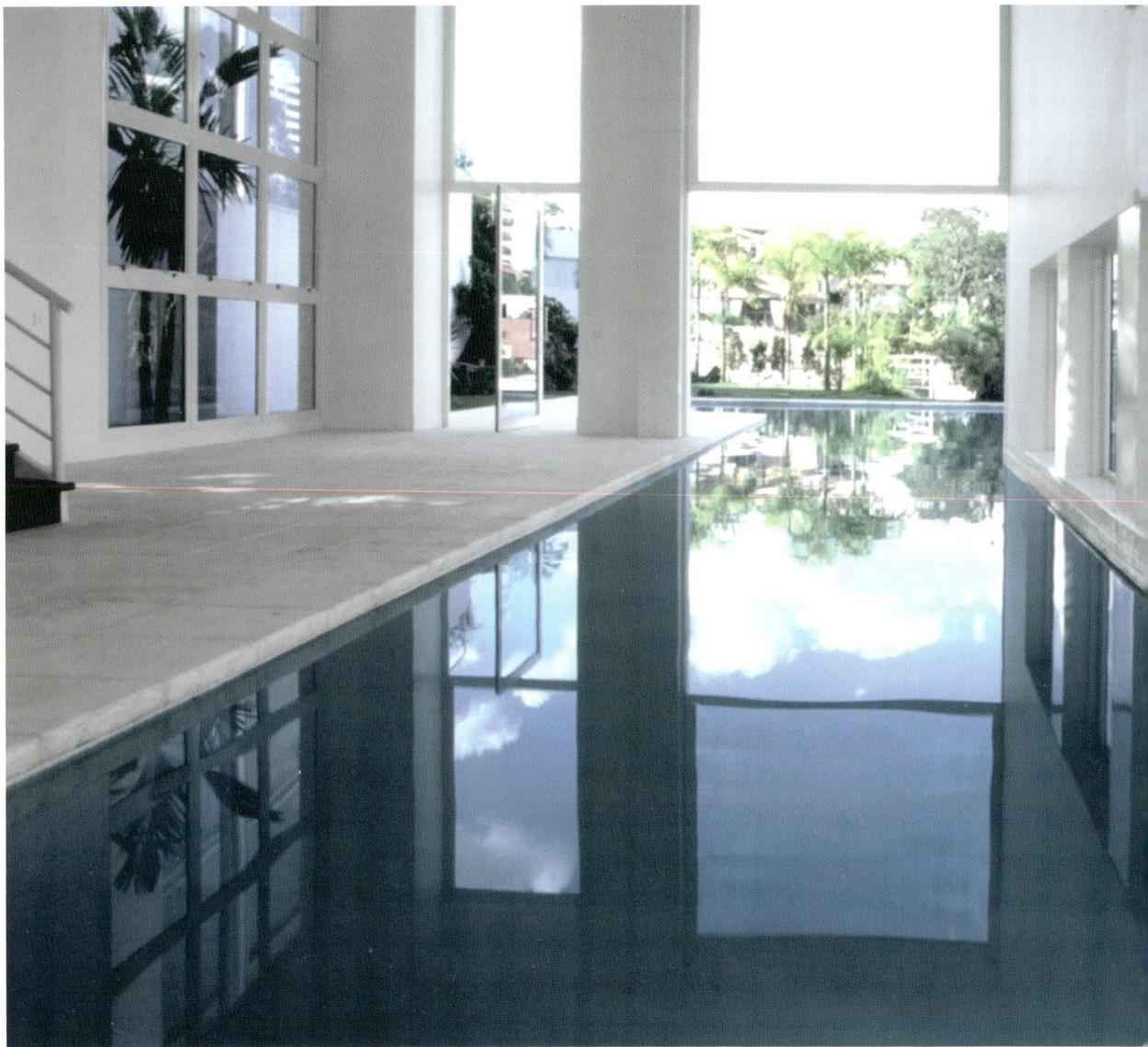

Atonis Stasinopoulos | Athens, Greece
House Galani
Kerameikos, Athens, Greece | 2002

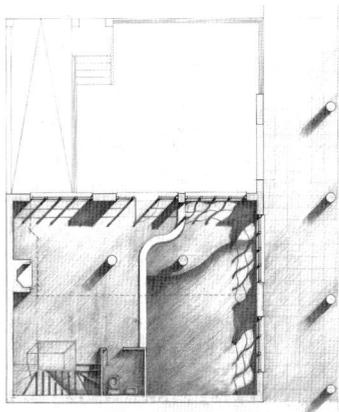

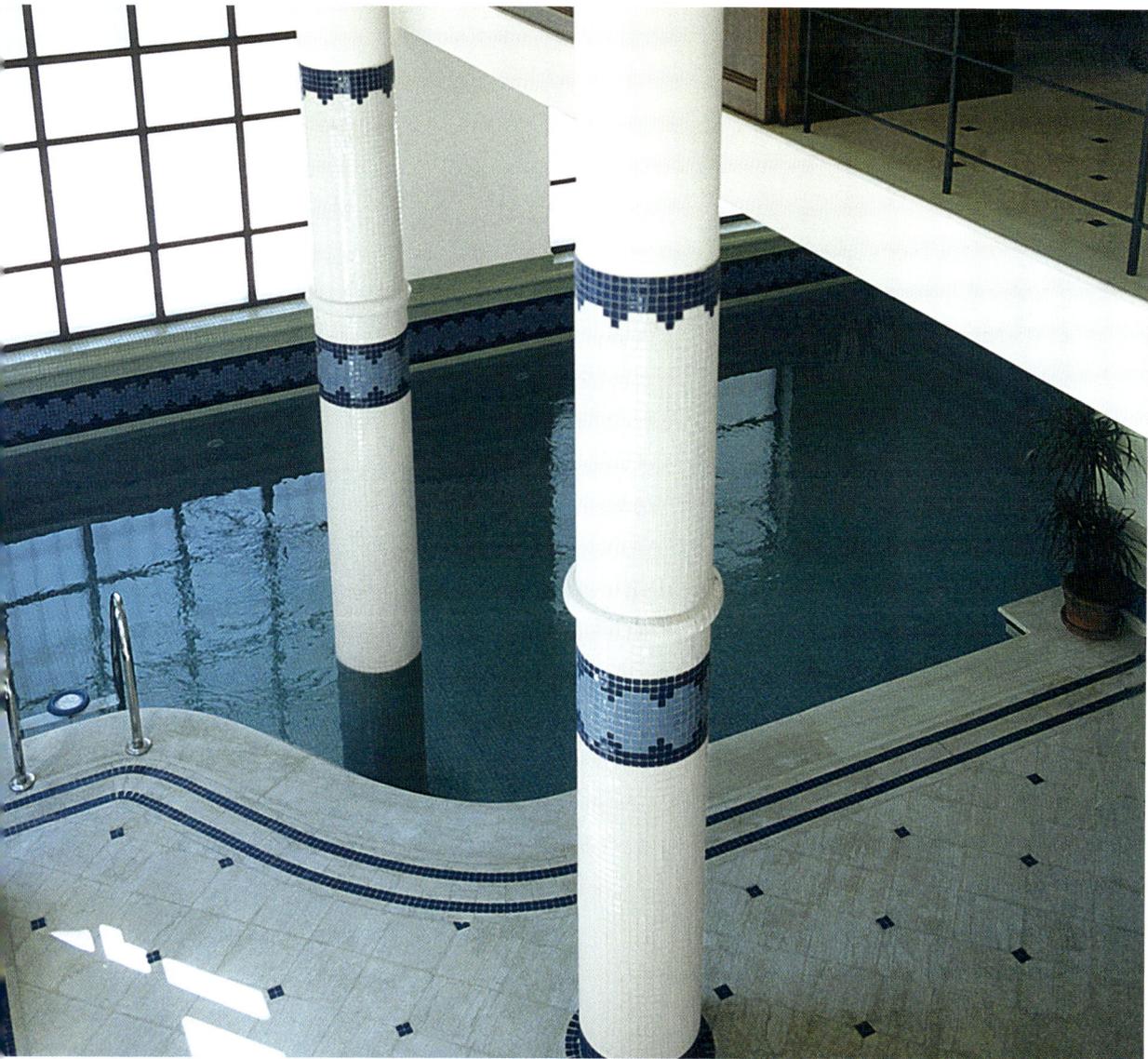

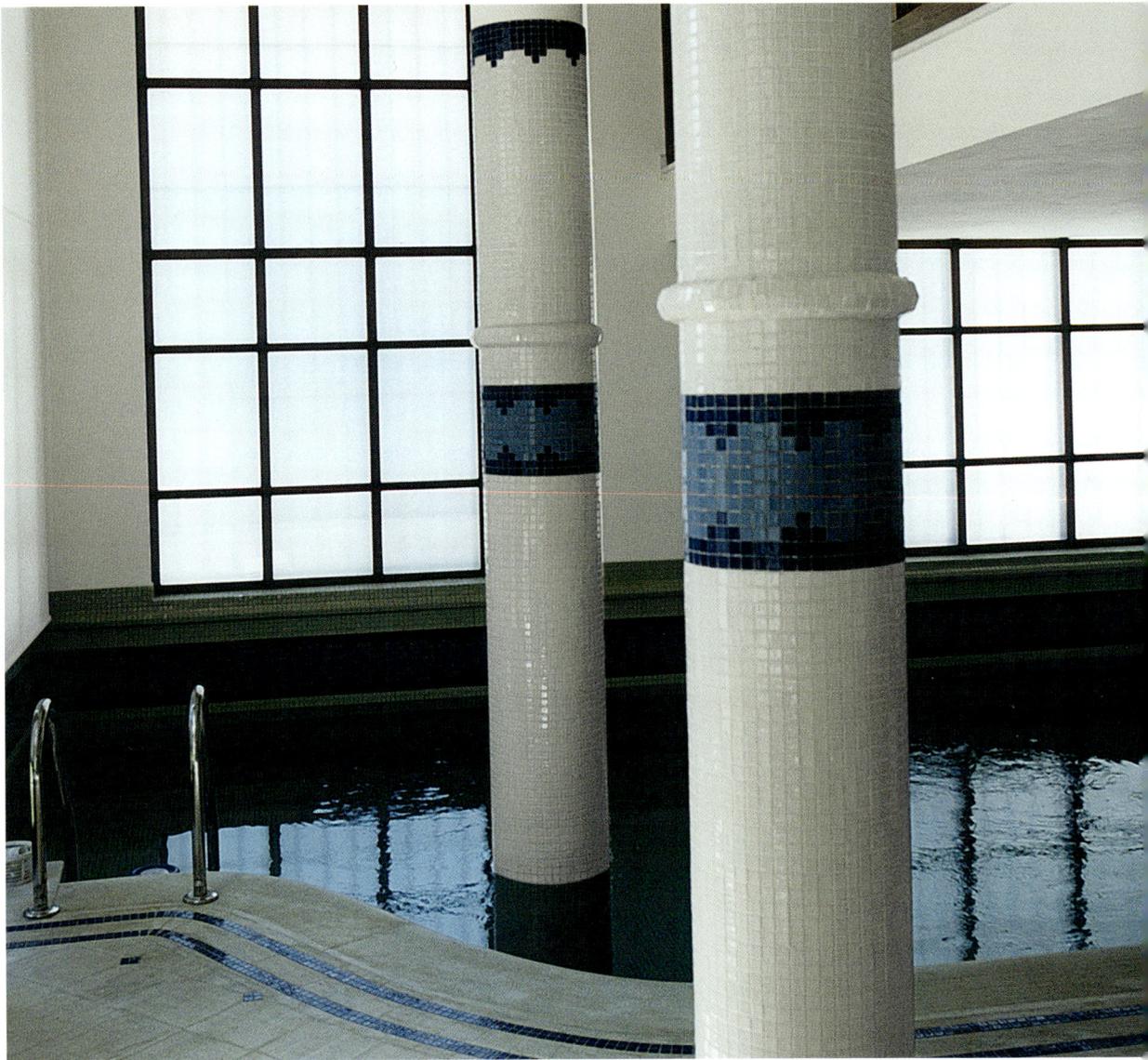

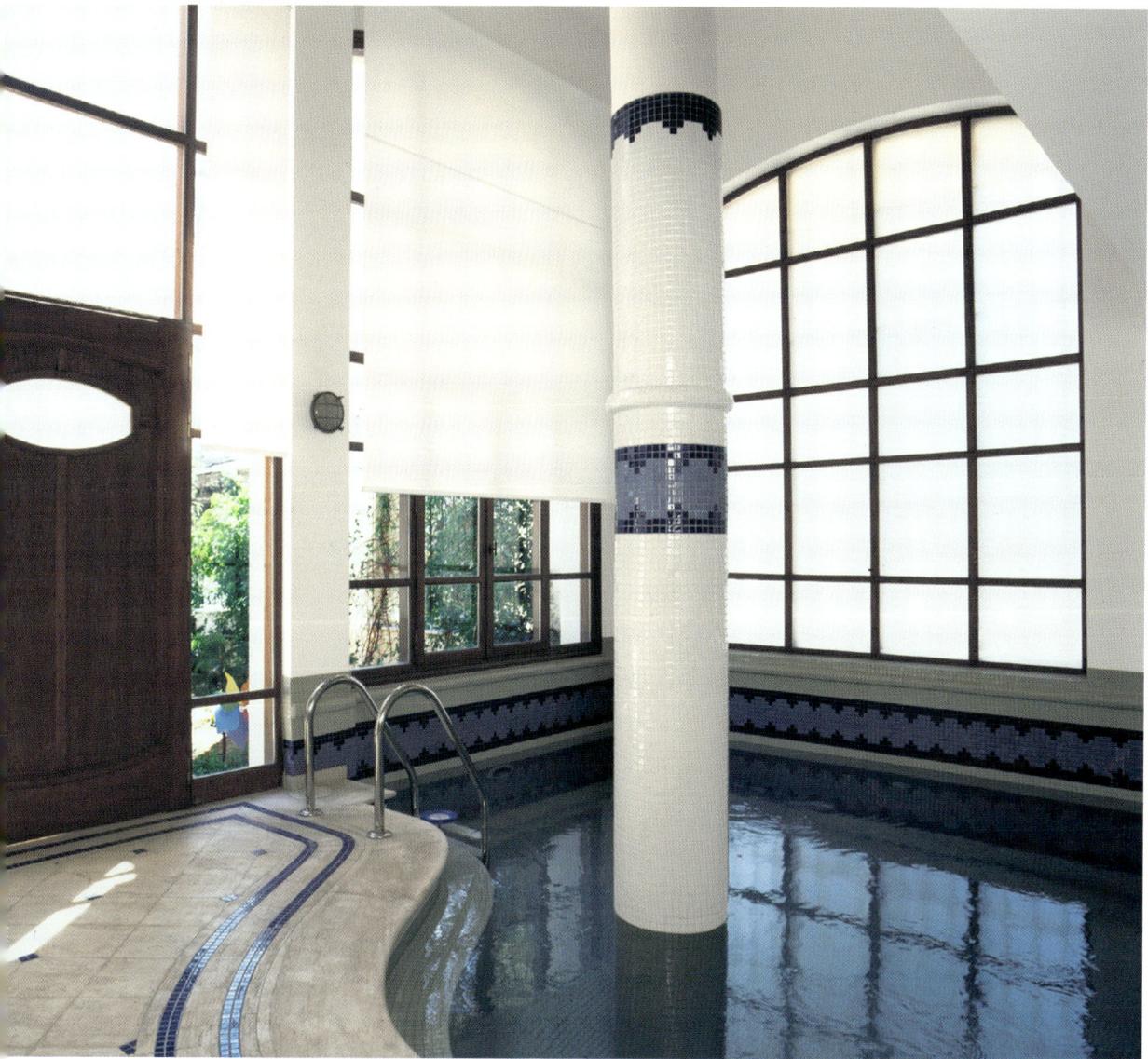

Atonis Stasinopoulos | Athens, Greece
House Nikolakopoulou
Kerameikos, Athens, Greece | 2000

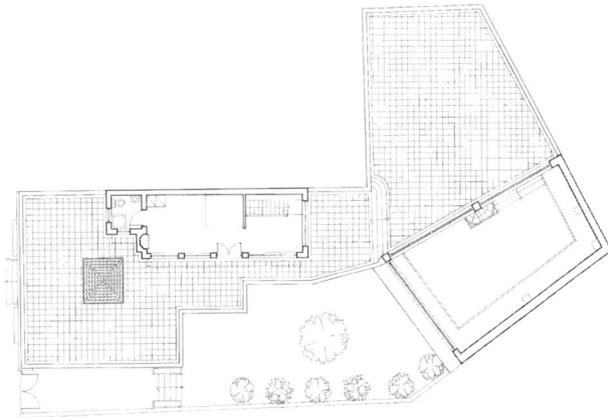

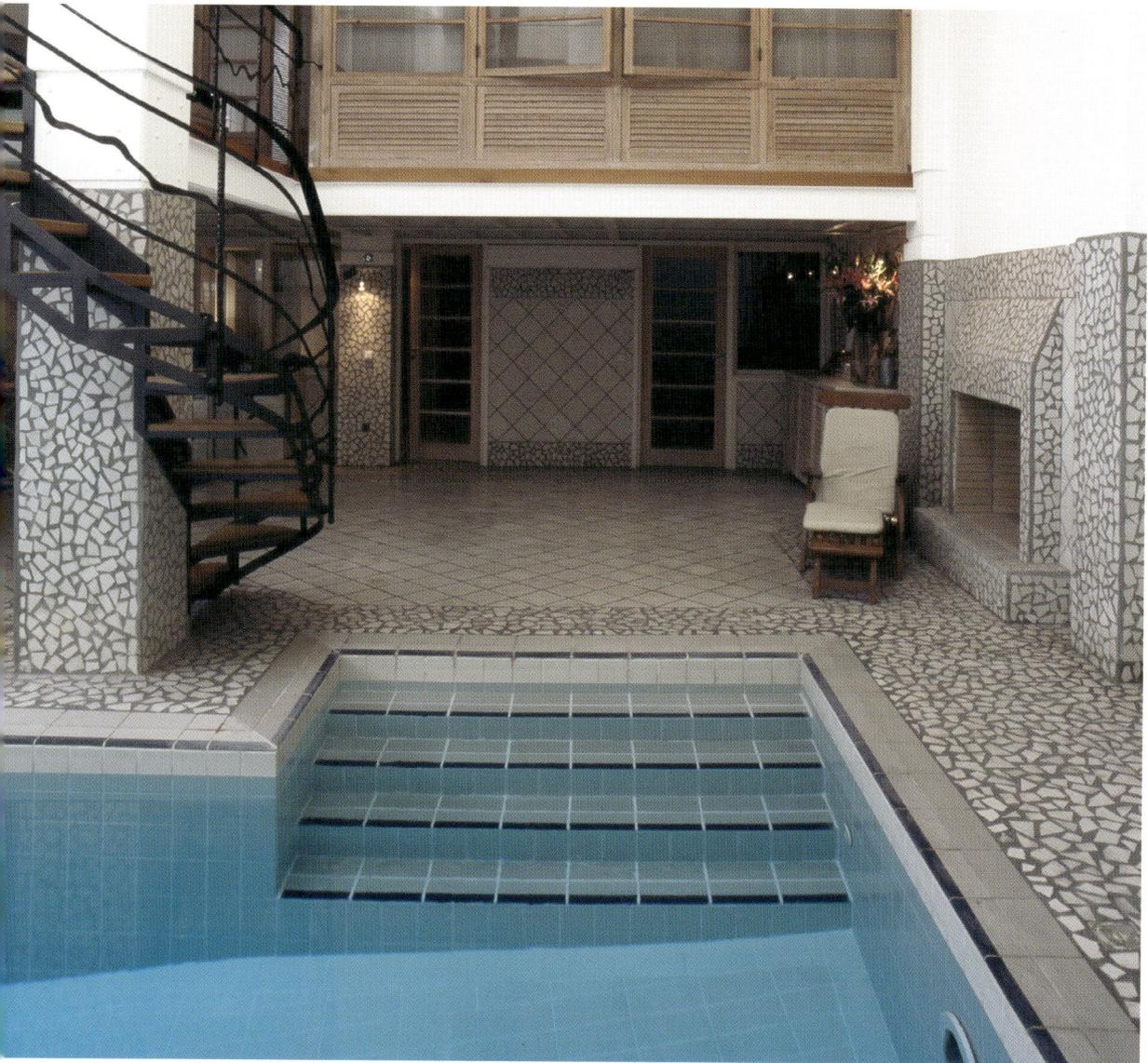

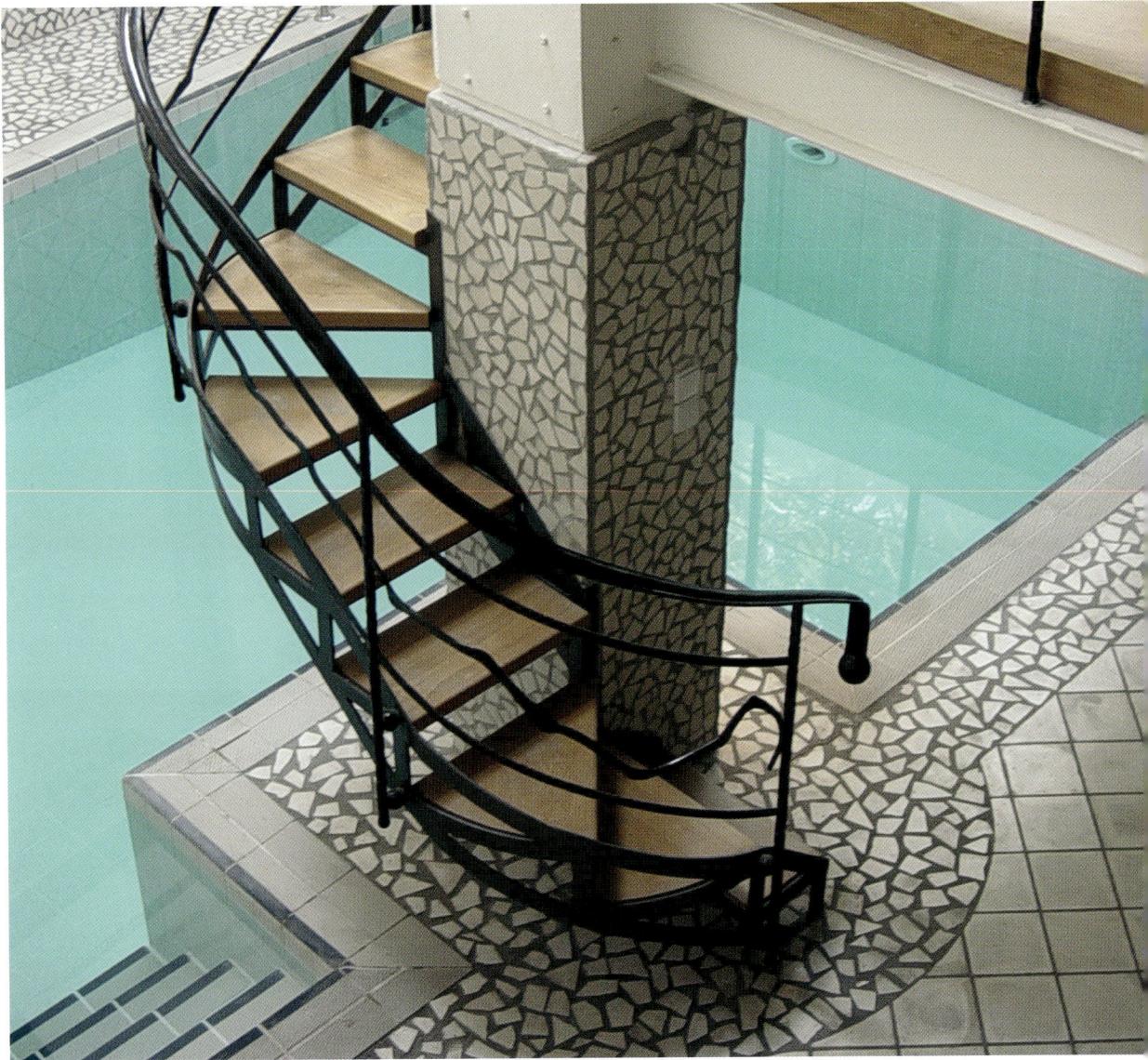

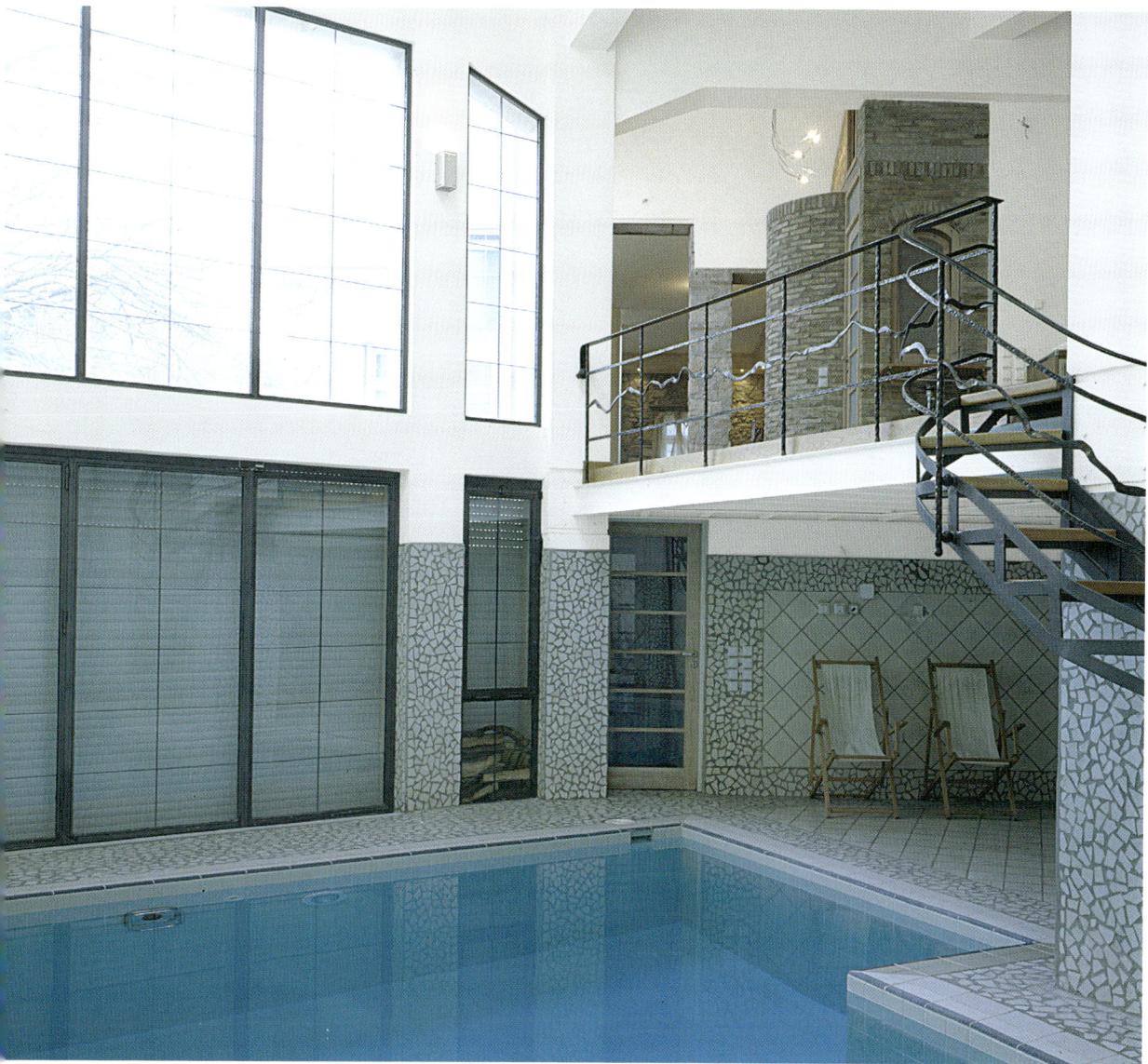

Atonis Stasinopoulos | Athens, Greece
House Symeonidi
Kerameikos, Athens, Greece | 2003

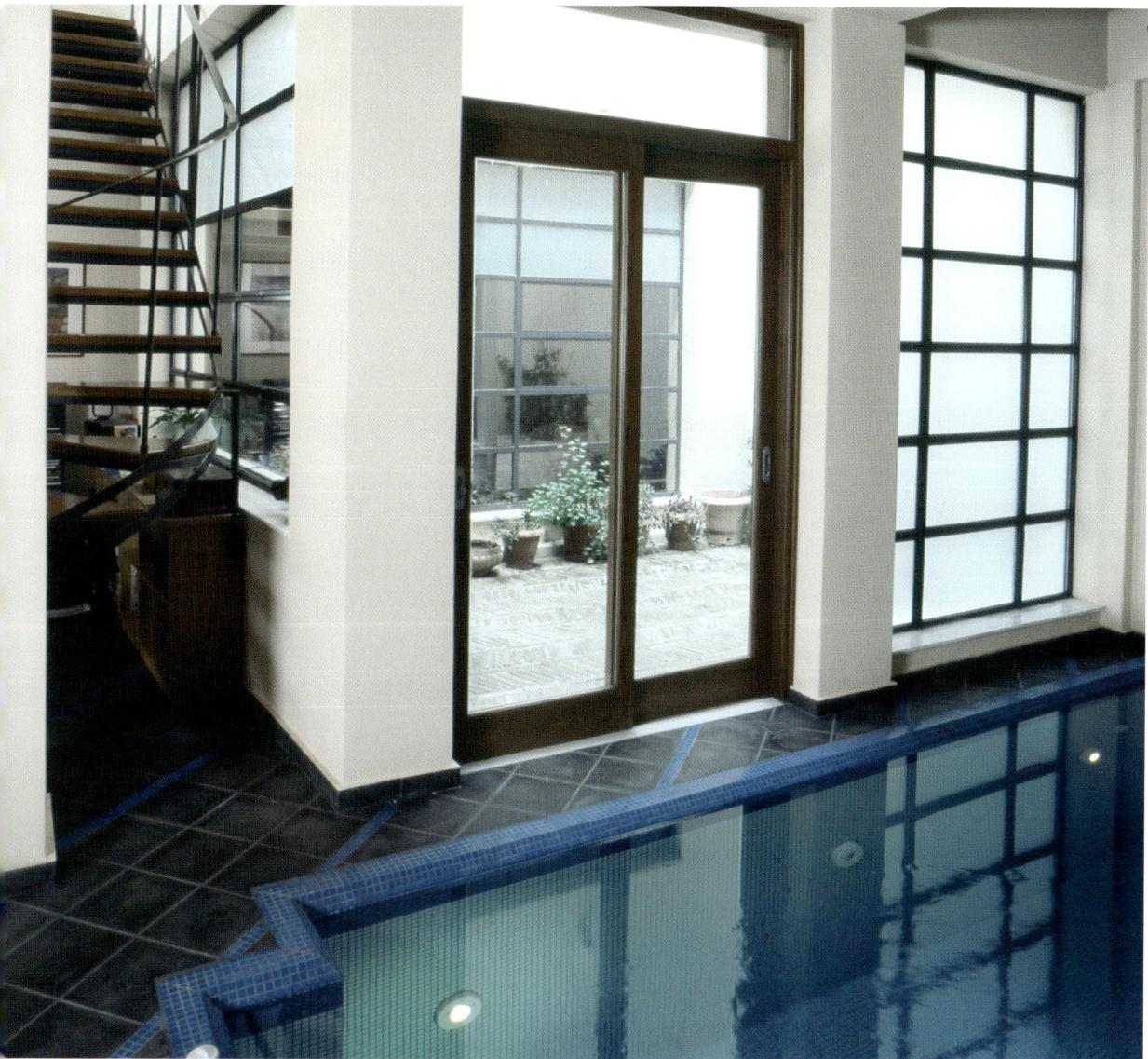

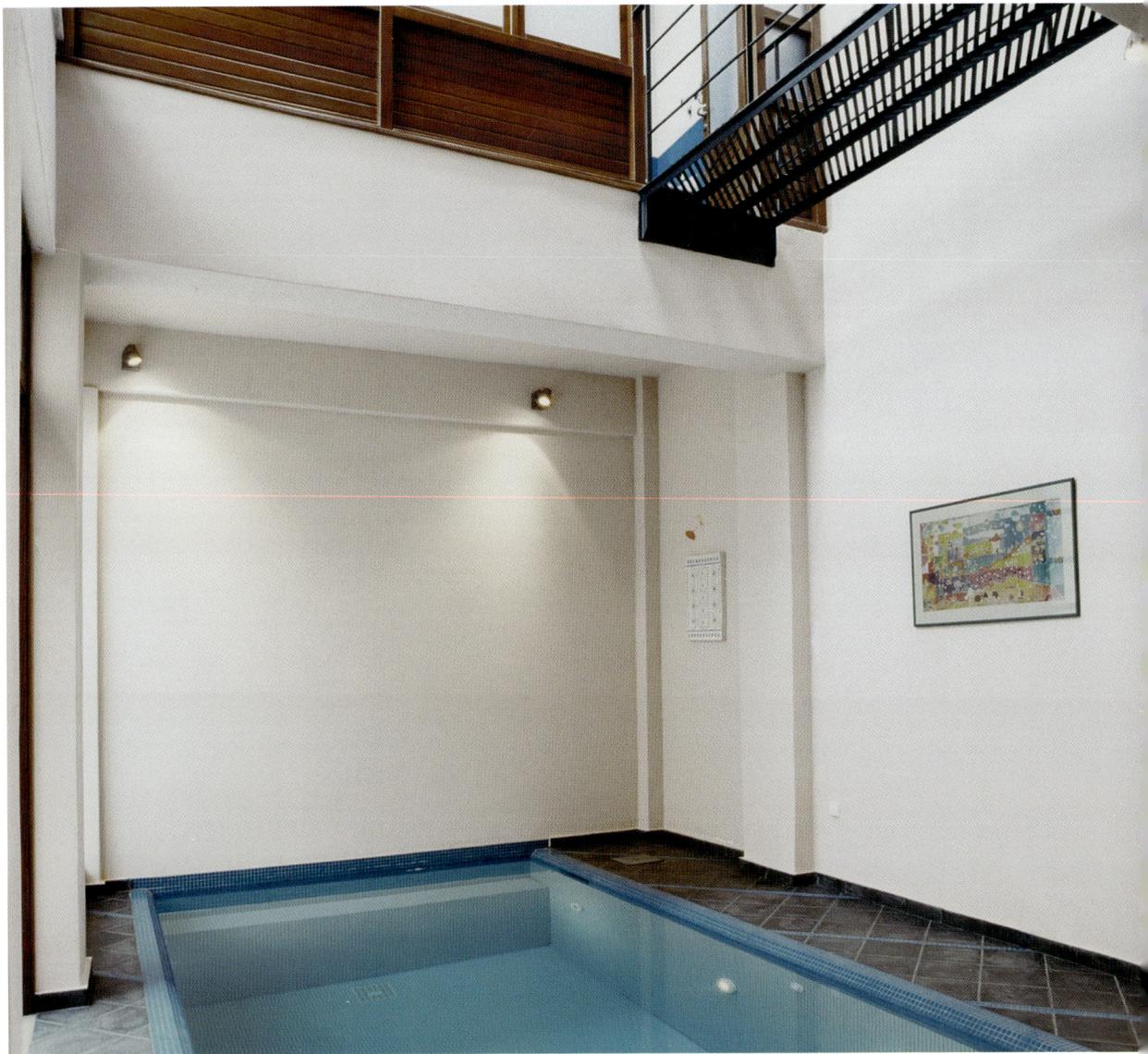

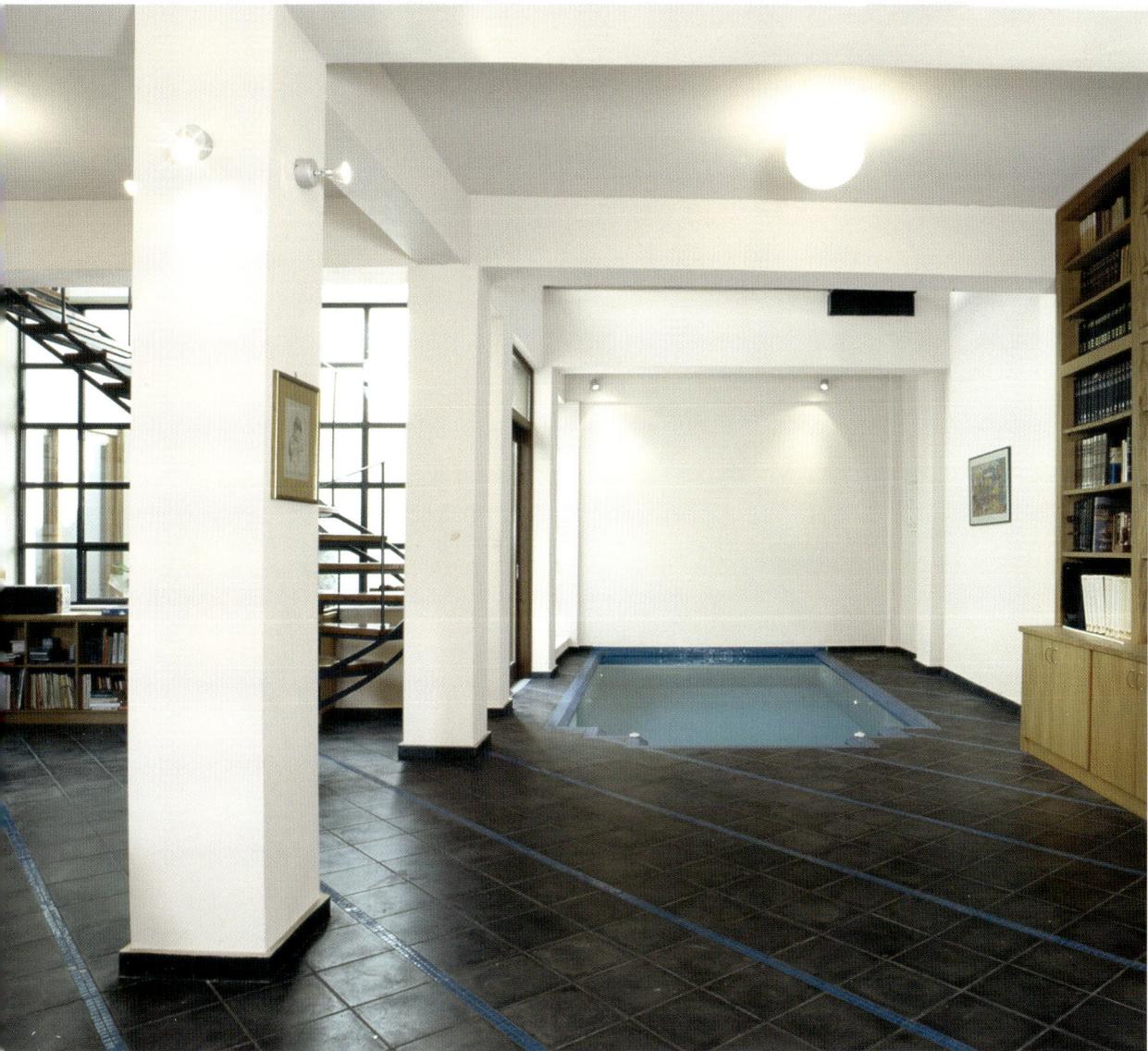

bammp/Francesc Bacardit | Terrassa, Barcelona, Spain
Xiol House
Matadepera, Barcelona, Spain | 2002

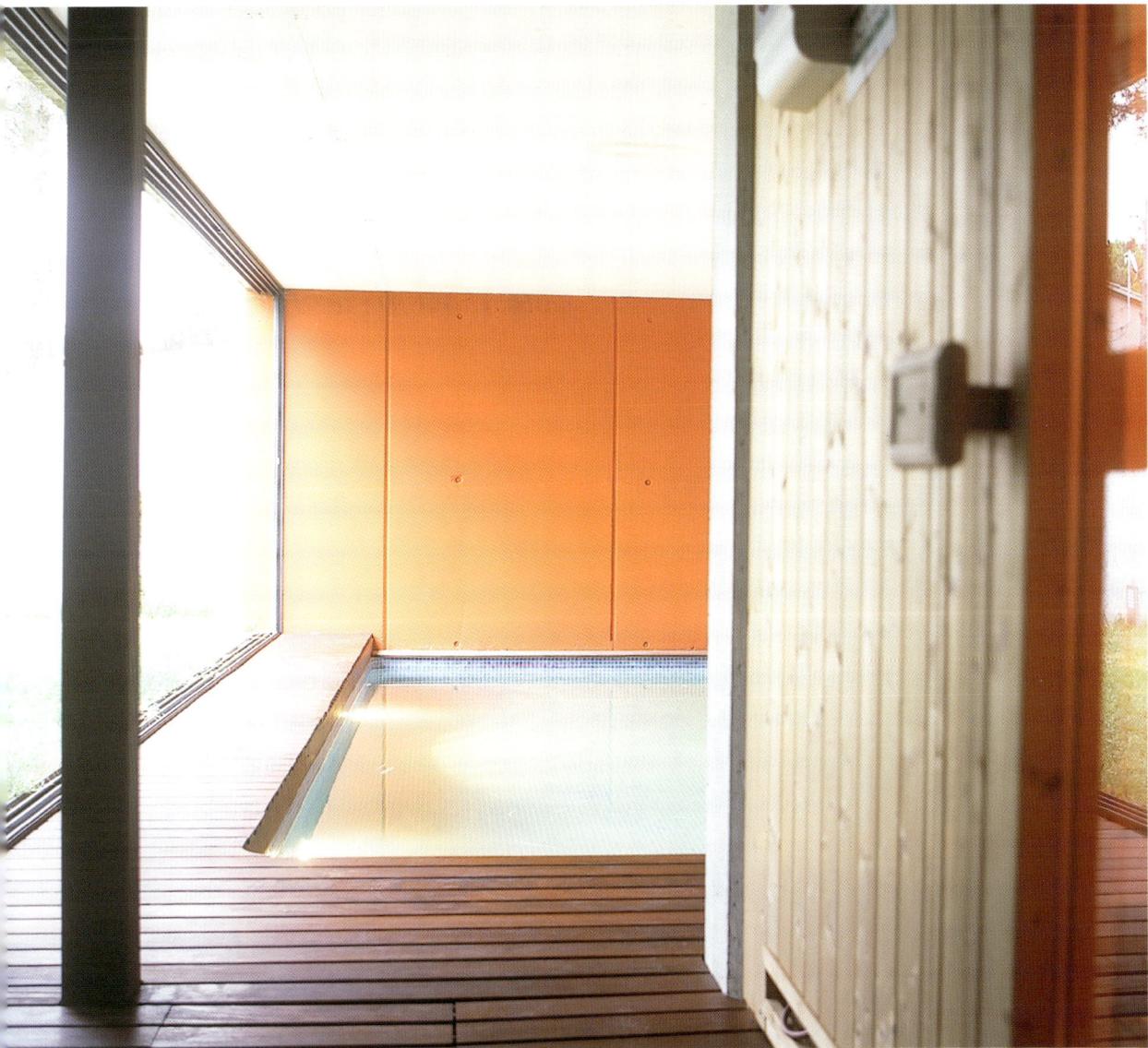

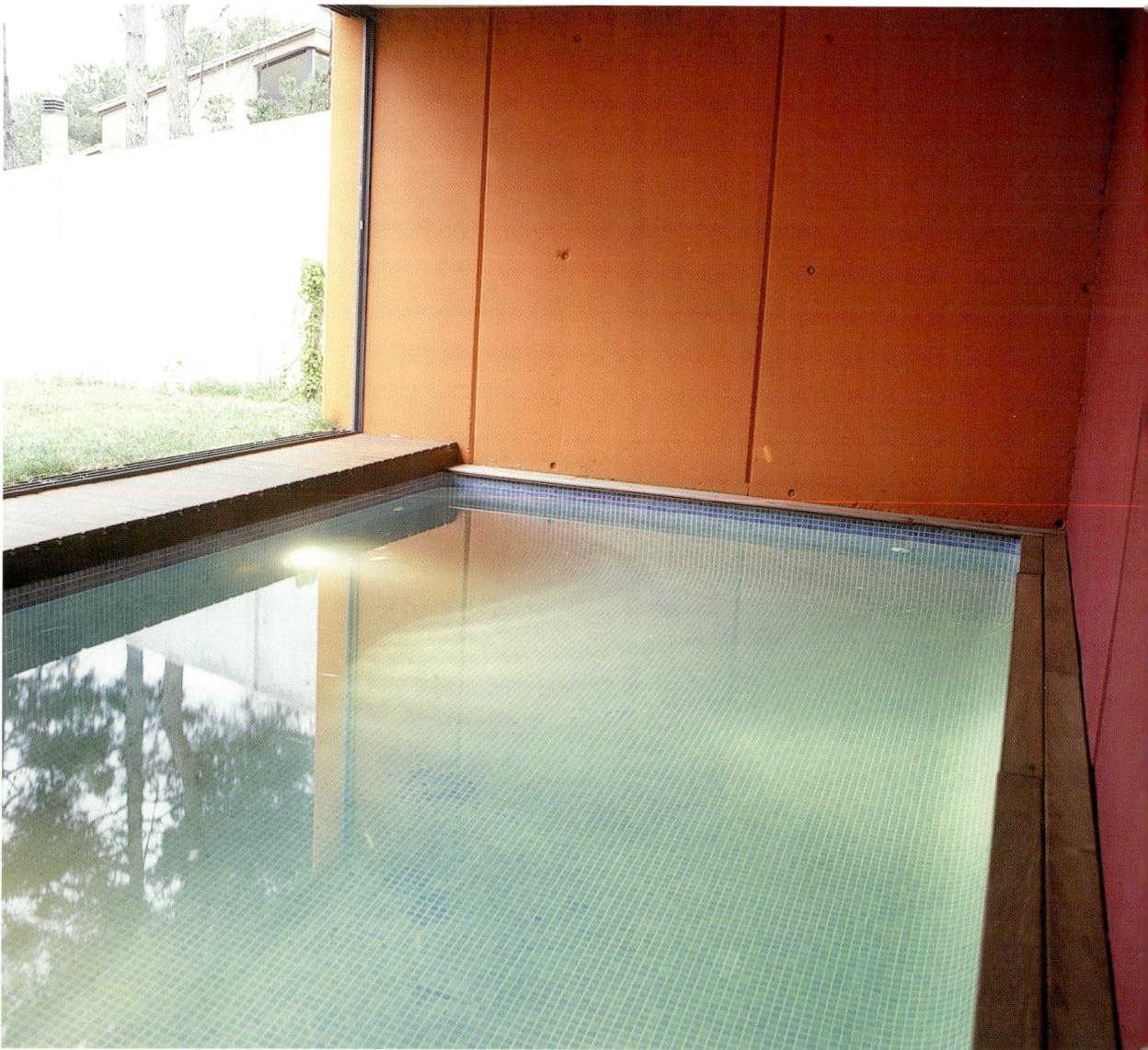

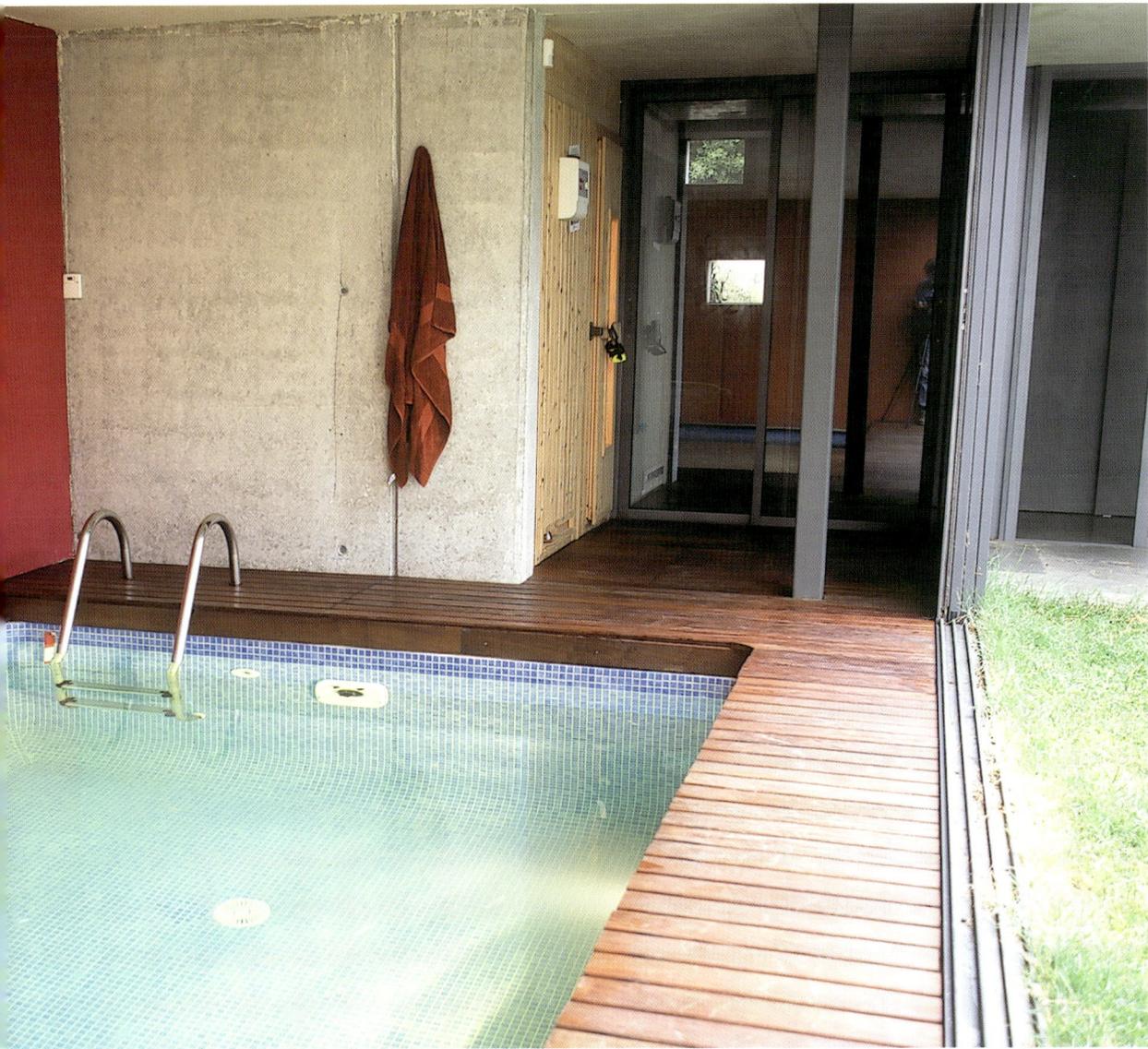

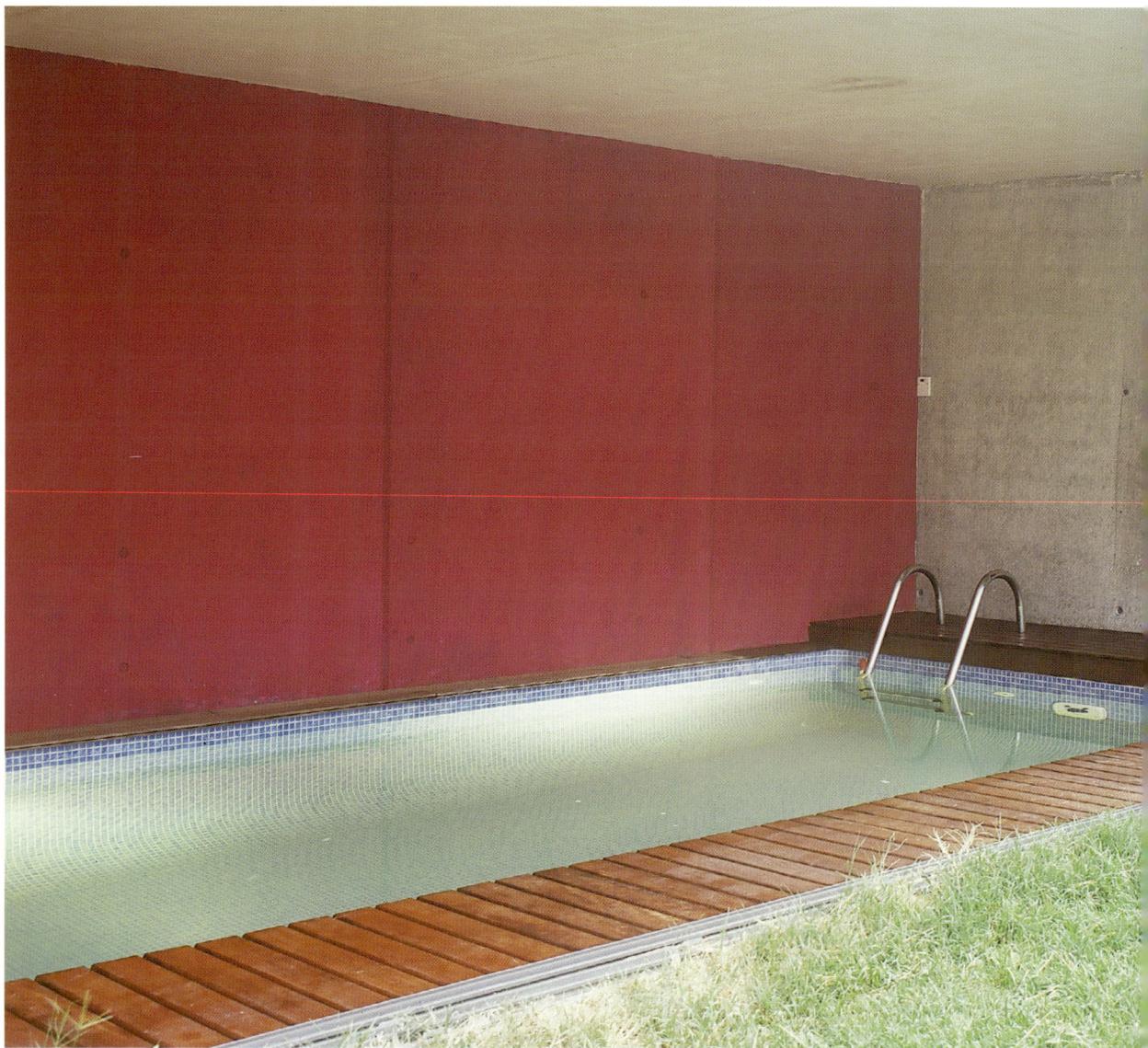

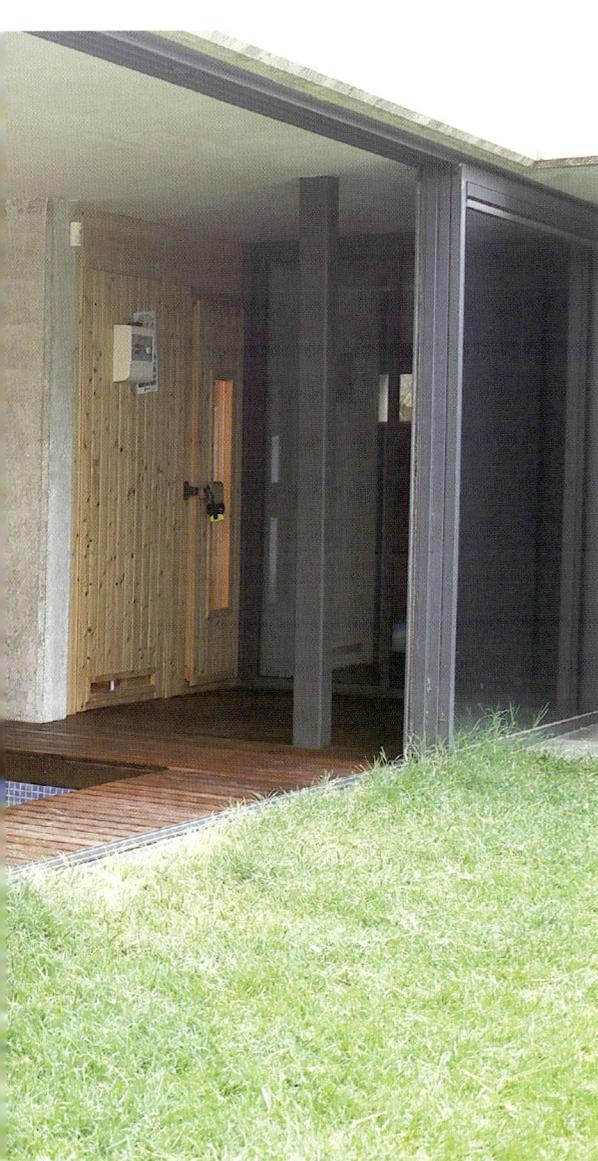

Caña y Caña/Design Elena Surribas | La Llagosta, Barcelona, Spain
Lloreda House
Les Franqueses del Vallès, Barcelona, Spain| 2001

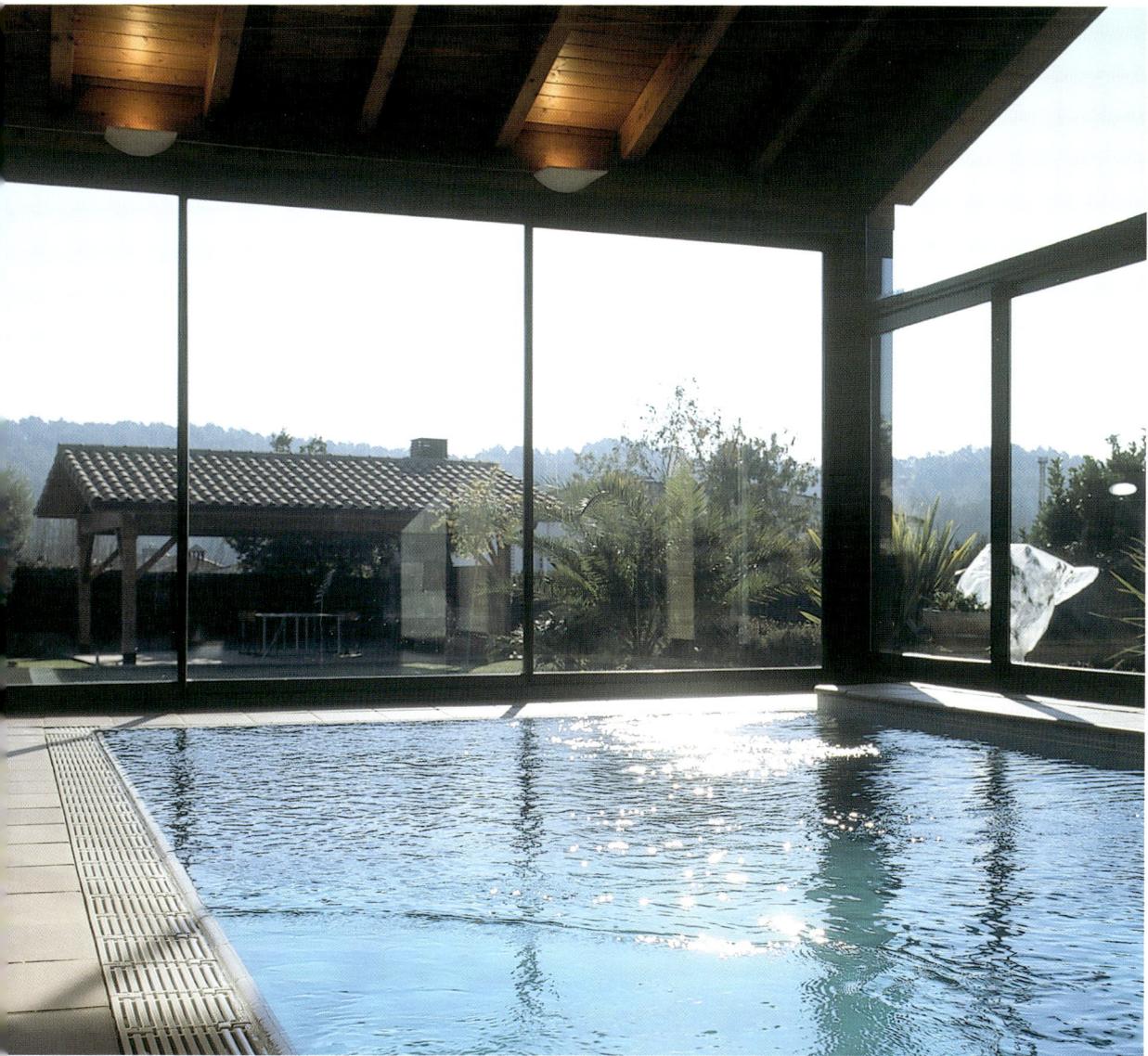

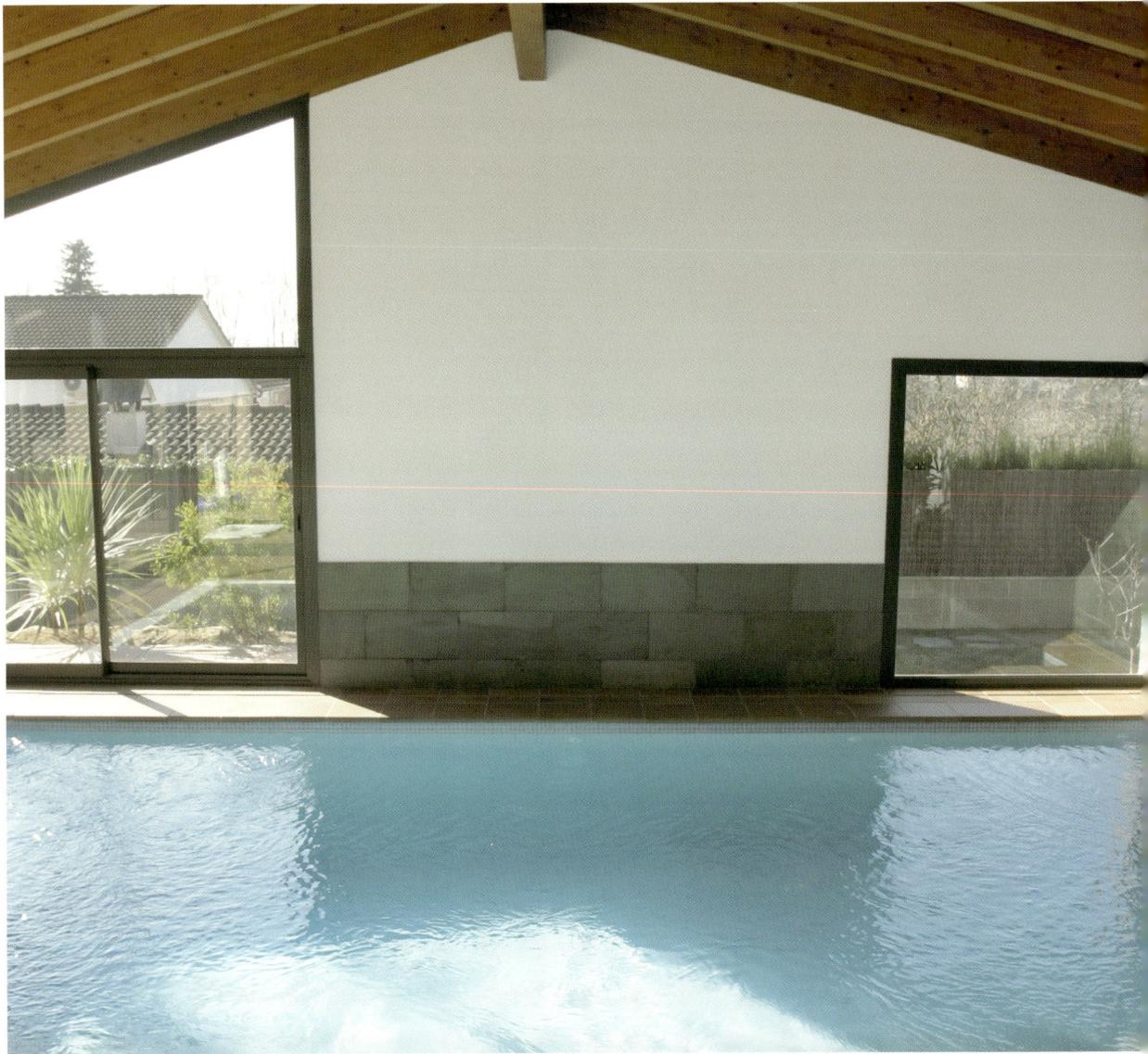

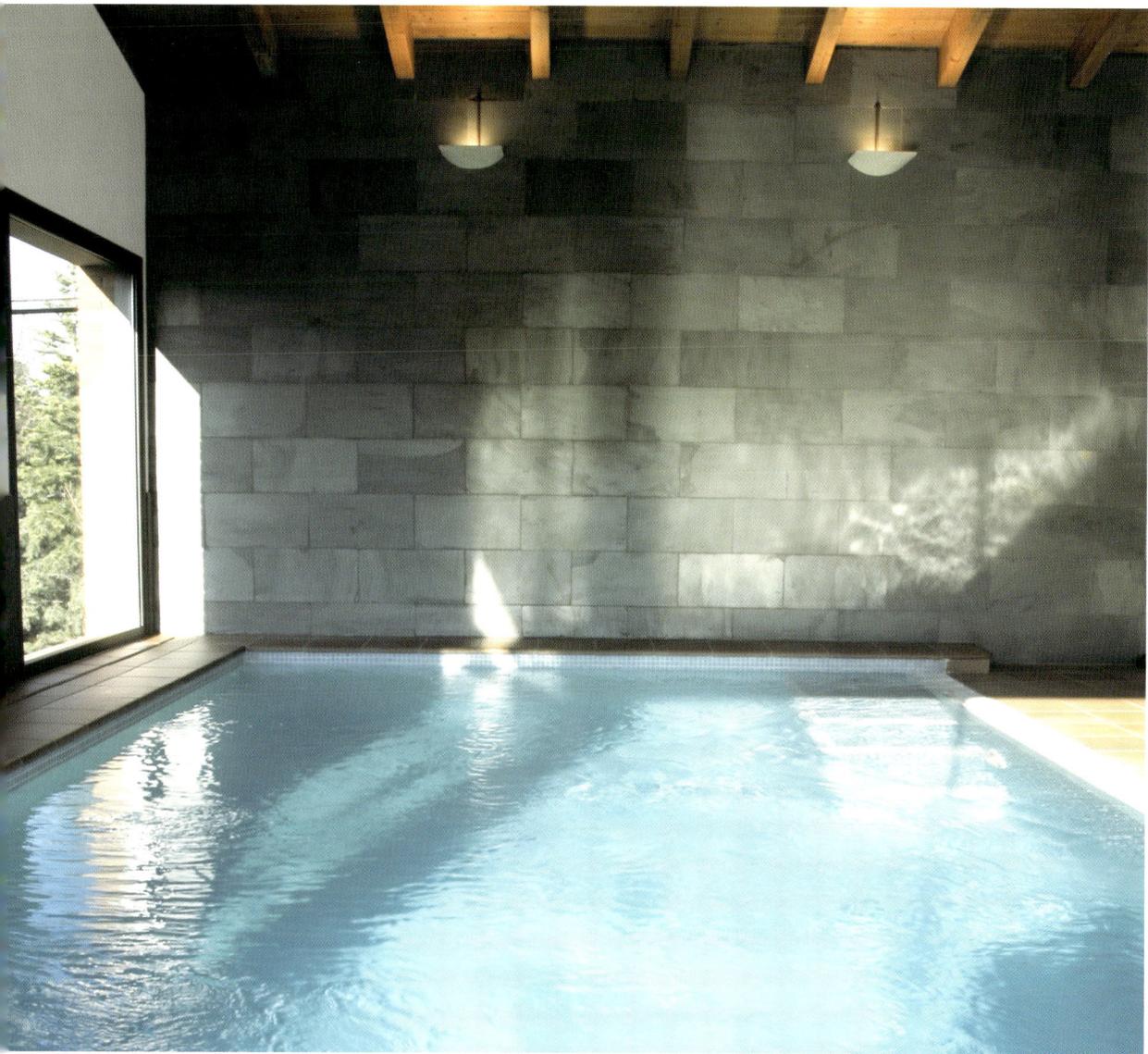

Carlo Donati | Milan, Italy
Casa a Patio
Milan, Italy | 2003

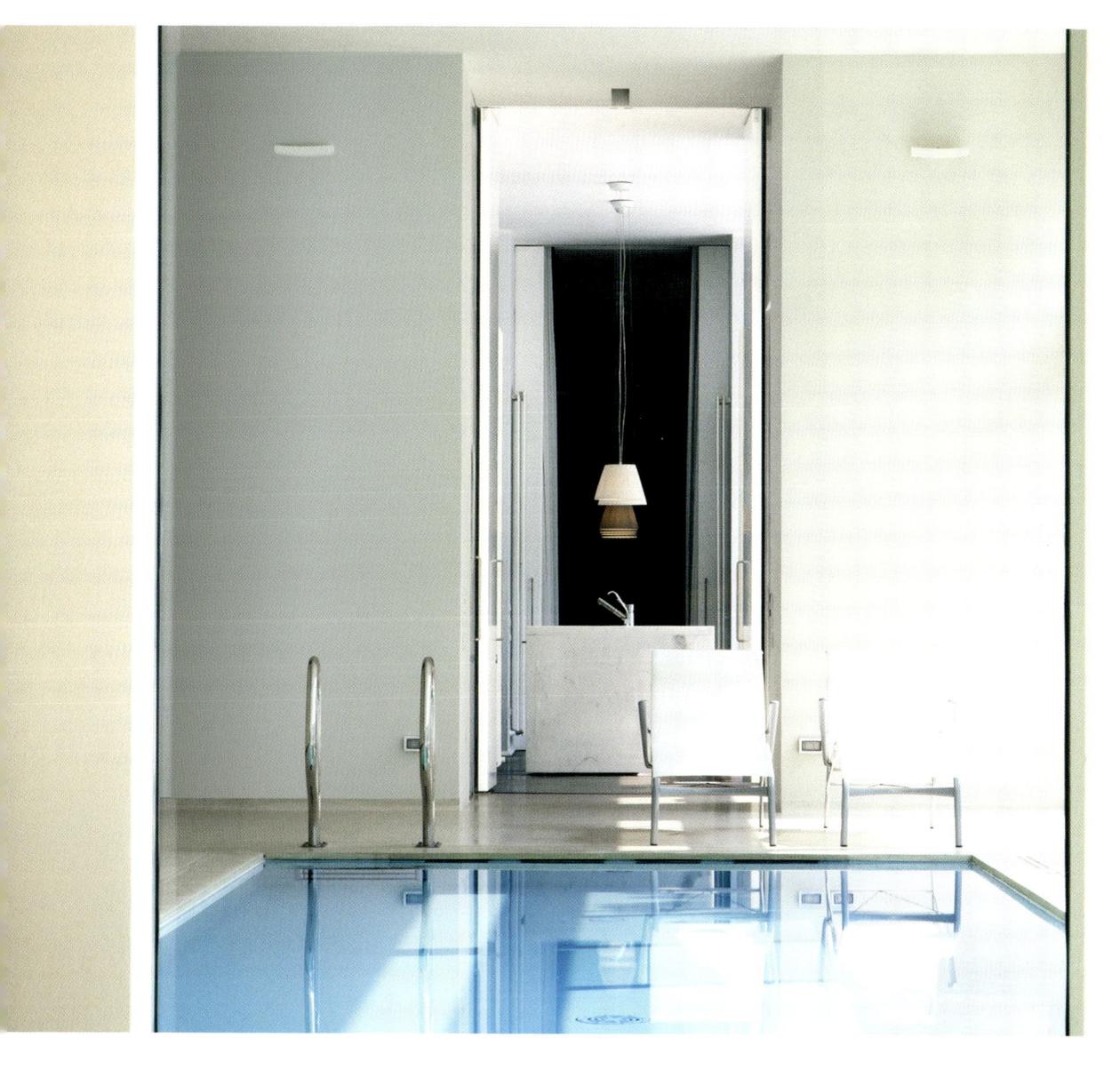

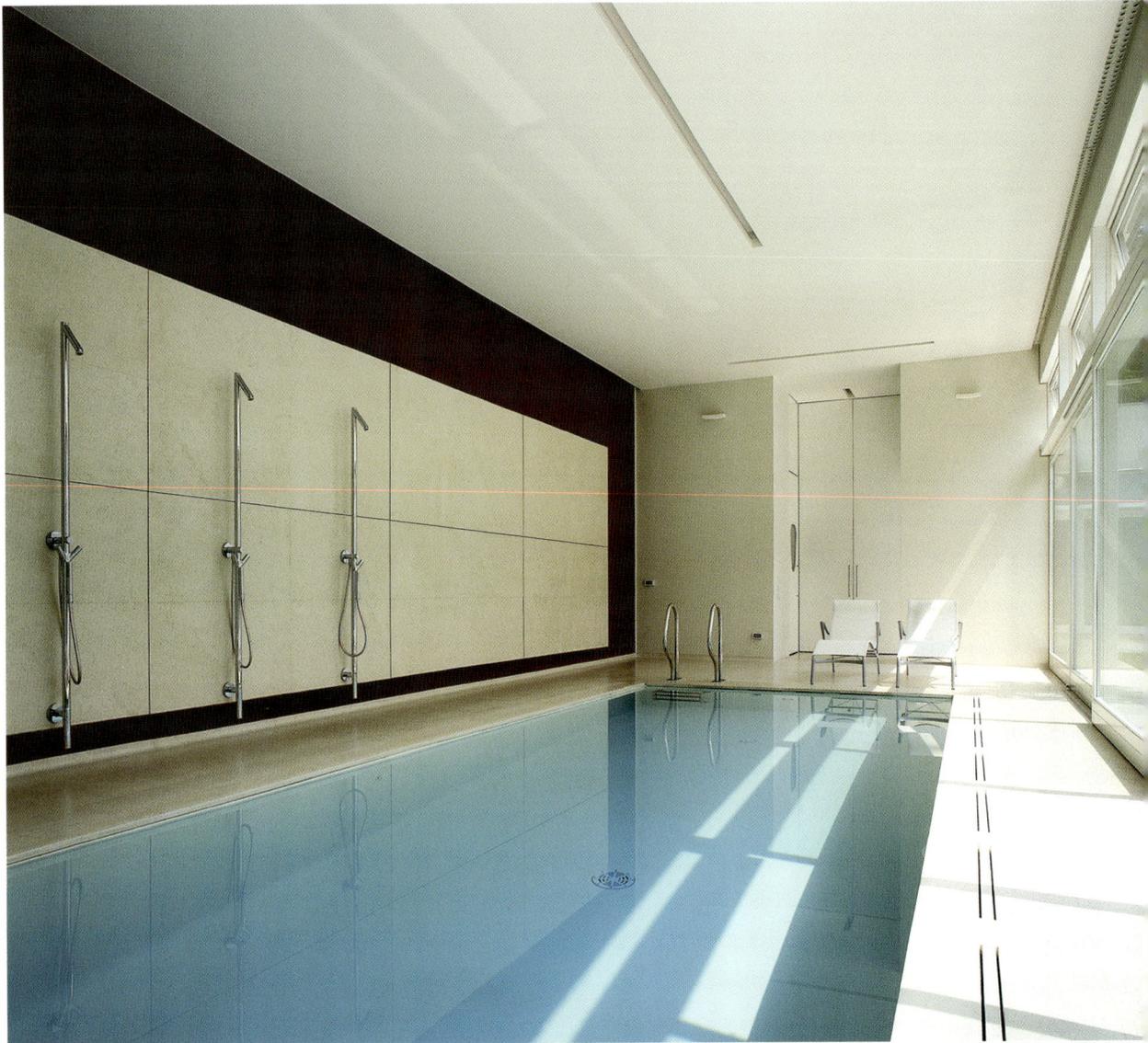

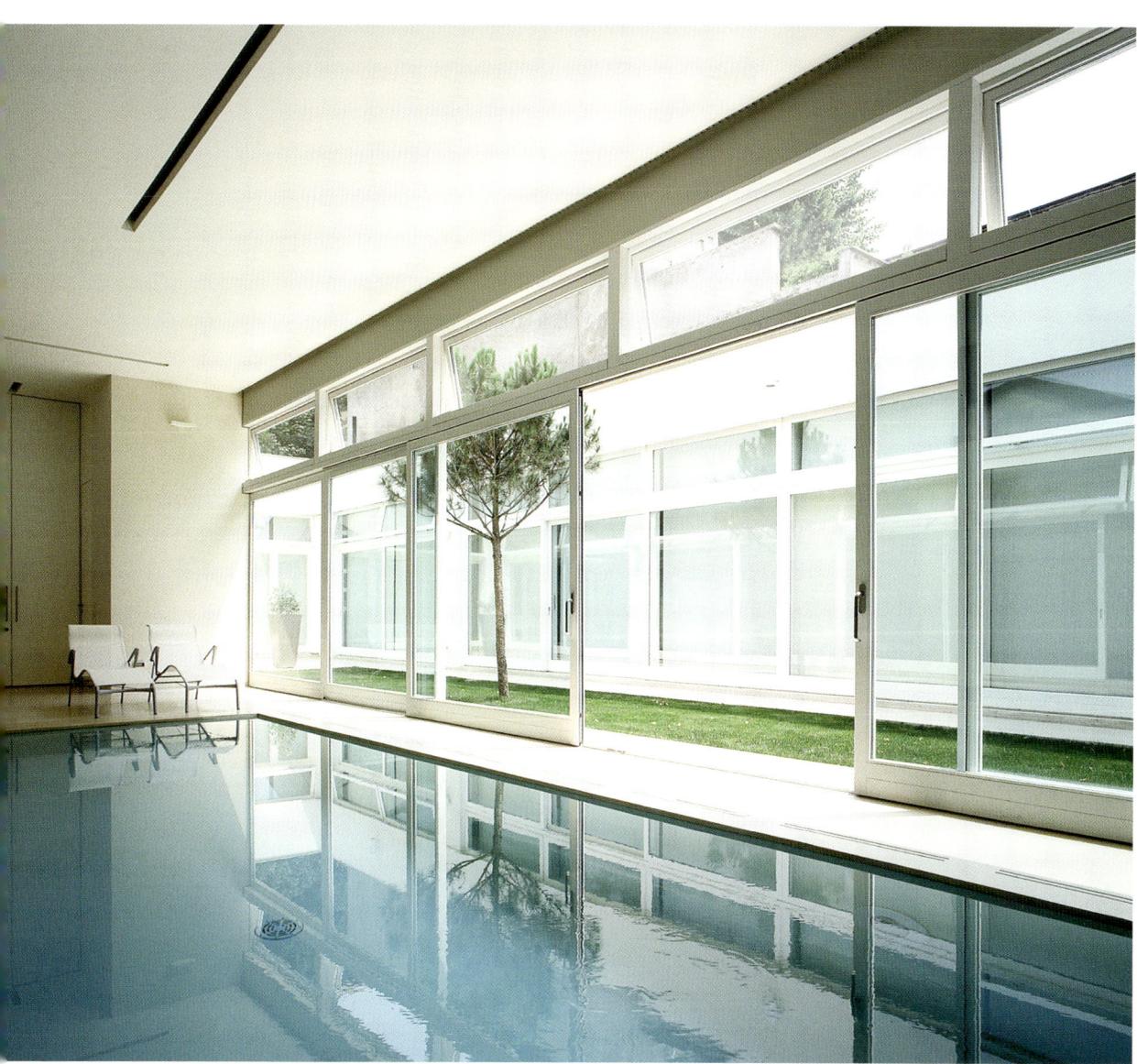

Carlo Donati | Milan, Italy
Loft A
Milan, Italy | 2003

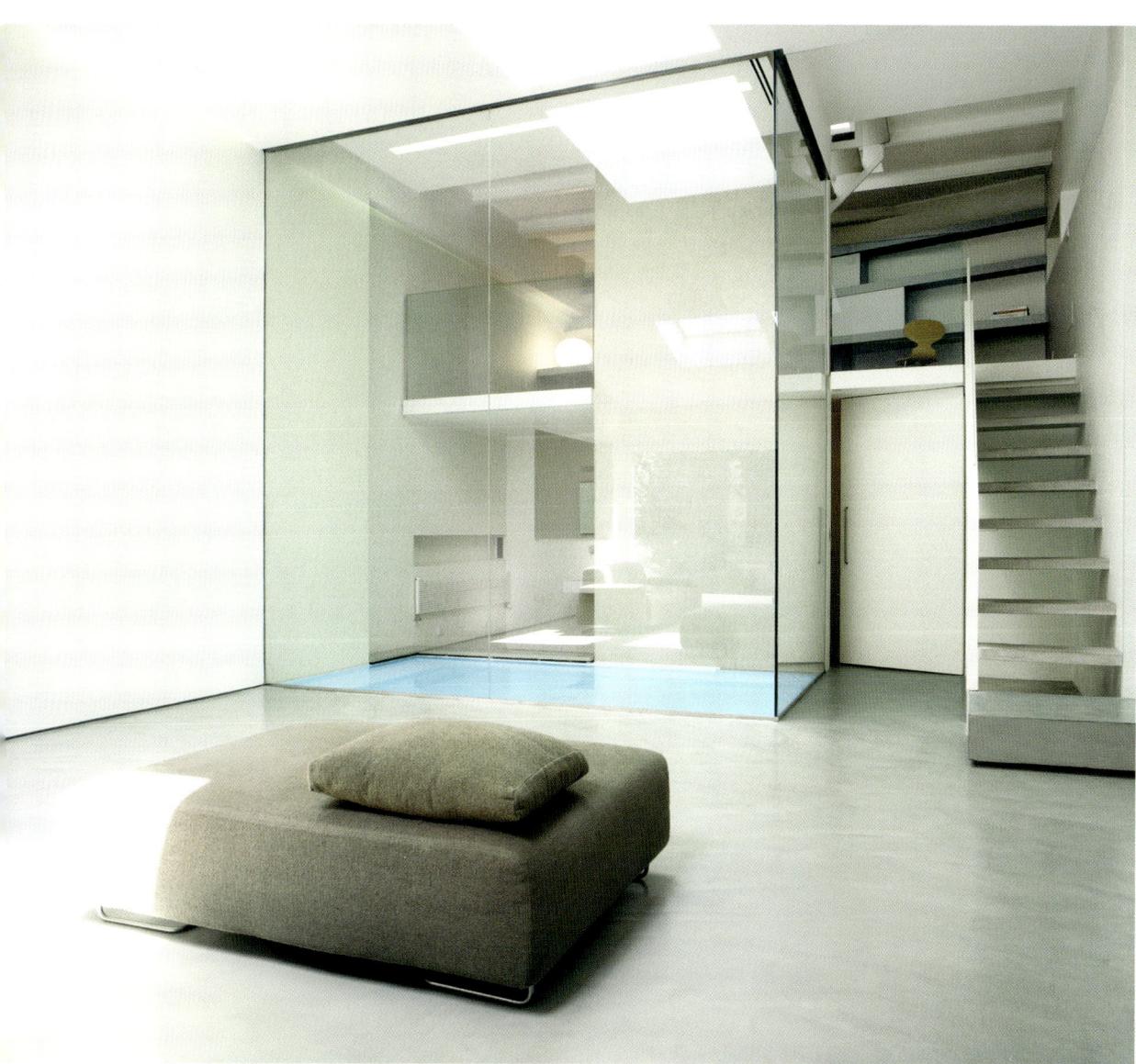

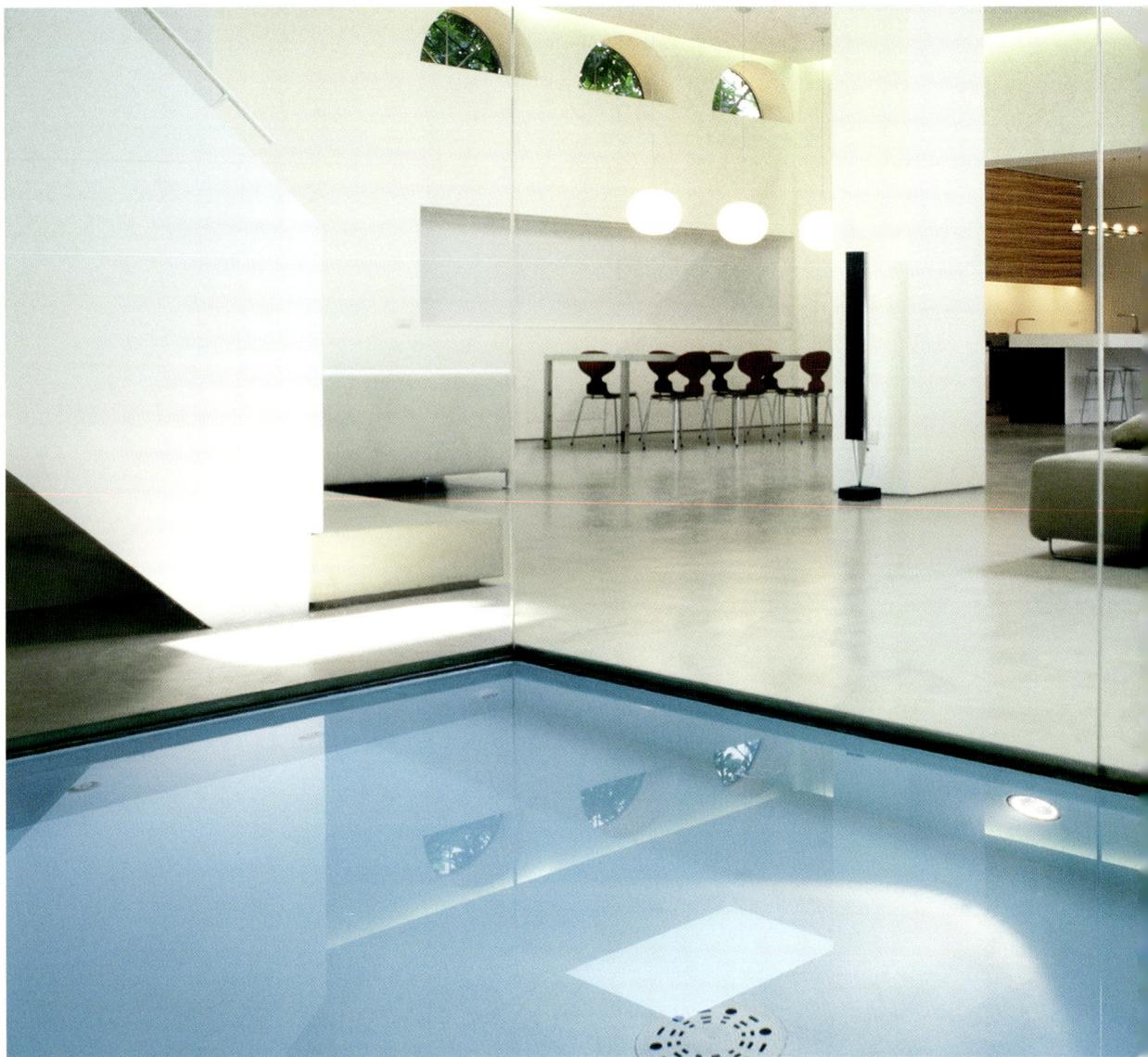

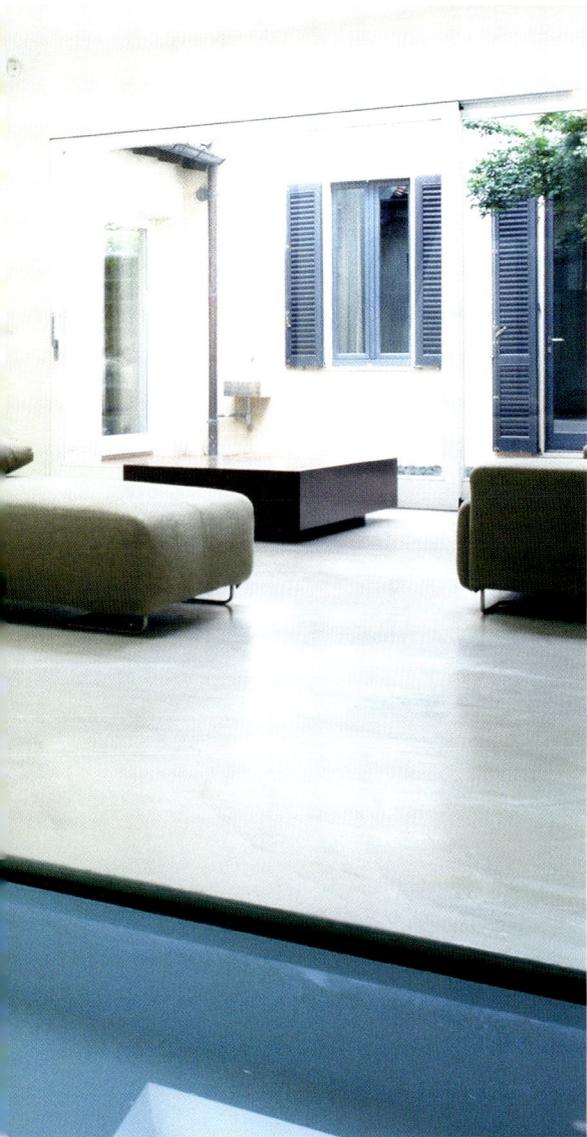

Comercial Blautec | Igualada, Barcelona, Spain
ArcsLlacuna
La Llacuna, Barcelona, Spain | 2005

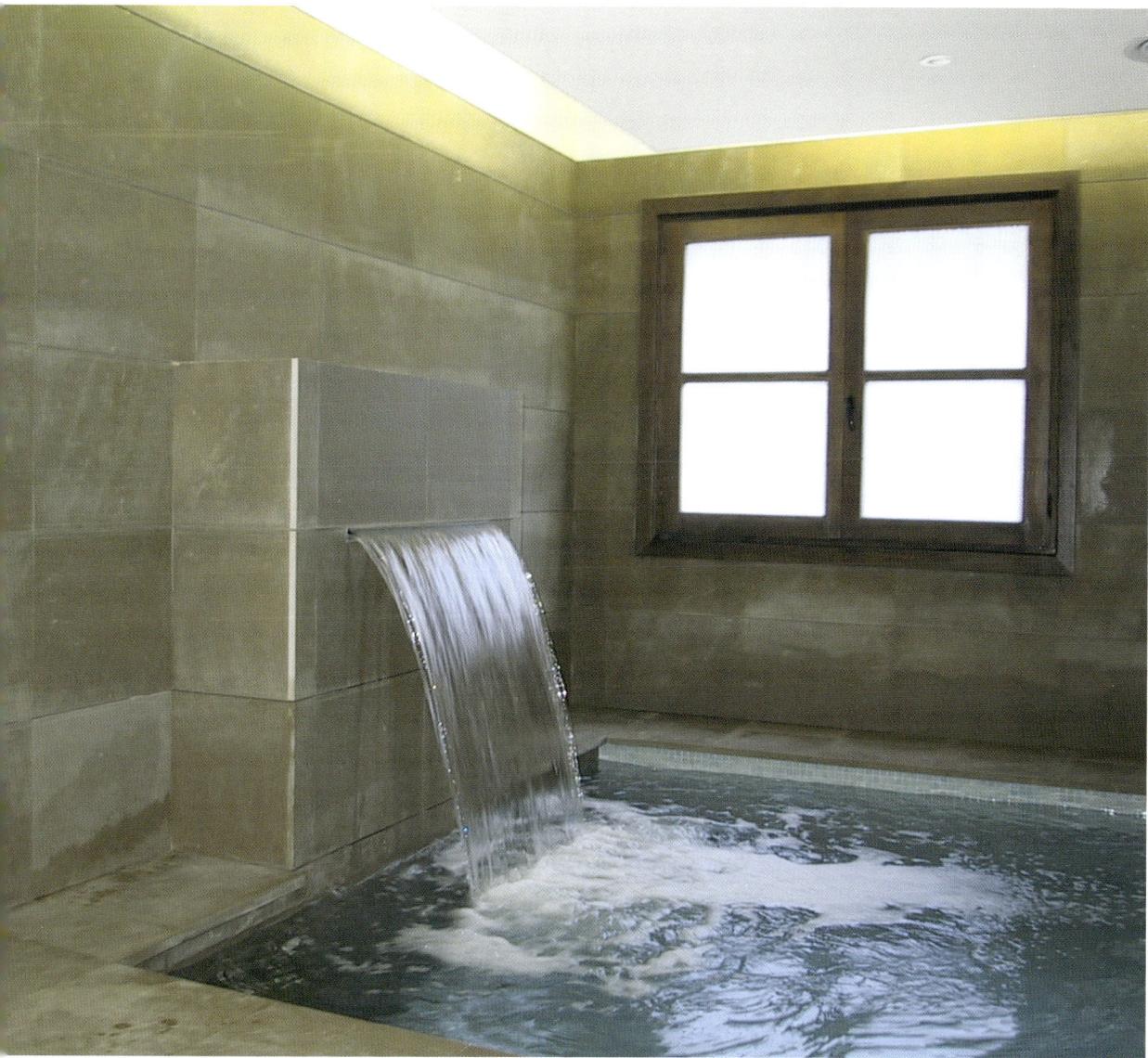

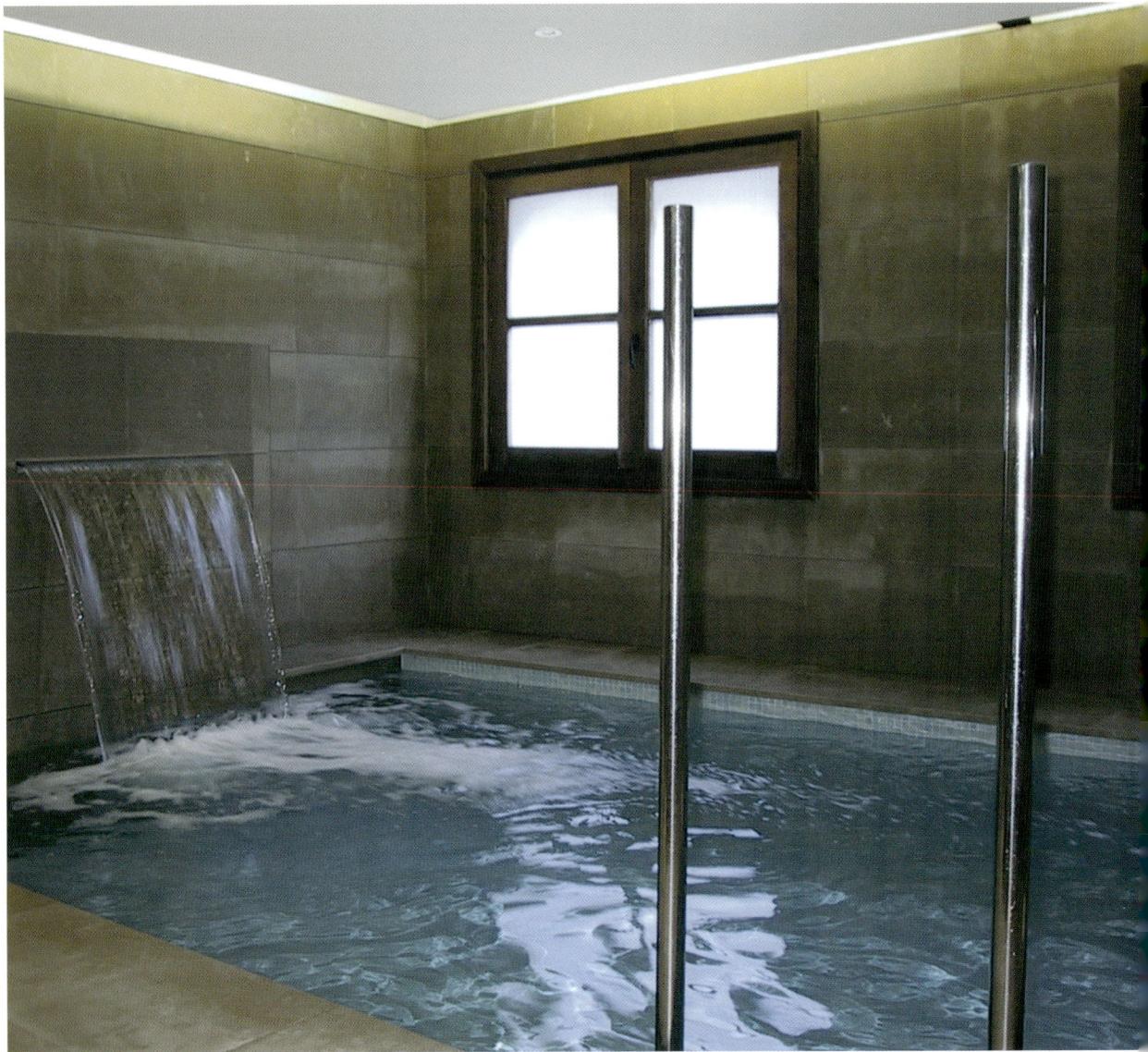

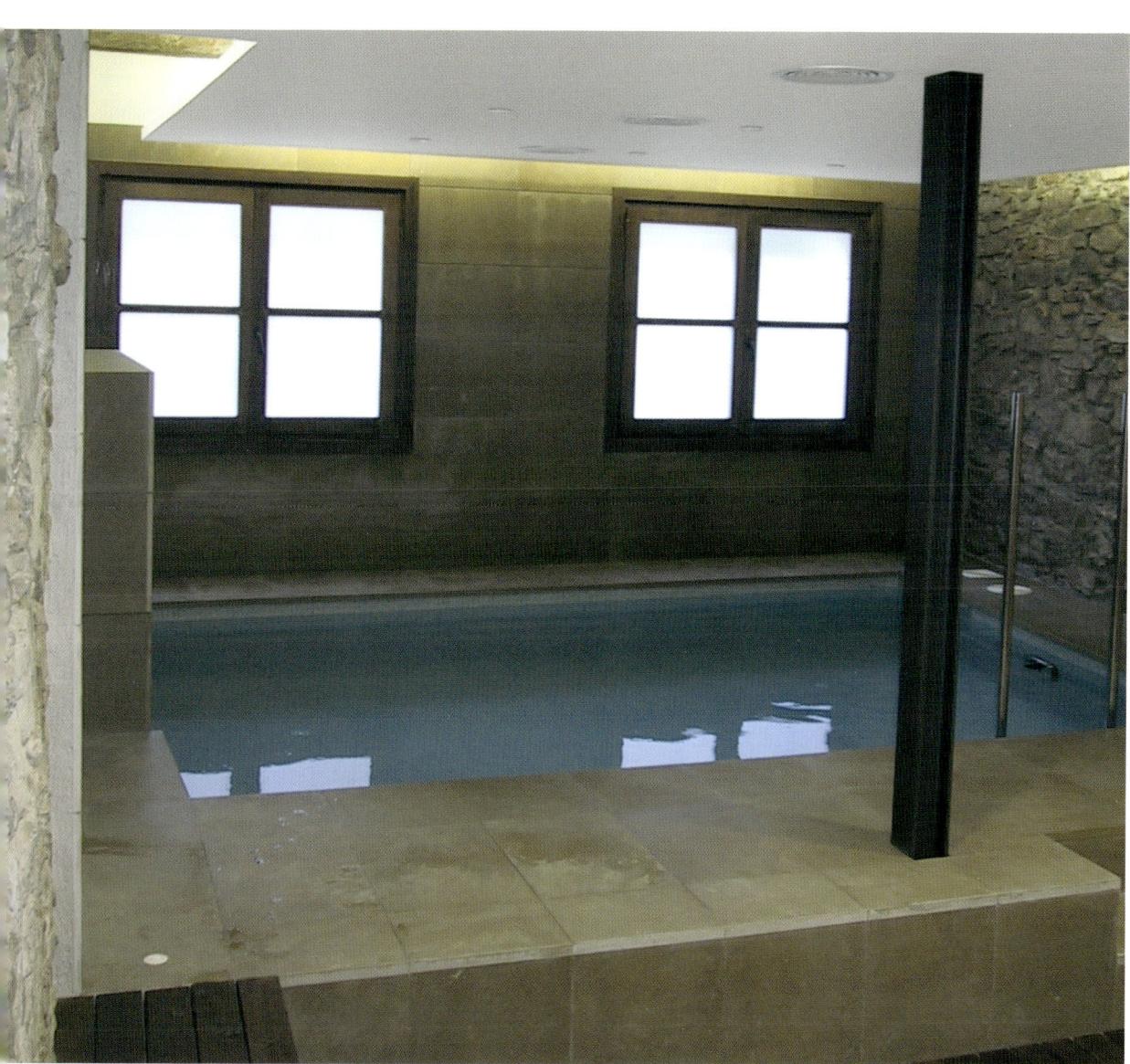

Corsin | Tarragona, Spain
House in Cala Tamarit
Tarragona, Spain | 2004

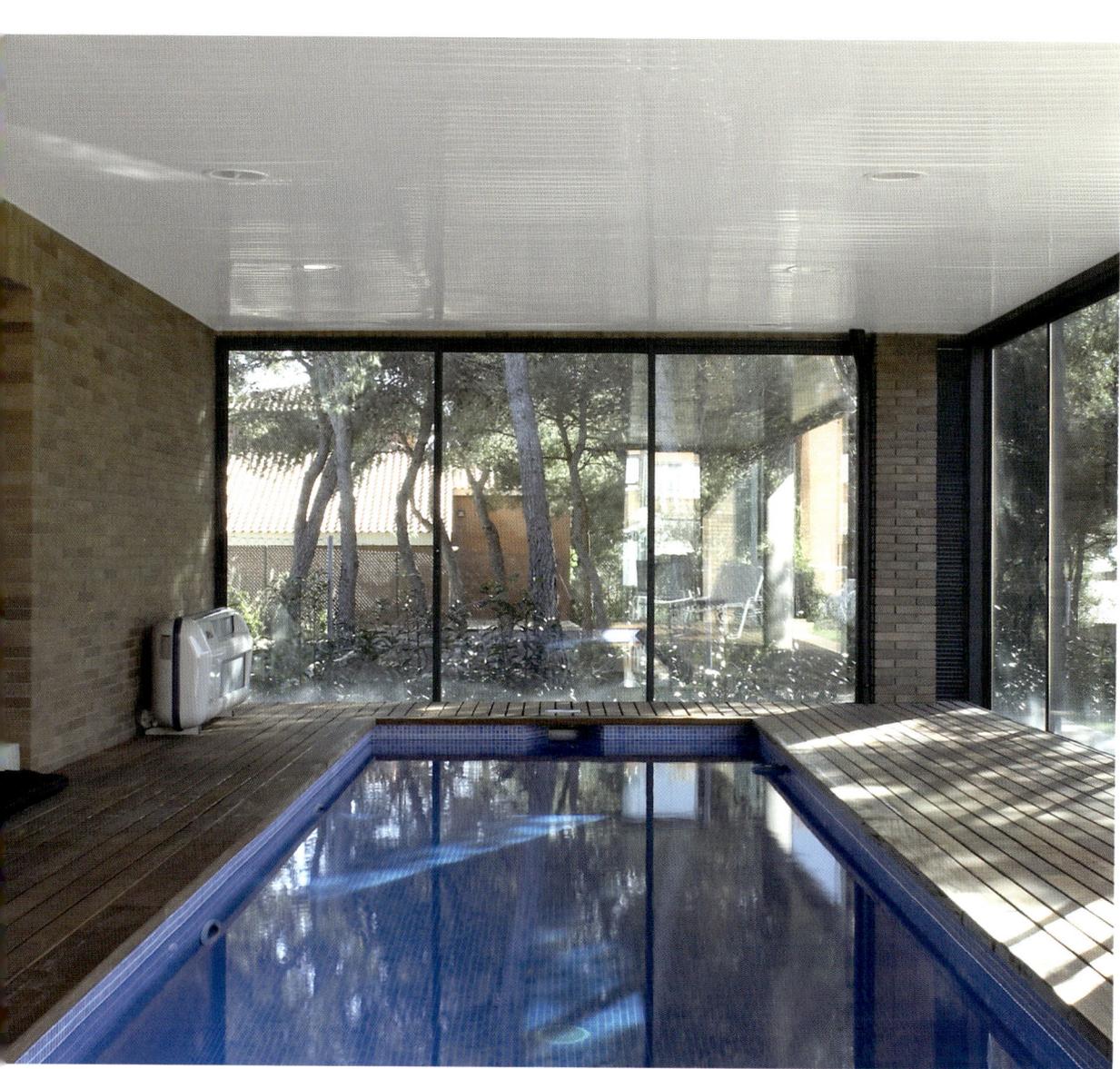

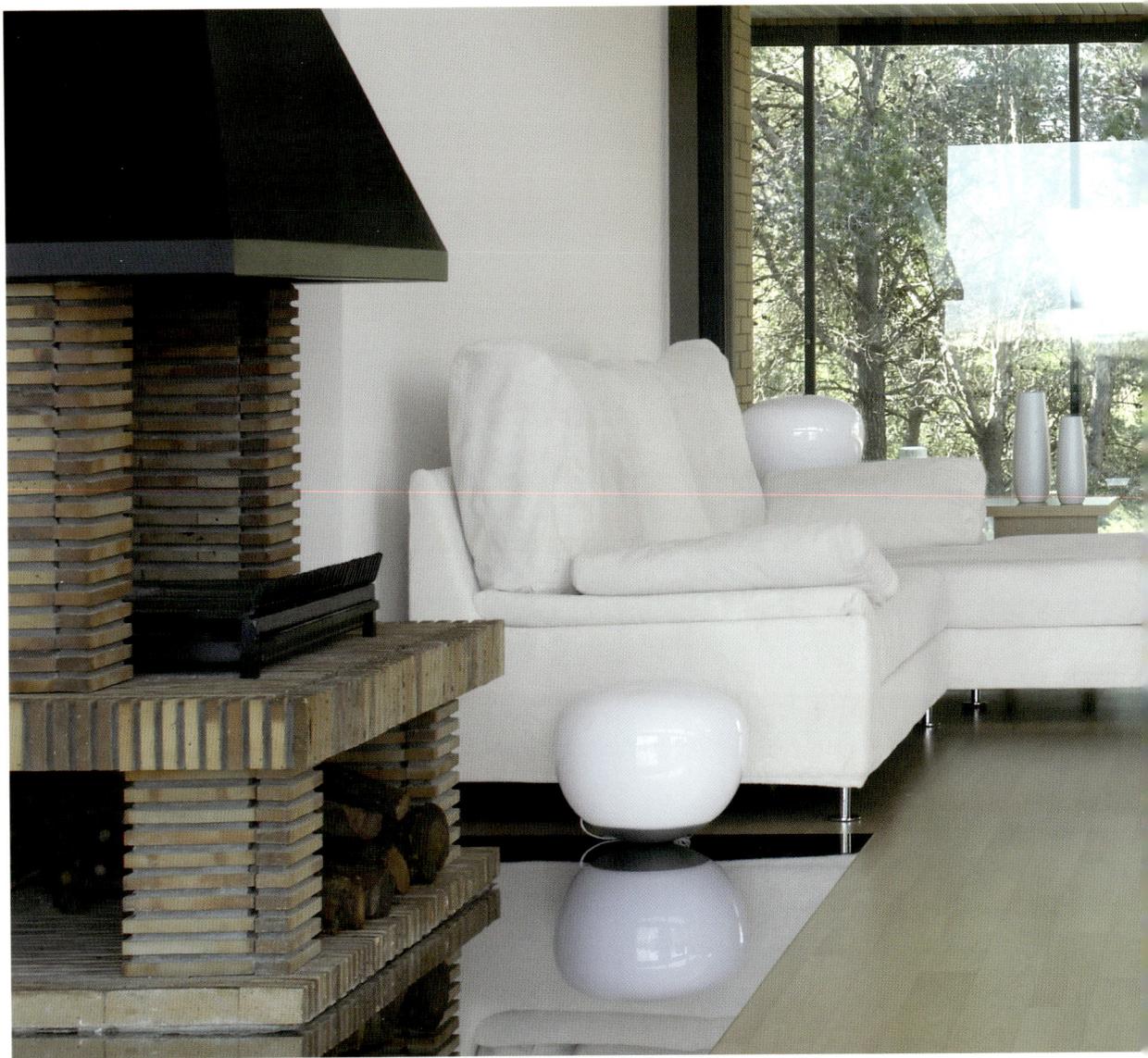

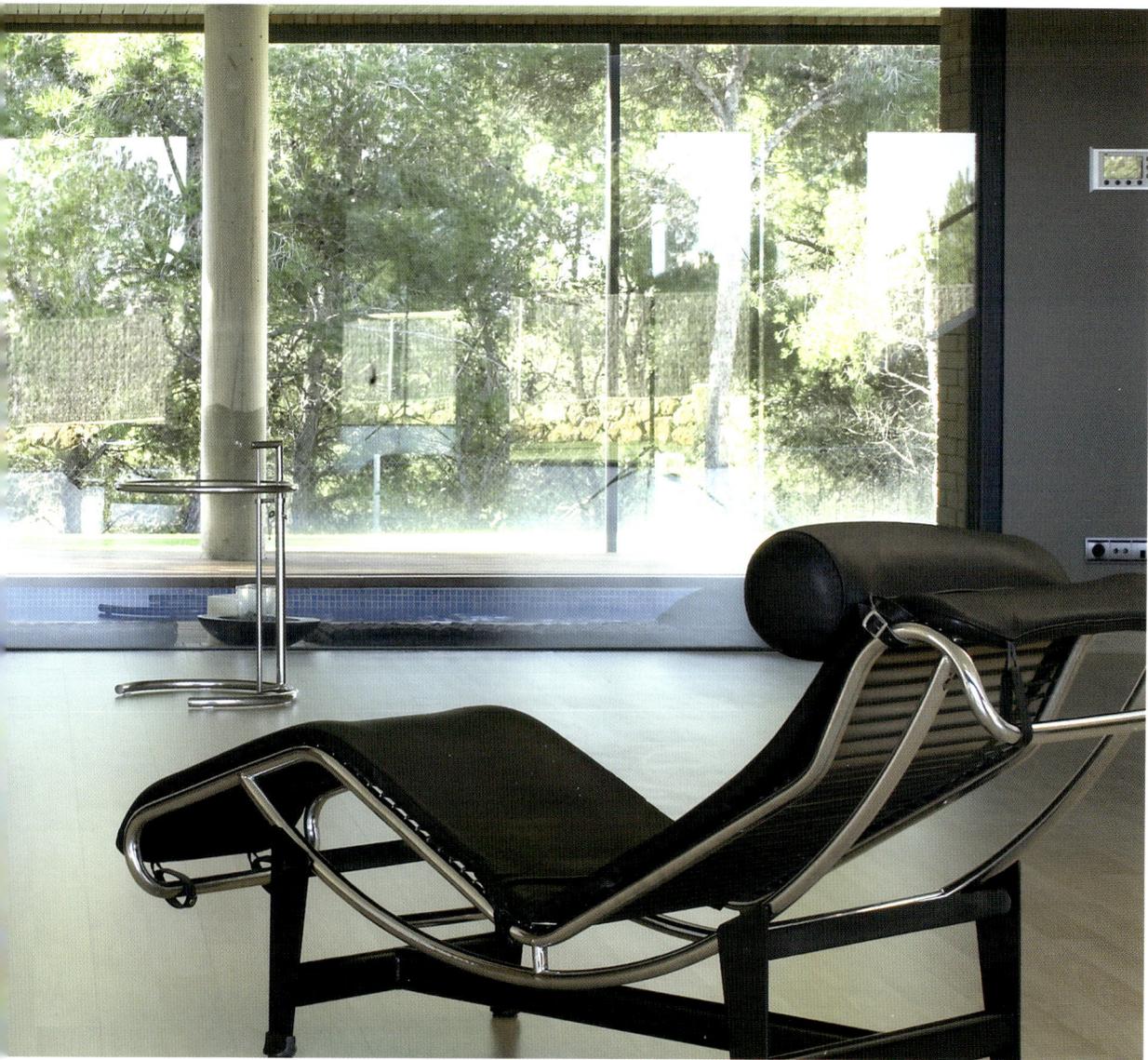

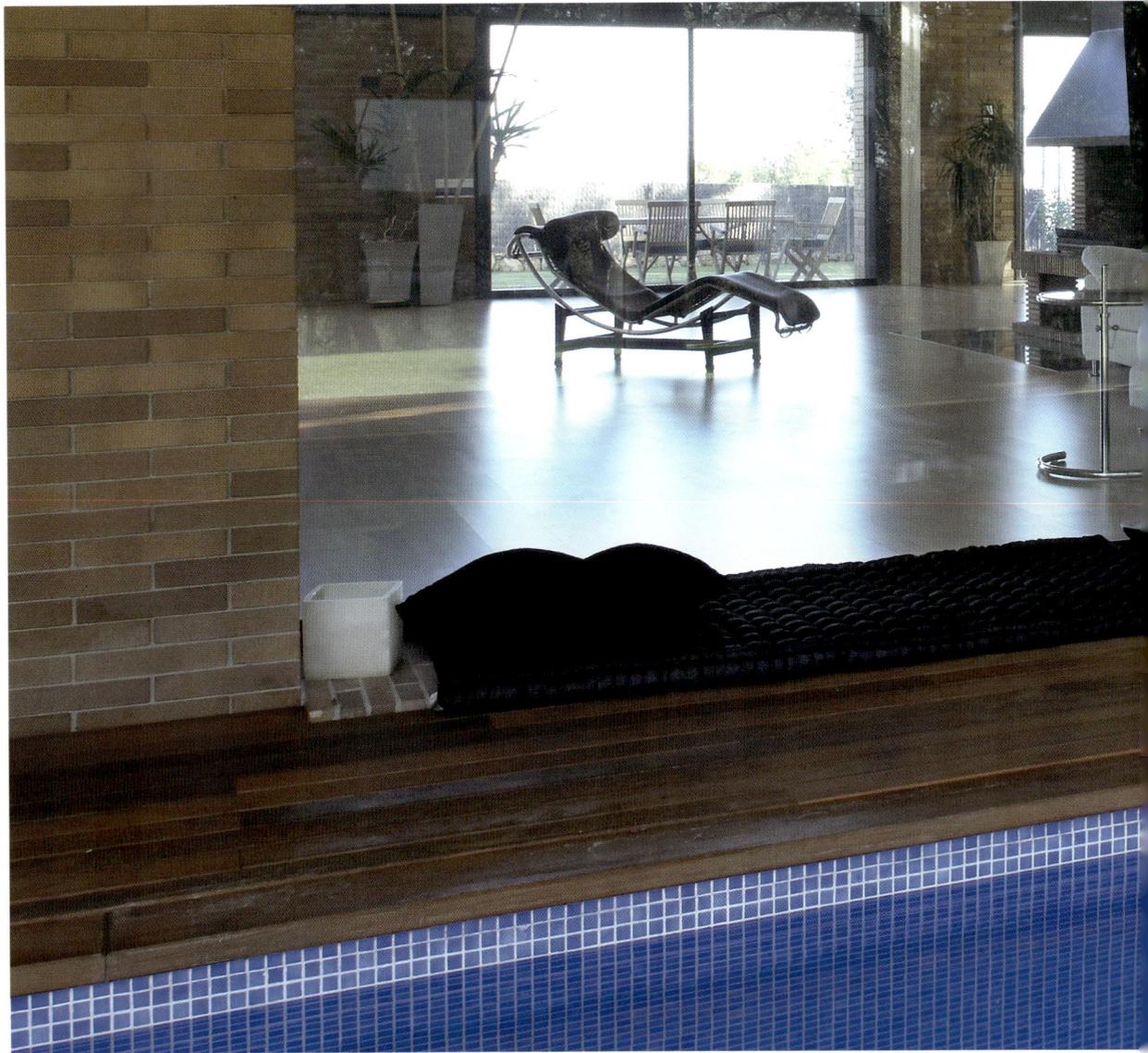

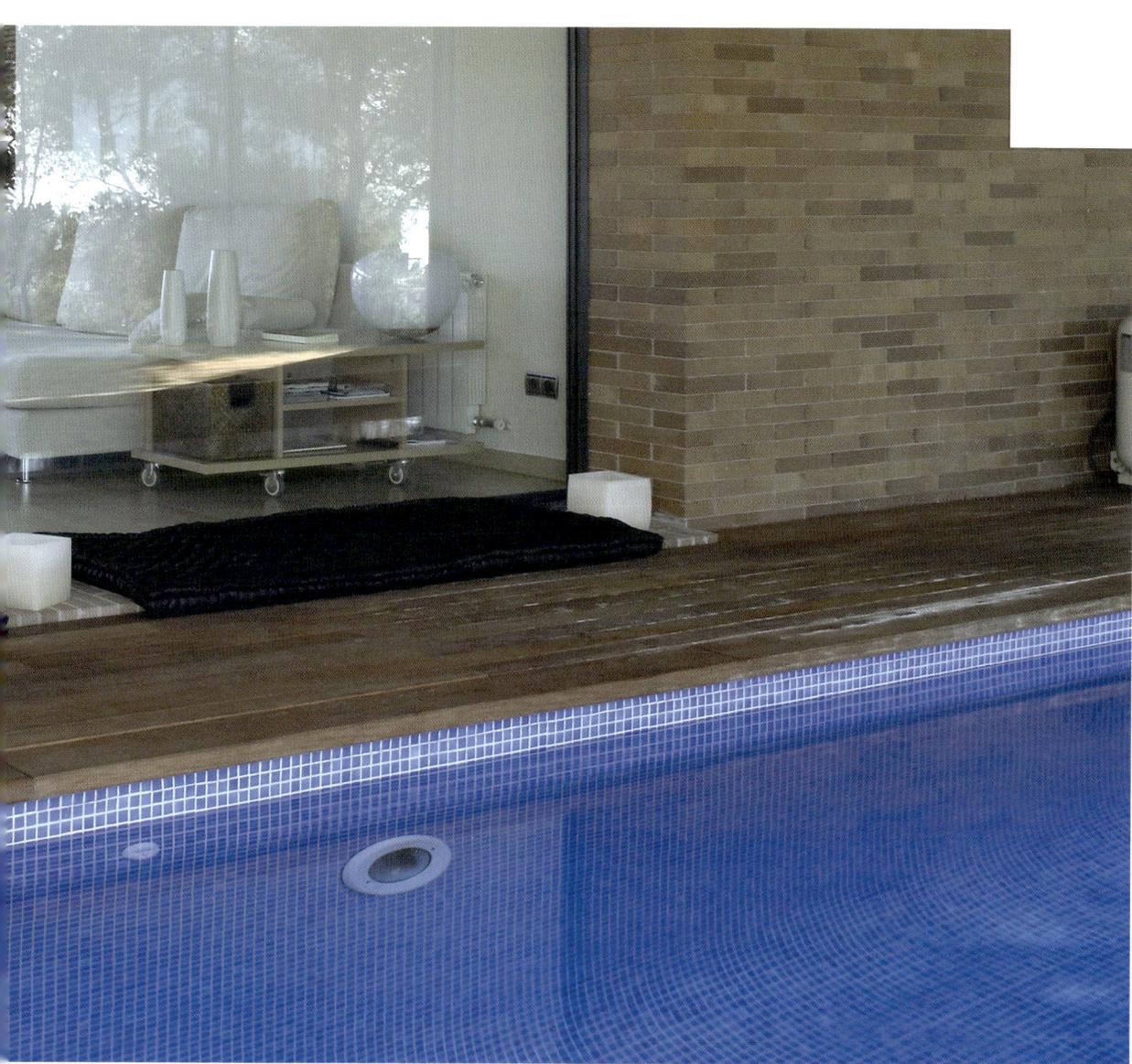

De Vita e Fici Architetti Associati | Florence, Italy
Old Glasshouse
Florence, Italy | 2004

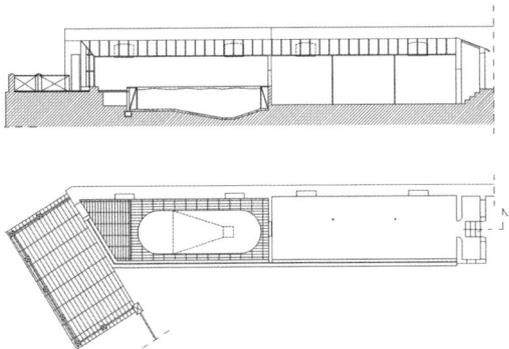

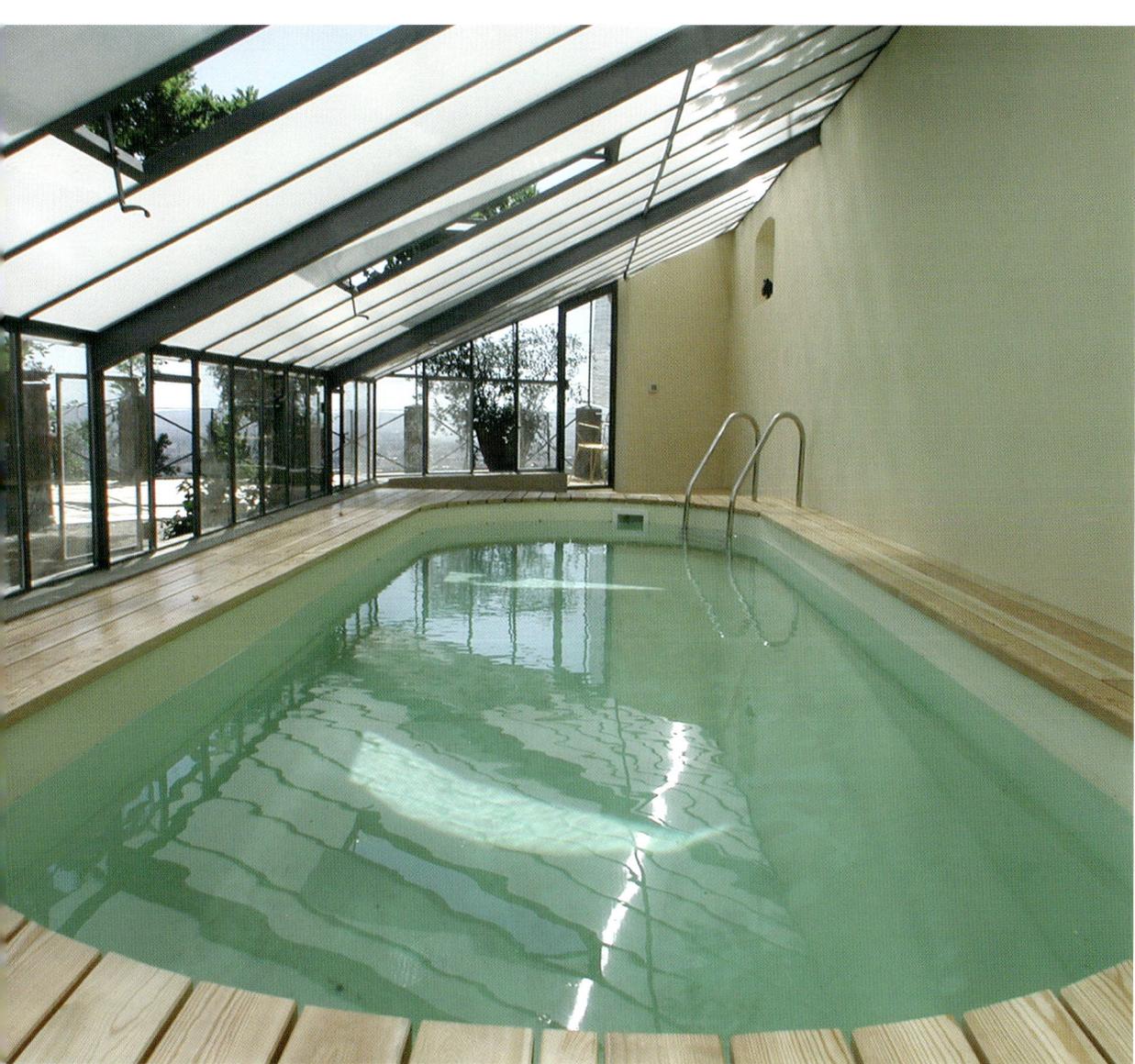

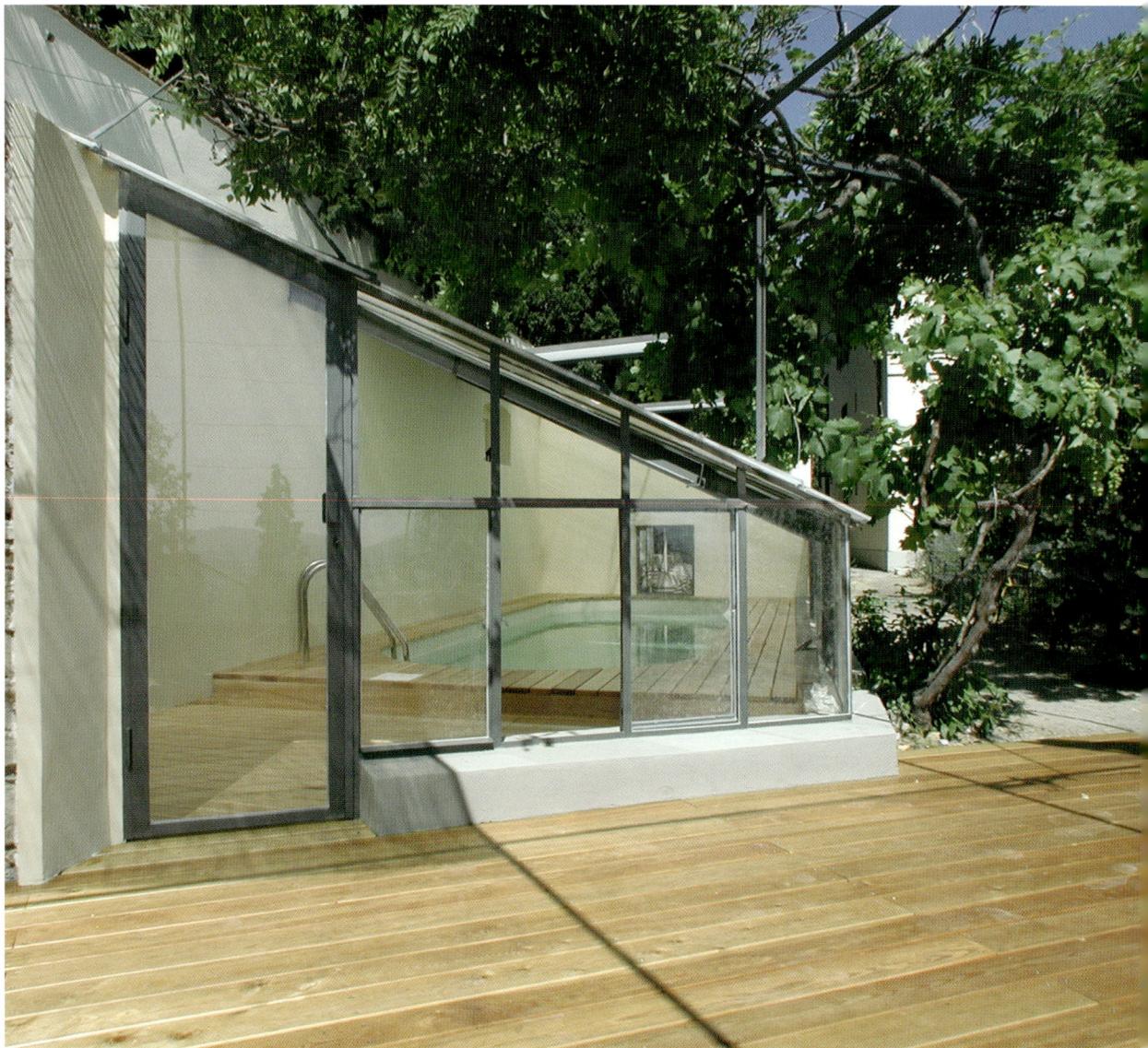

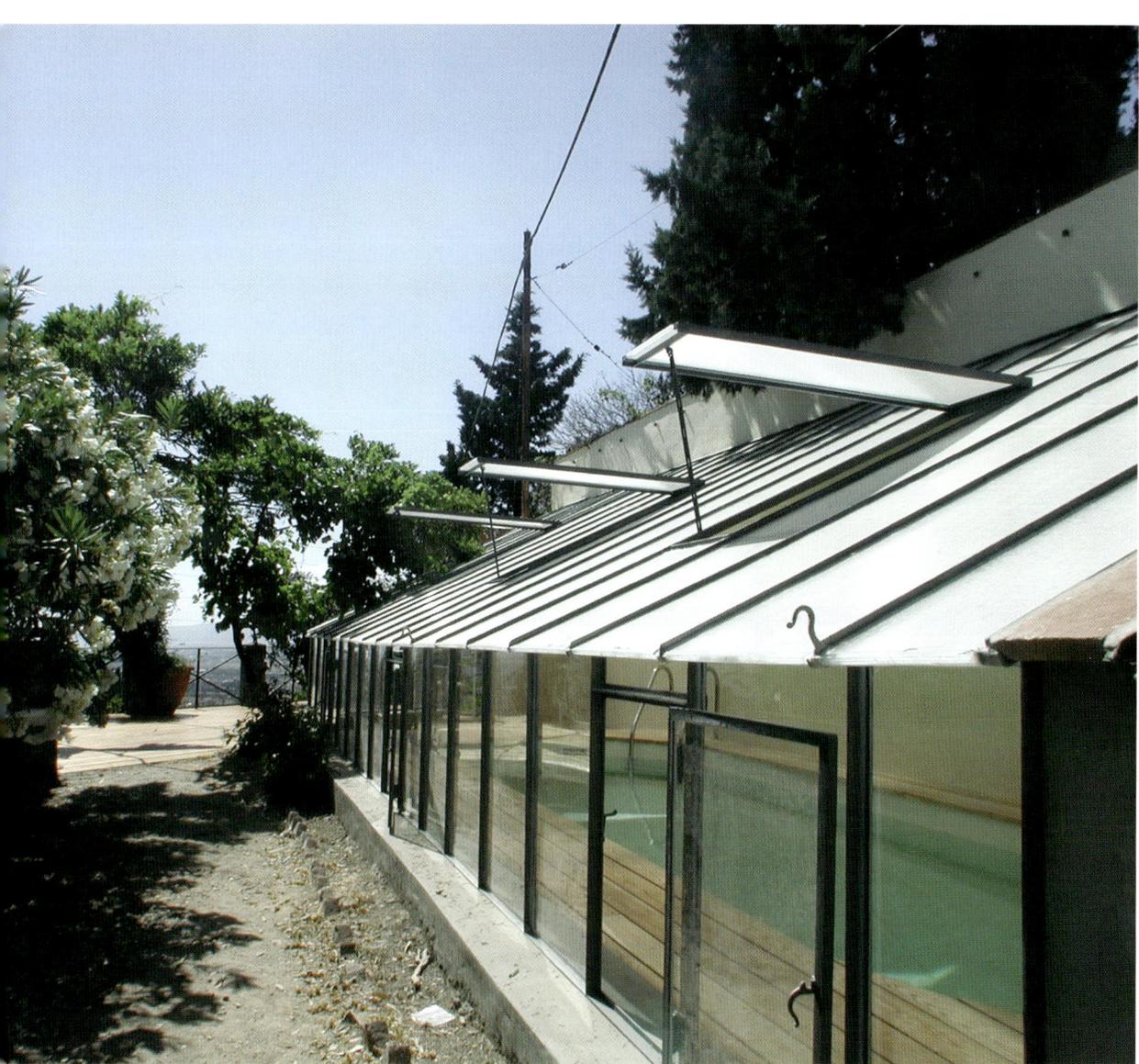

Donald Billinkoff Architects | New York, USA
Old Branchville Road
Ridgefield, Connecticut, USA

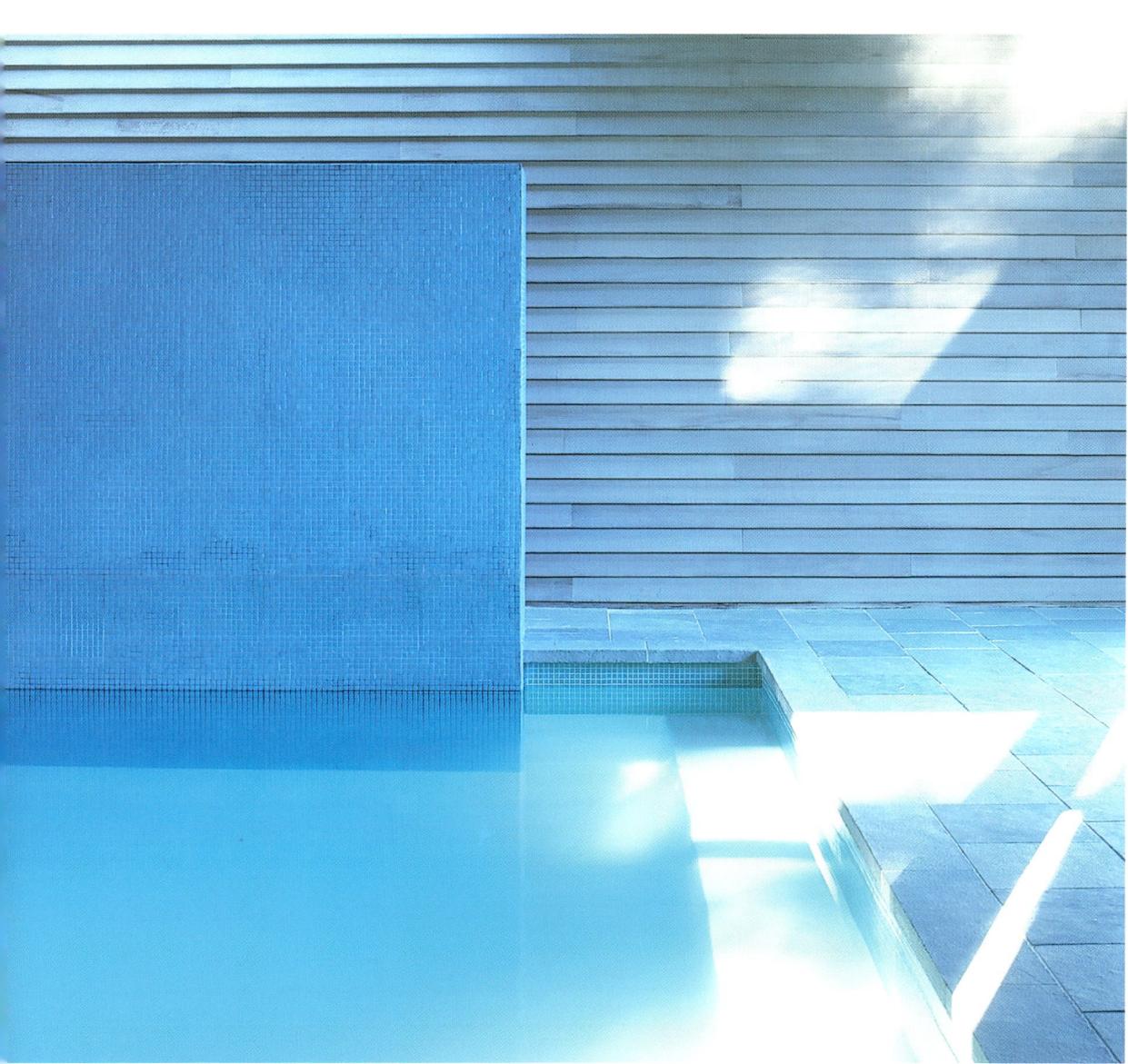

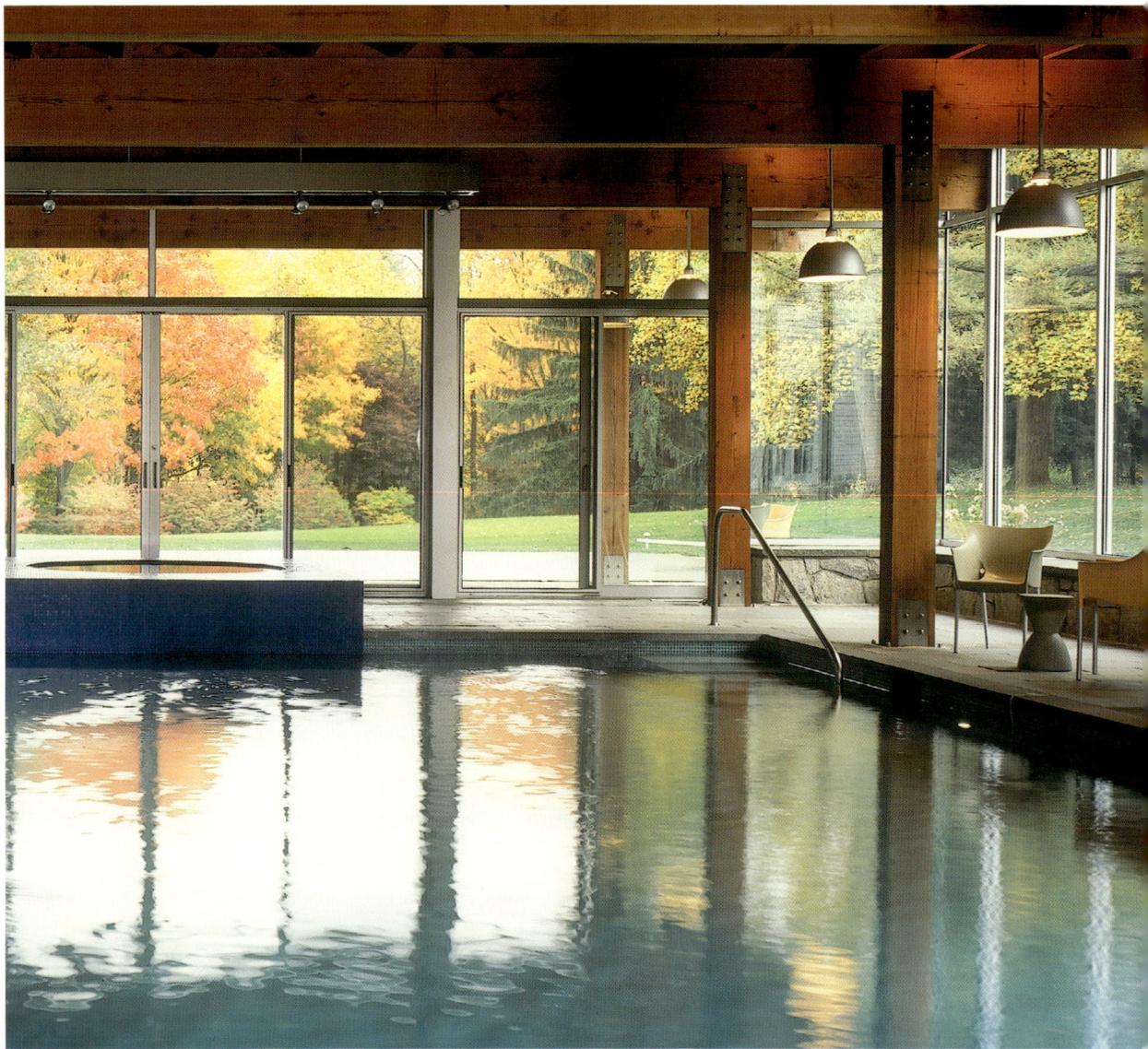

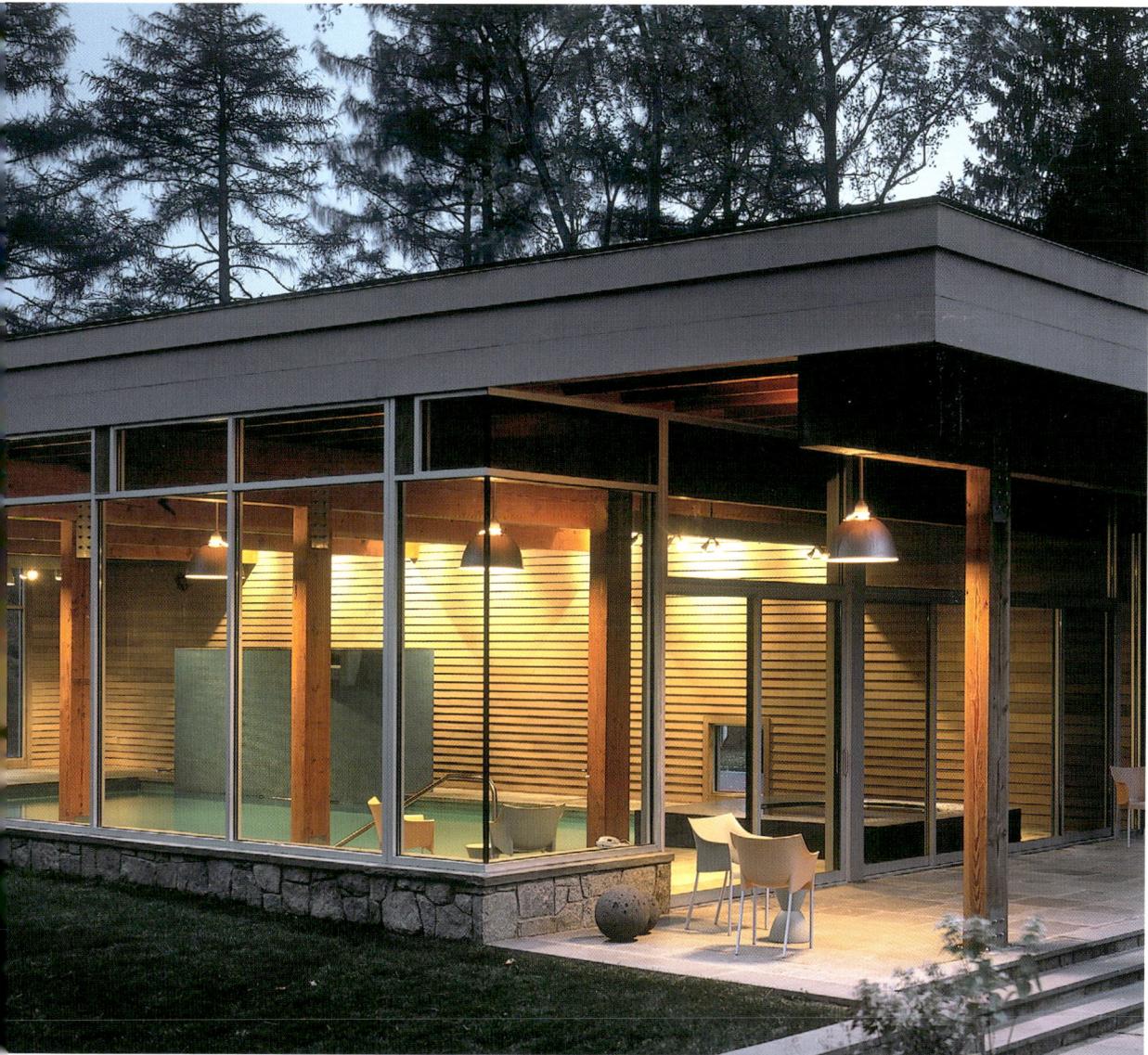

Espinet & Ubach Arquitectes i Associats | Barcelona, Spain
V House
Lloret de Mar, Girona, Spain | 2004

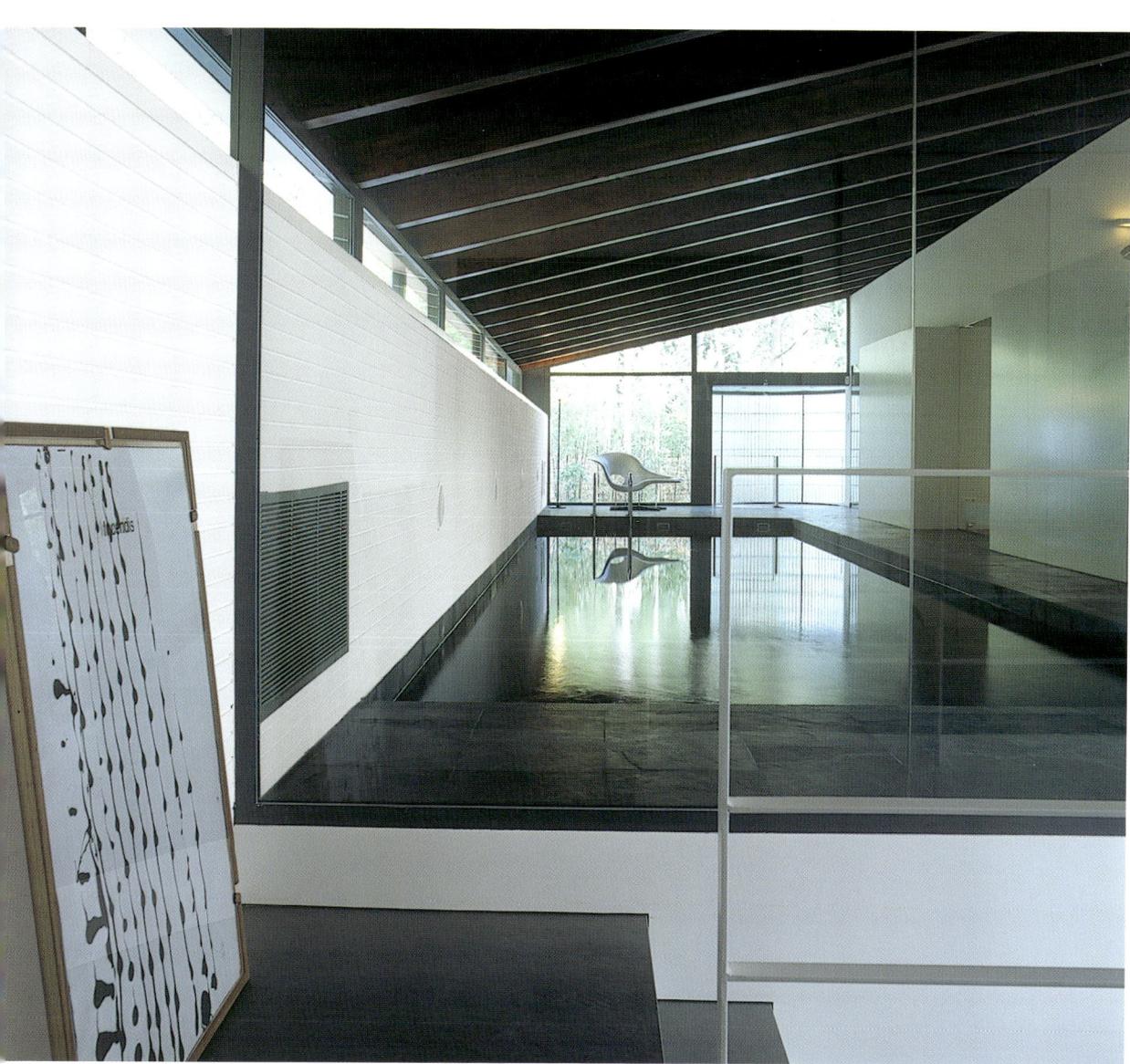

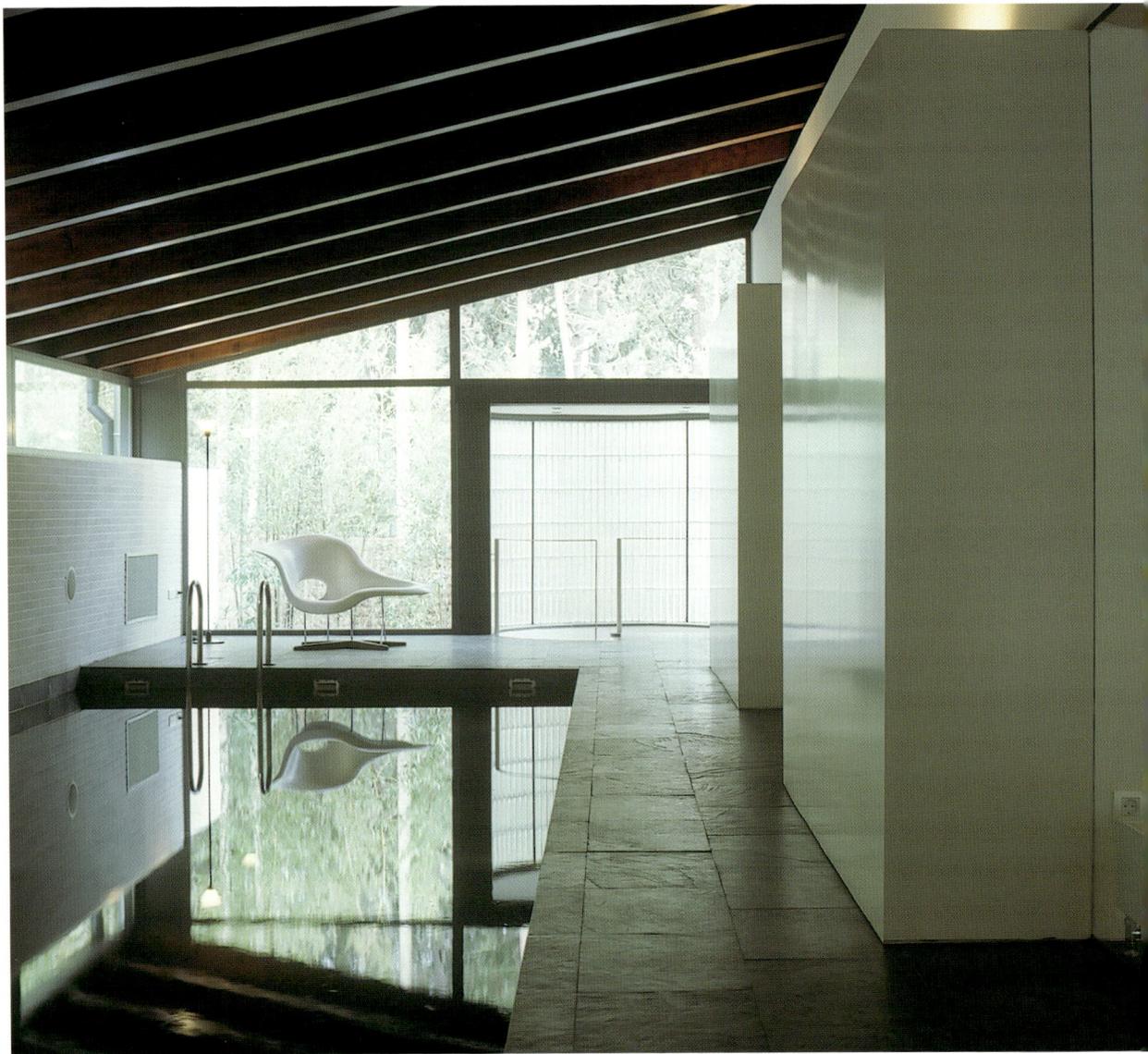

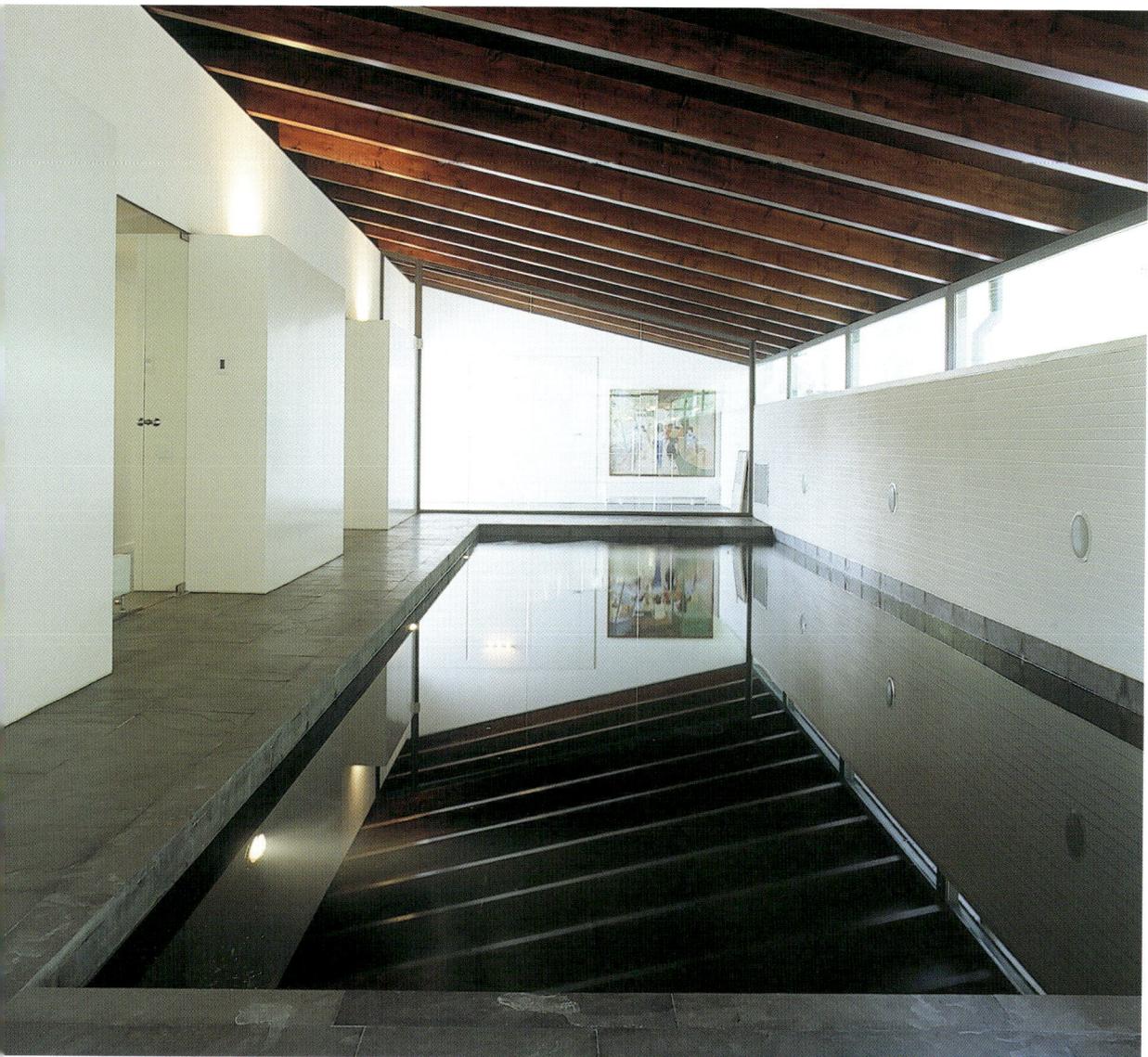

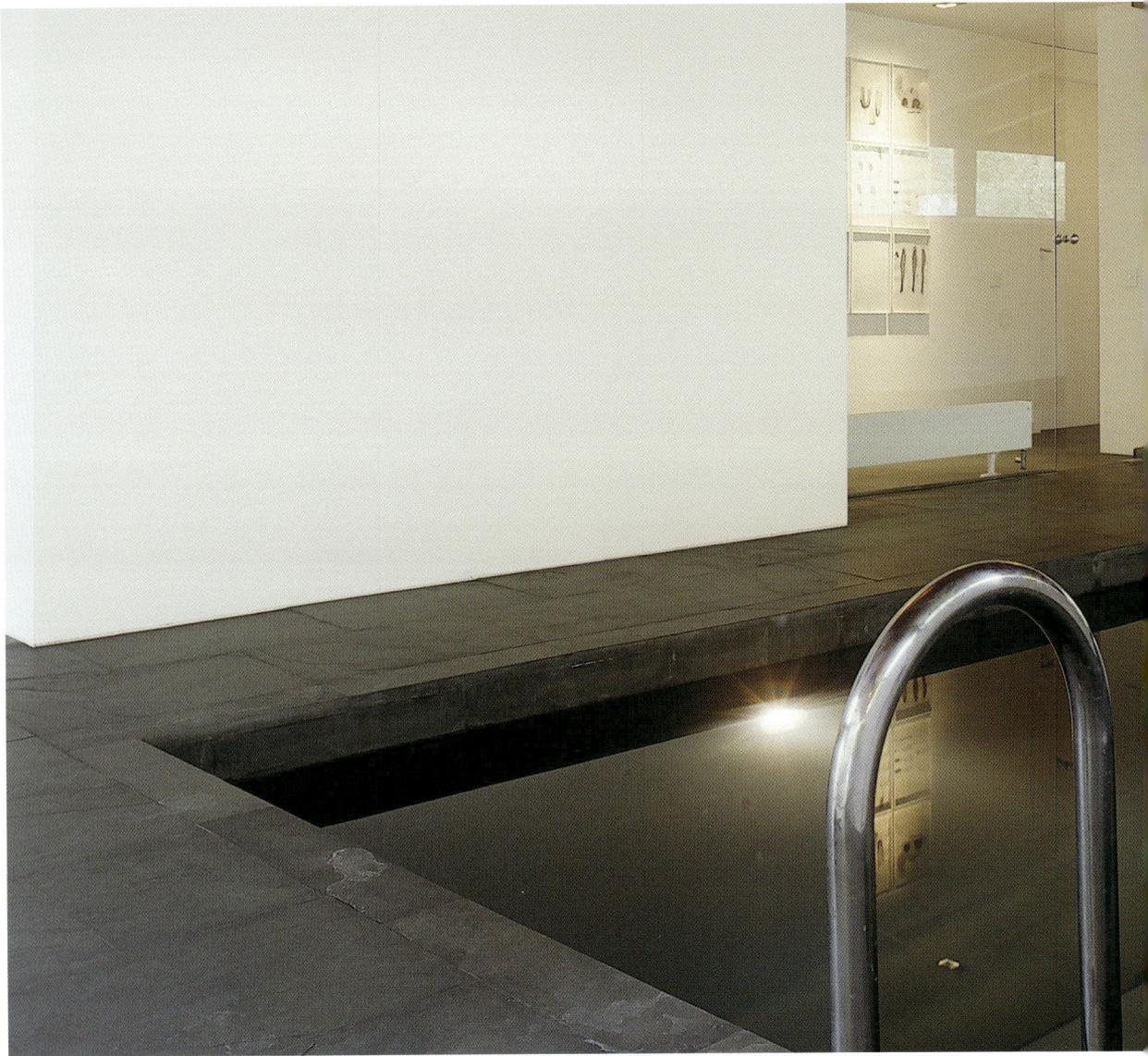

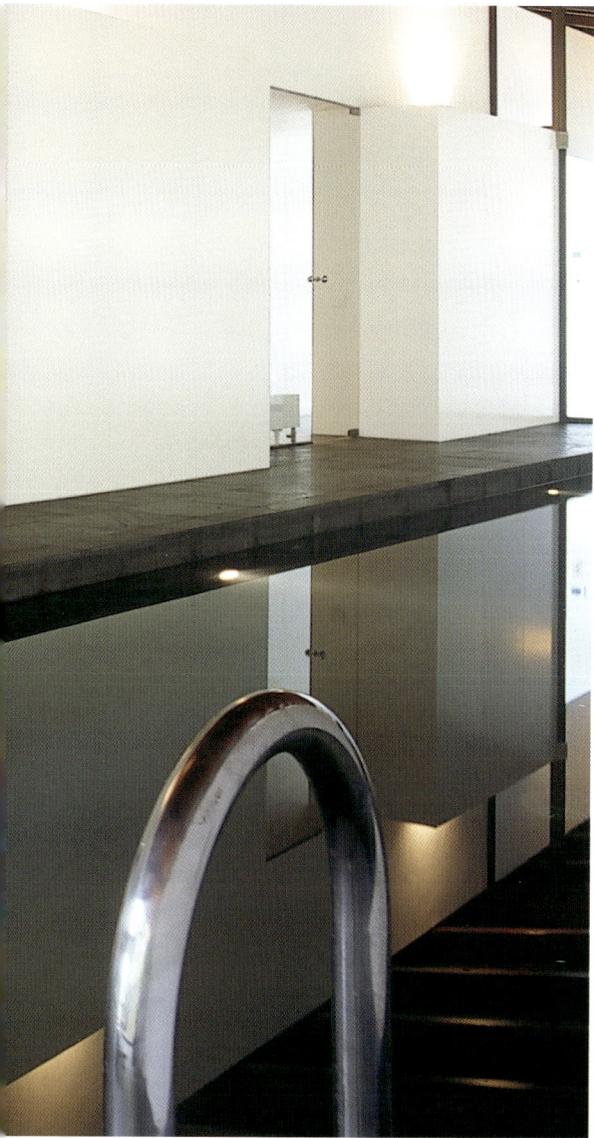

Estudi PSP Arquitectura | Barcelona, Spain
House in Les Corts
Barcelona, Spain | 2000

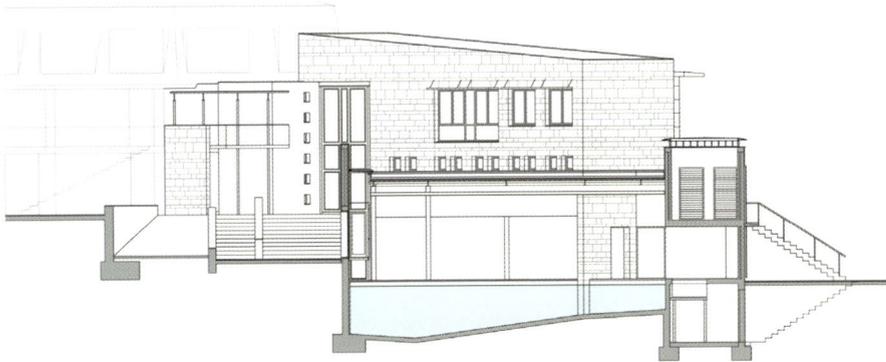

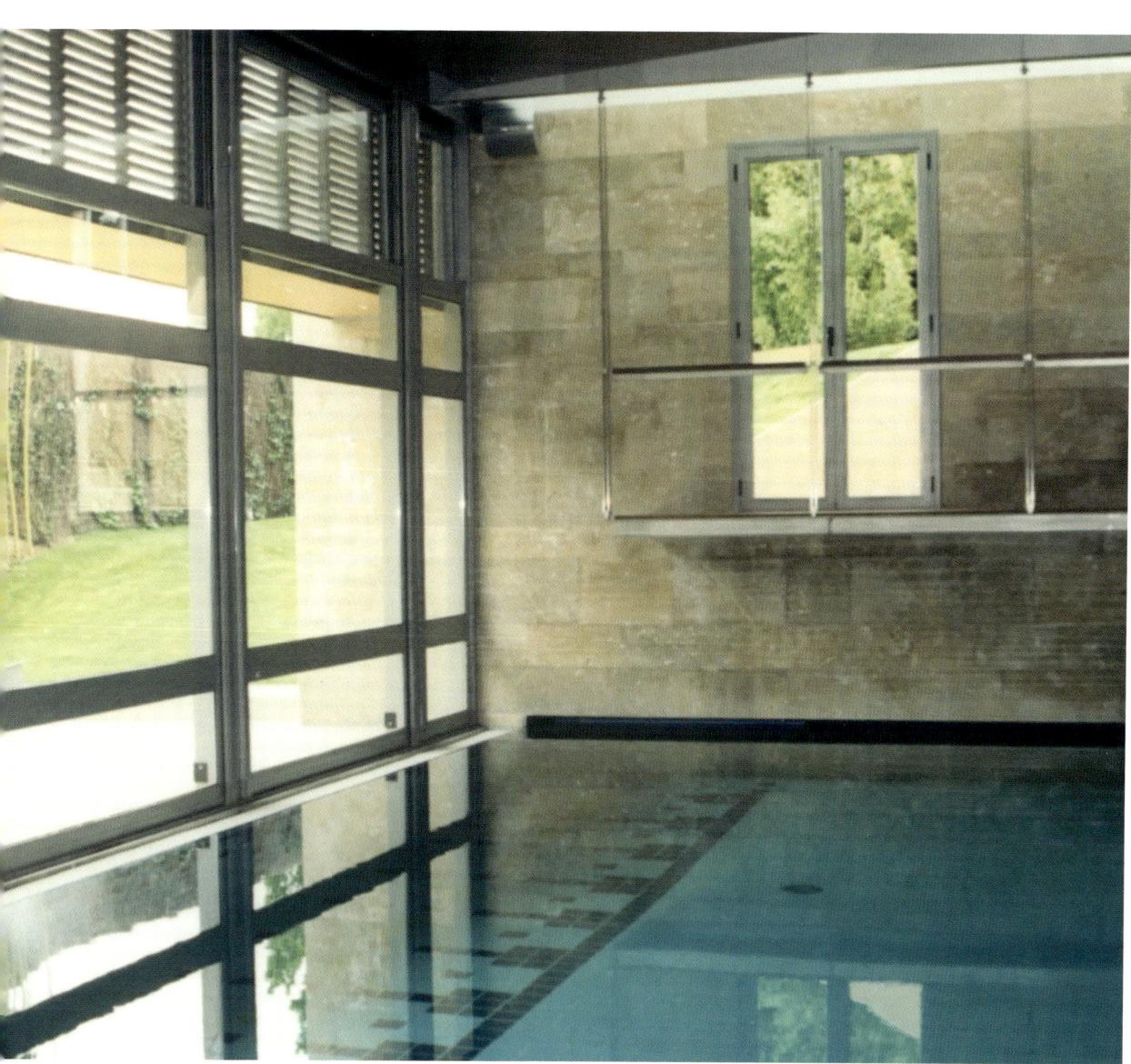

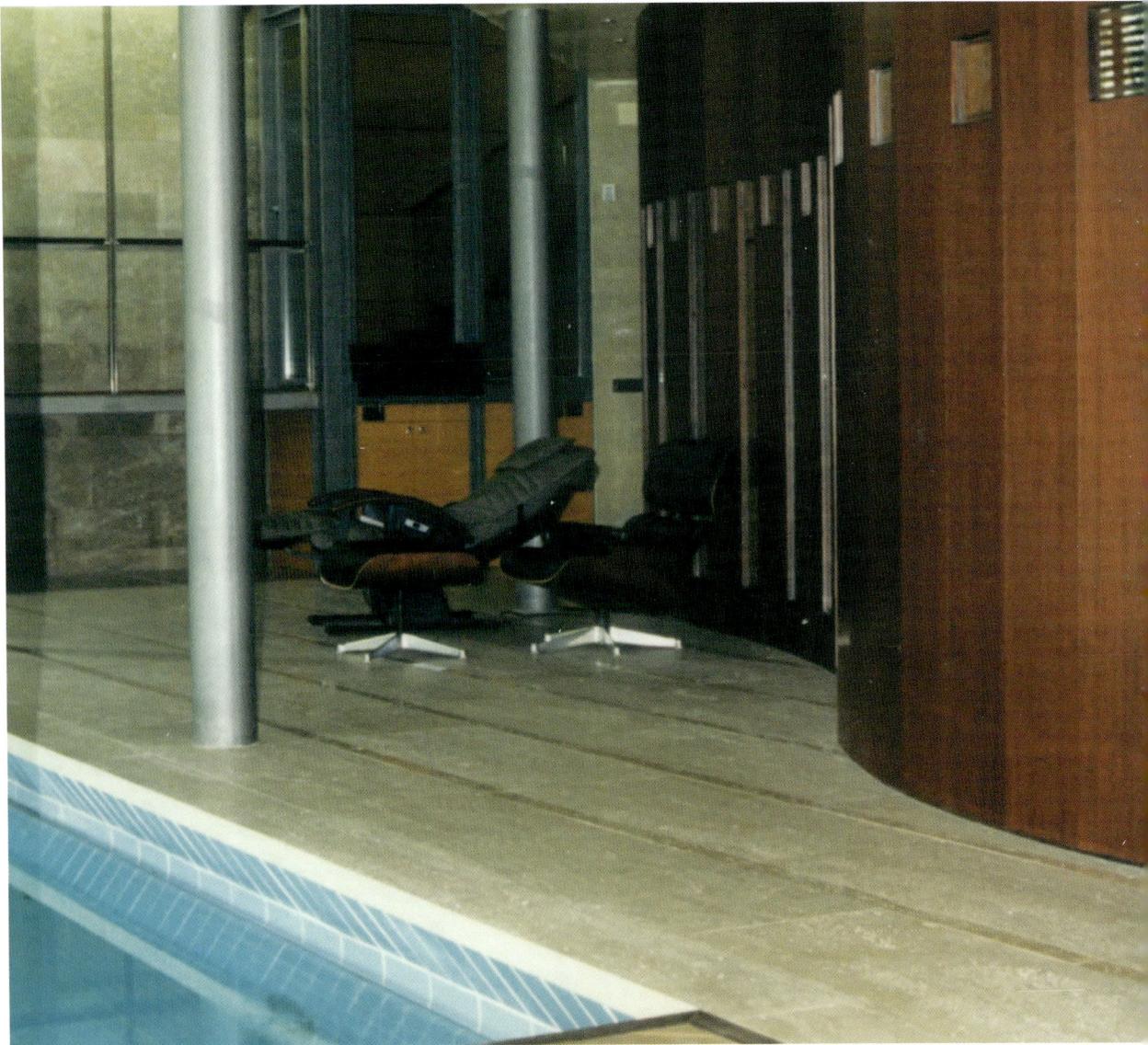

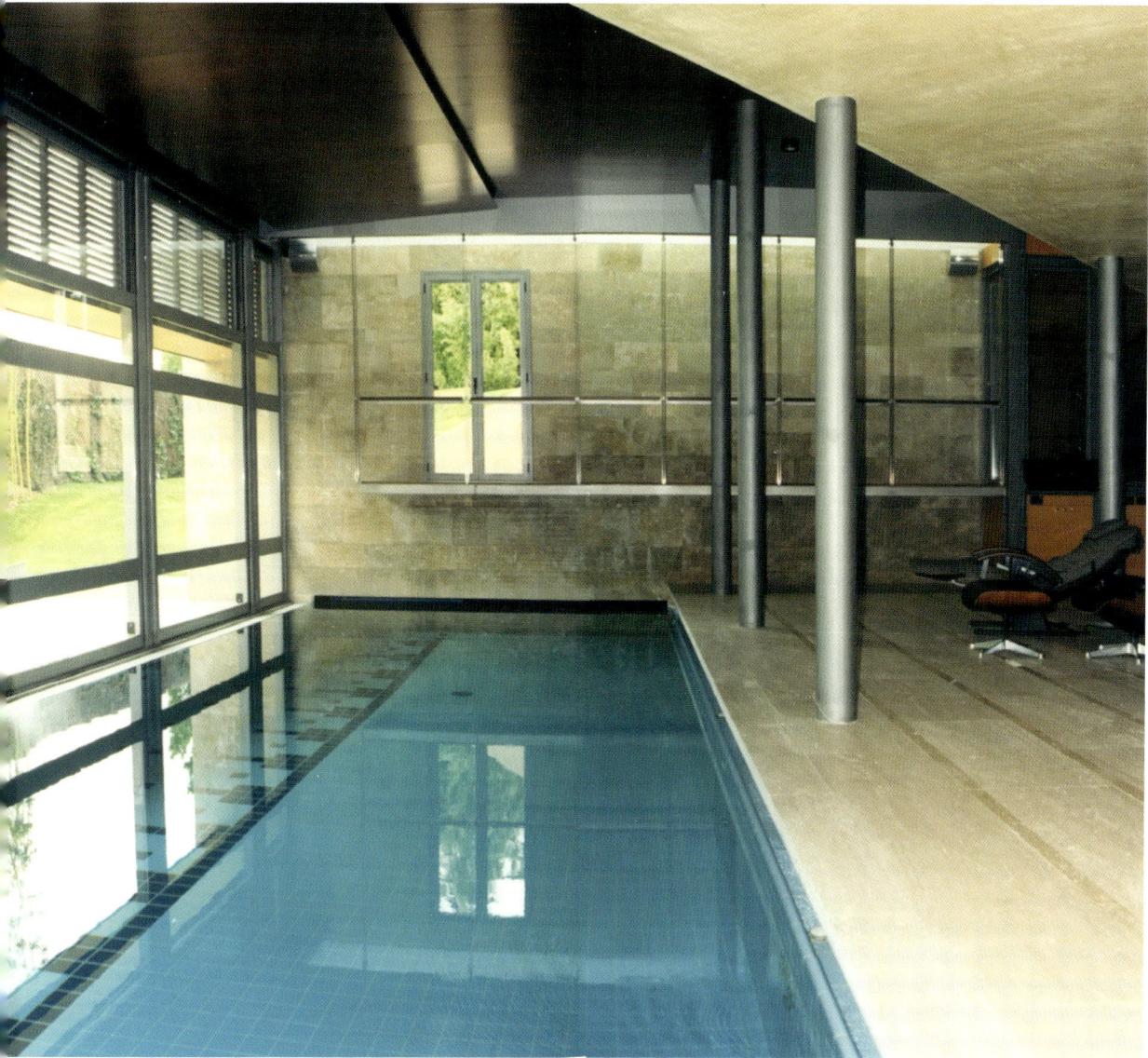

Estudio de Arquitectura Mangado y Asociados/Francisco Mangado | Pamplona, Spain
House in Gorraiz
Pamplona, Spain | 2000

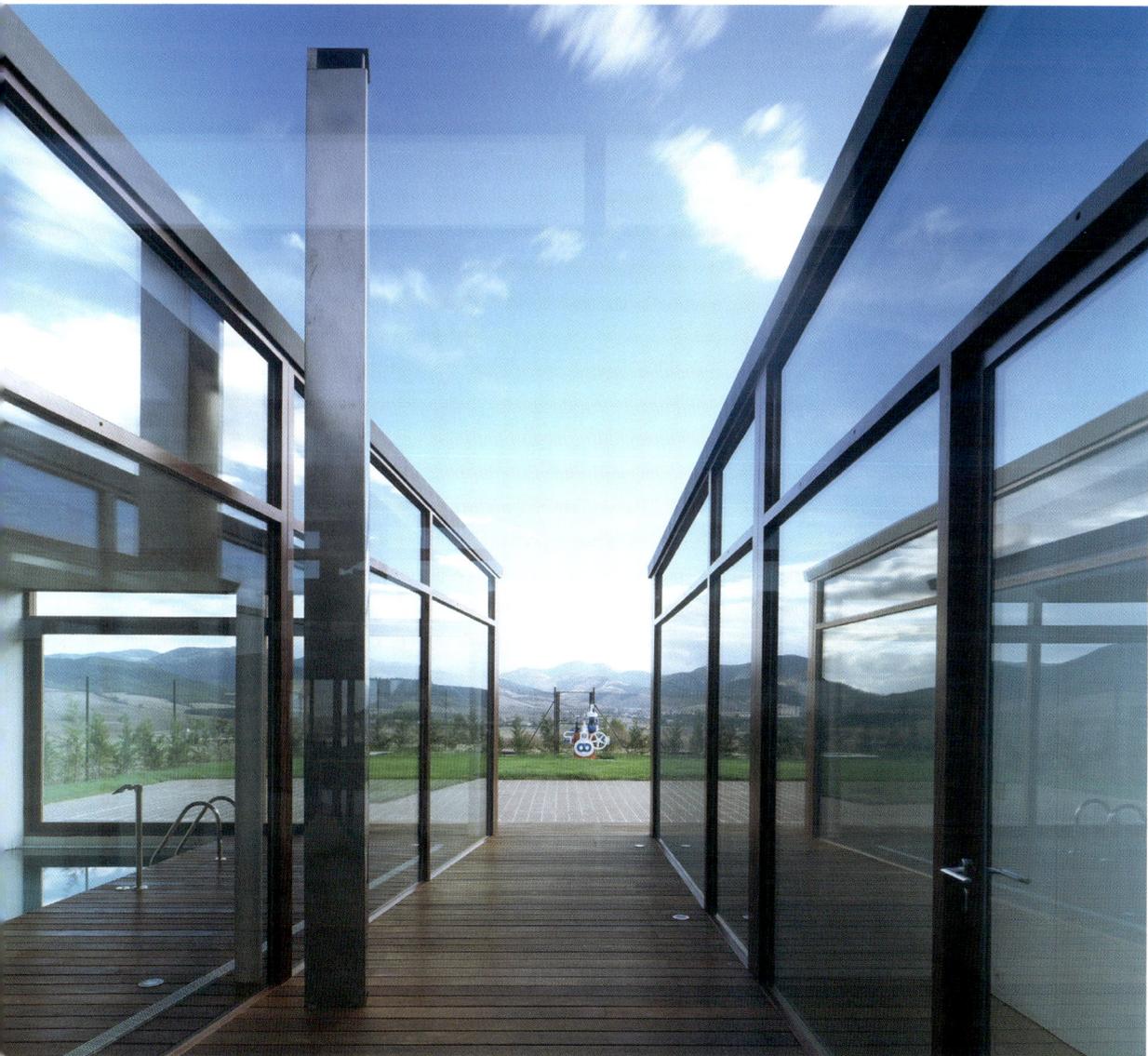

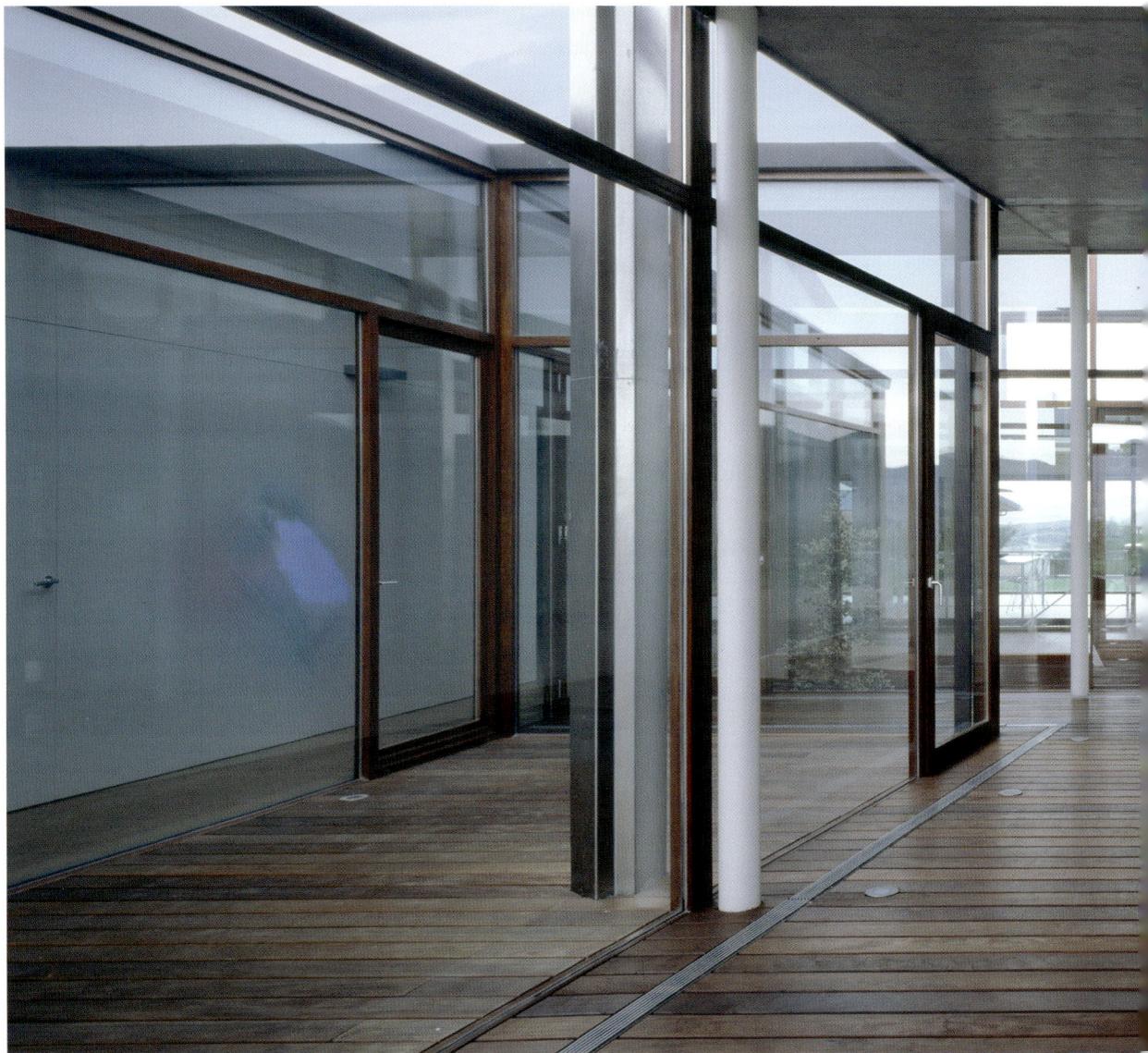

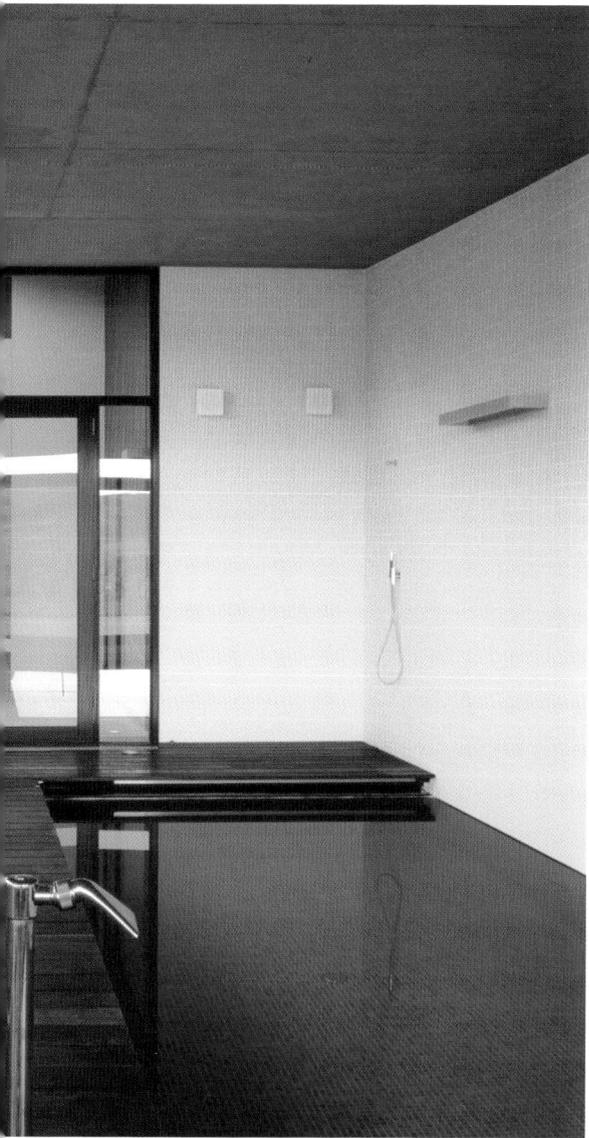

Guilhem Roustan | Paris, France
Levallois Pool
Ile-de-France, France

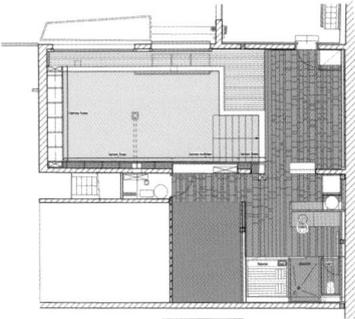

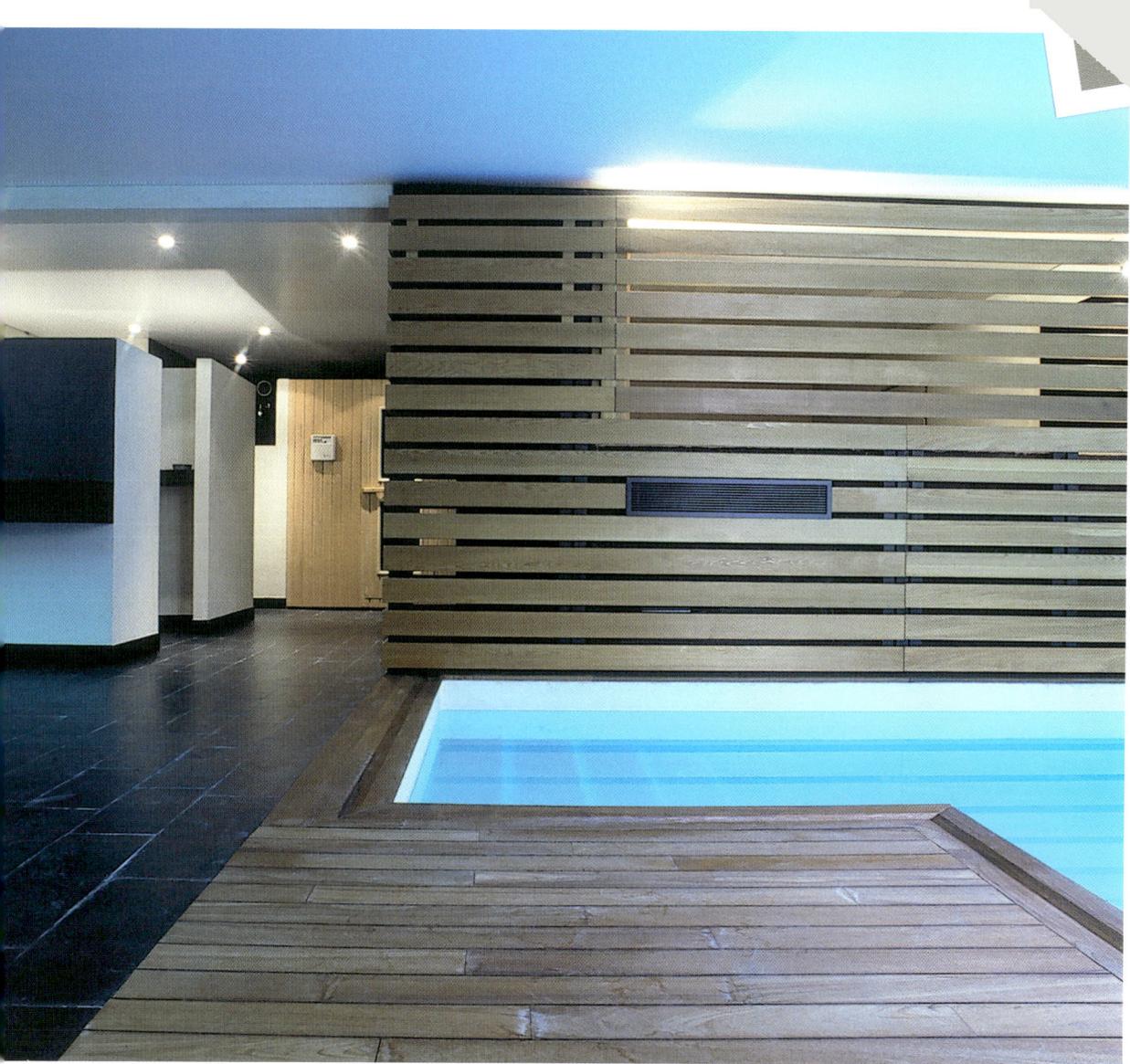

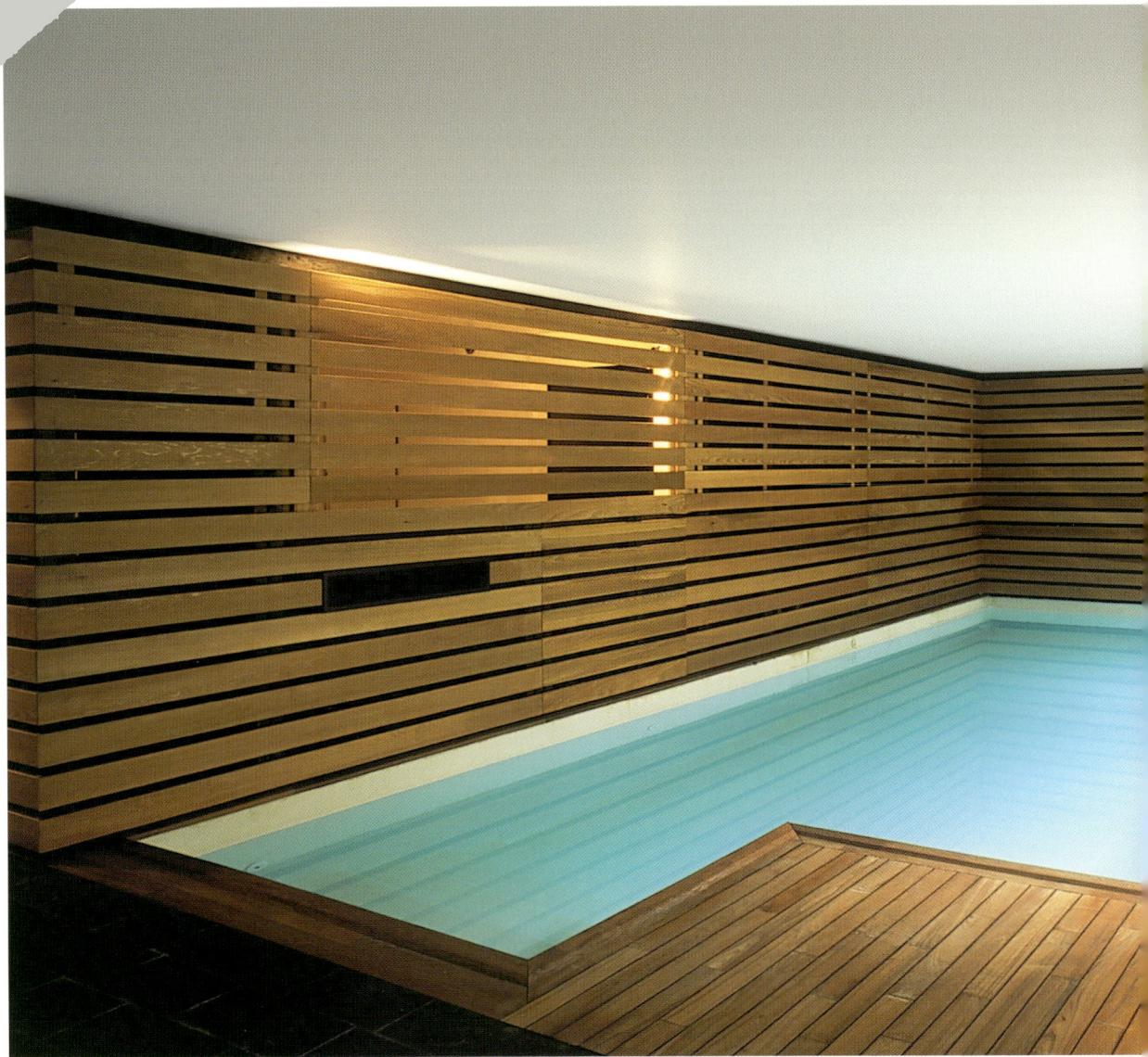

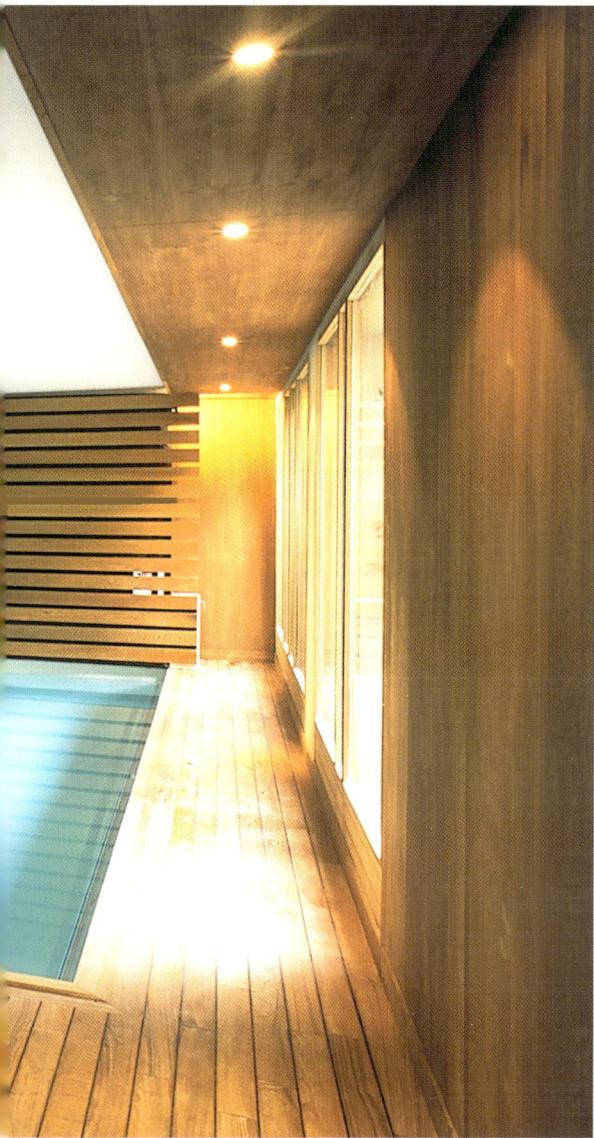

Habitación 8/Gonzalo Concheiro | Madrid, Spain
Concheiro House
Santiago de Compostela, Spain | 2005

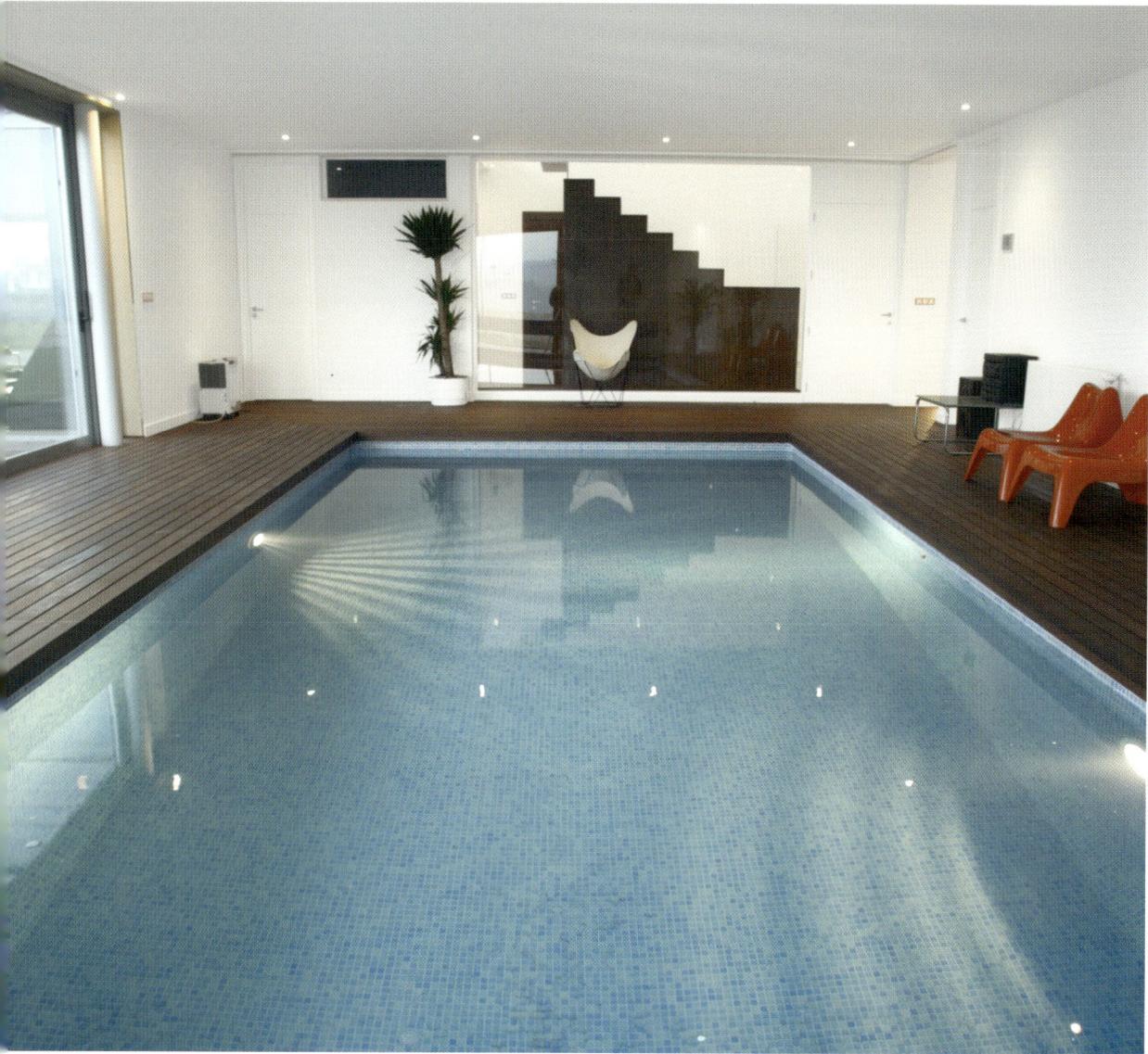

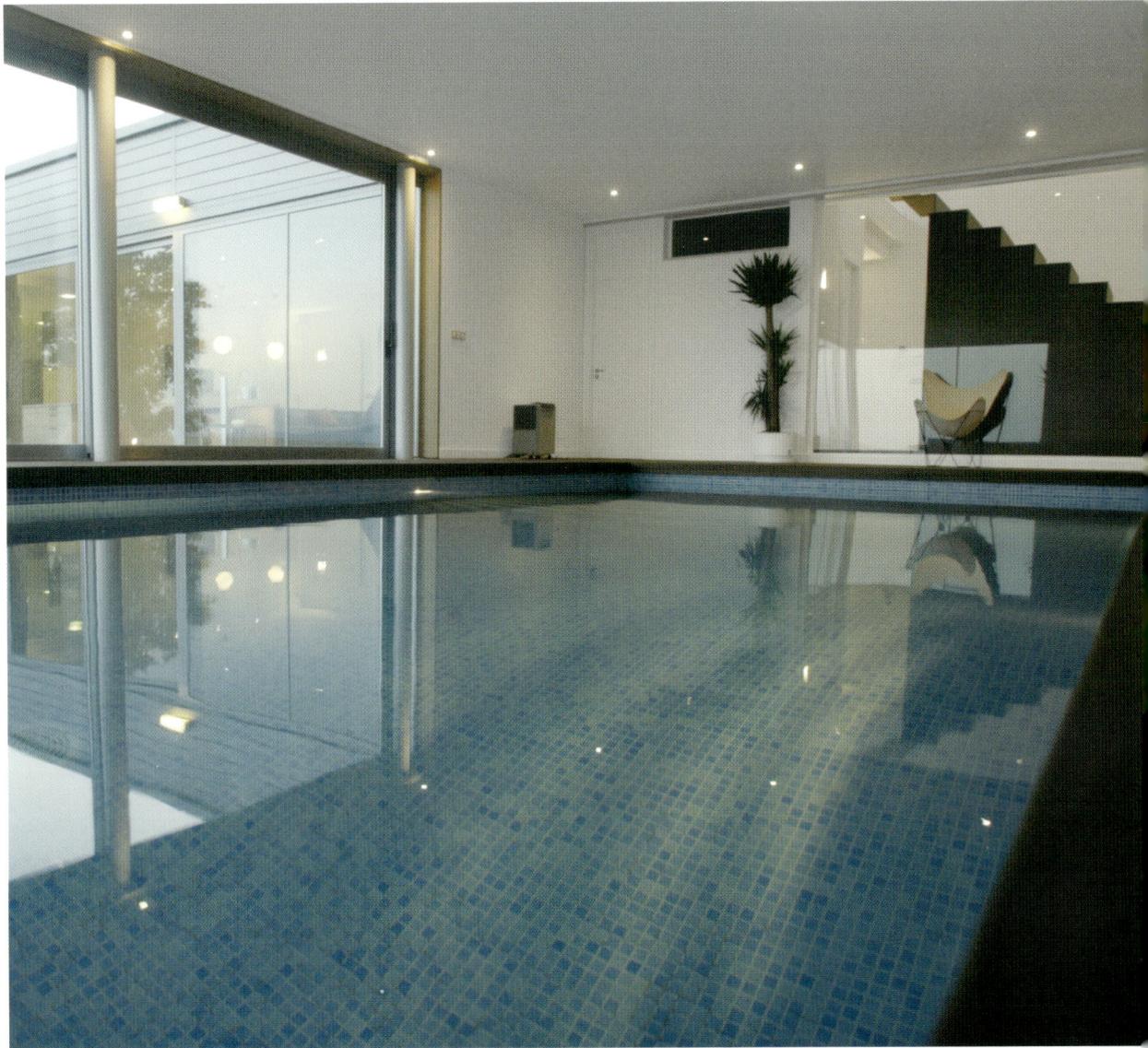

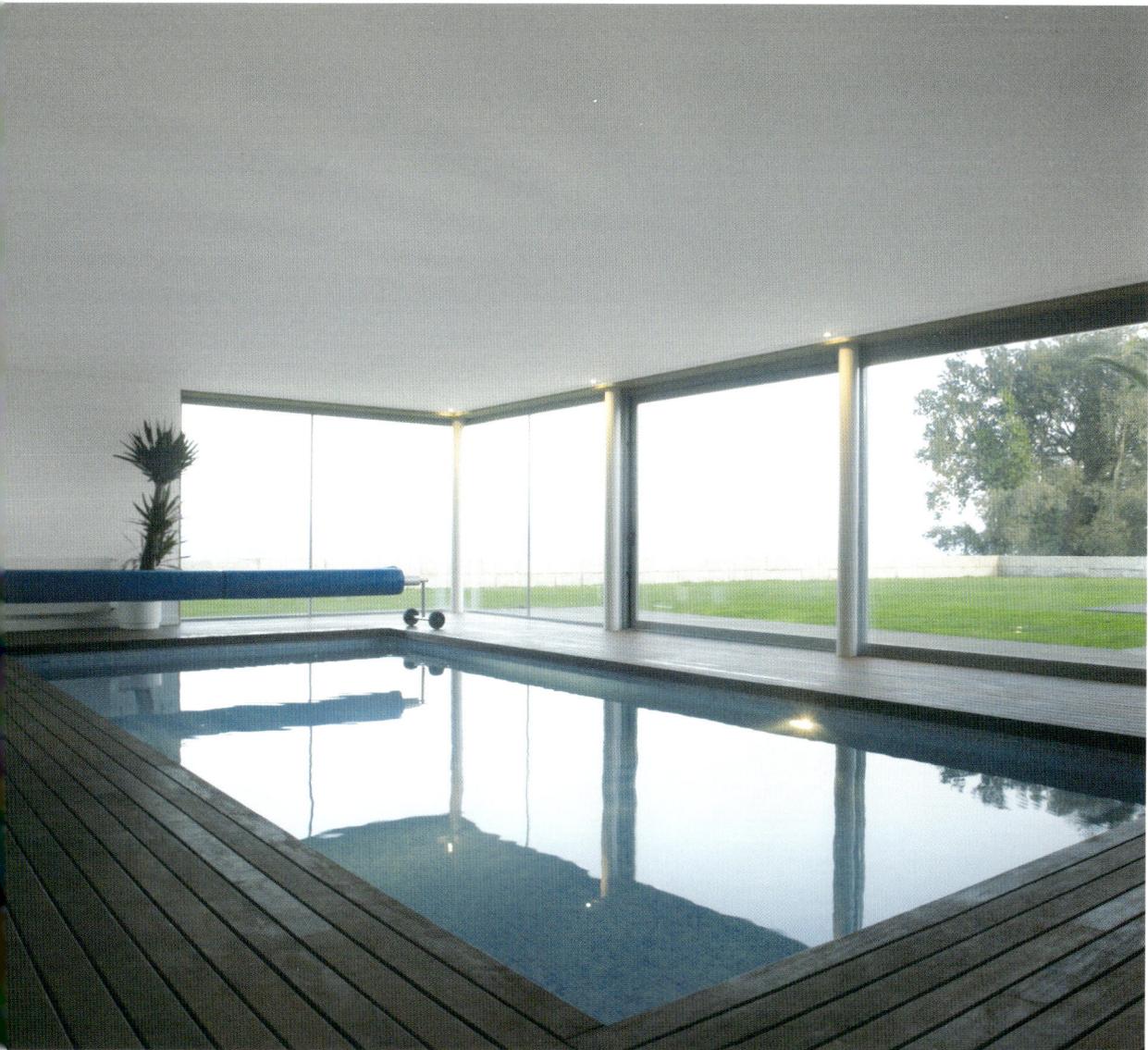

Hariri Pontarini Architects | Toronto, Canada
Art Collector's Residence
Toronto, Canada | 2005

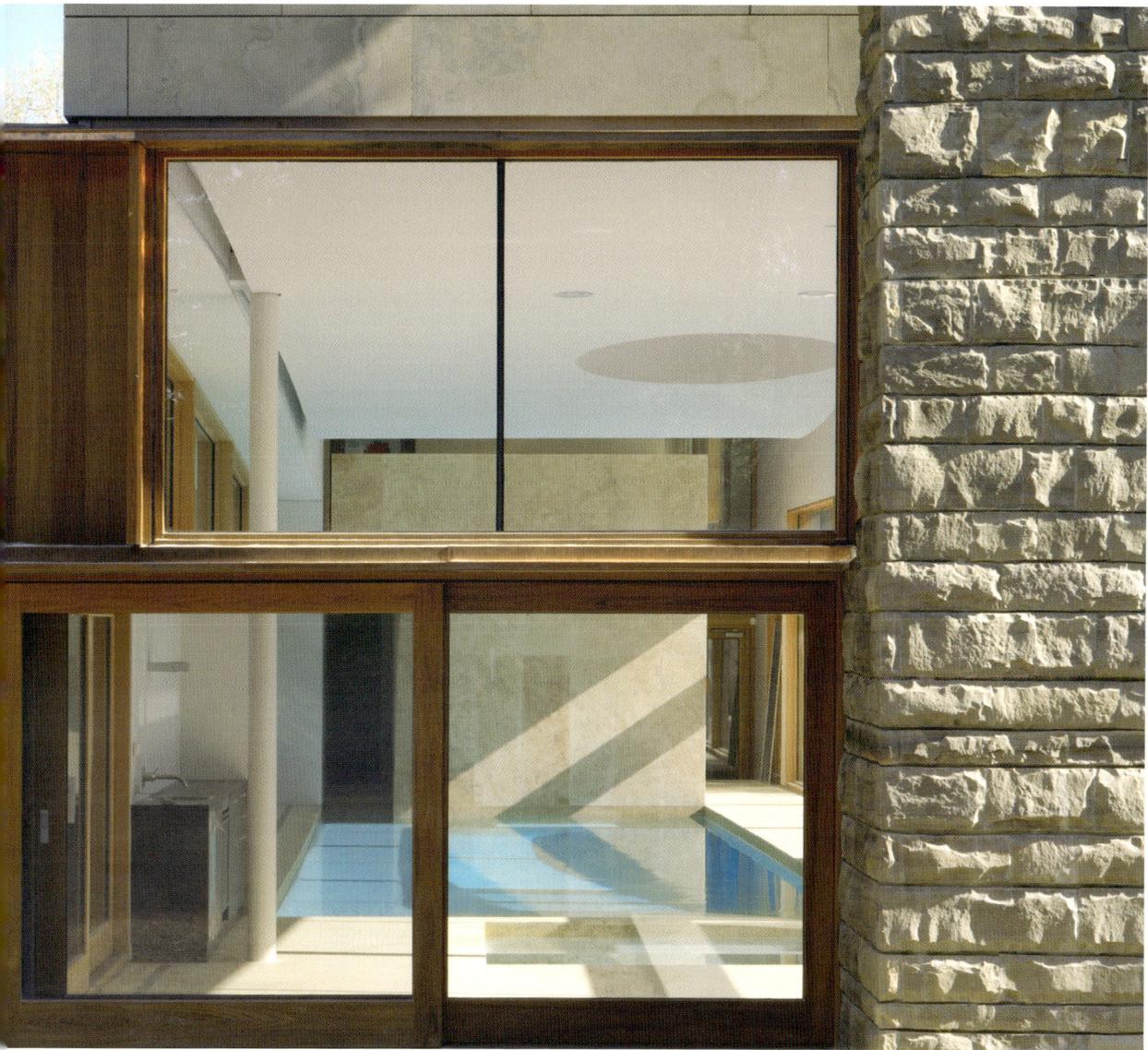

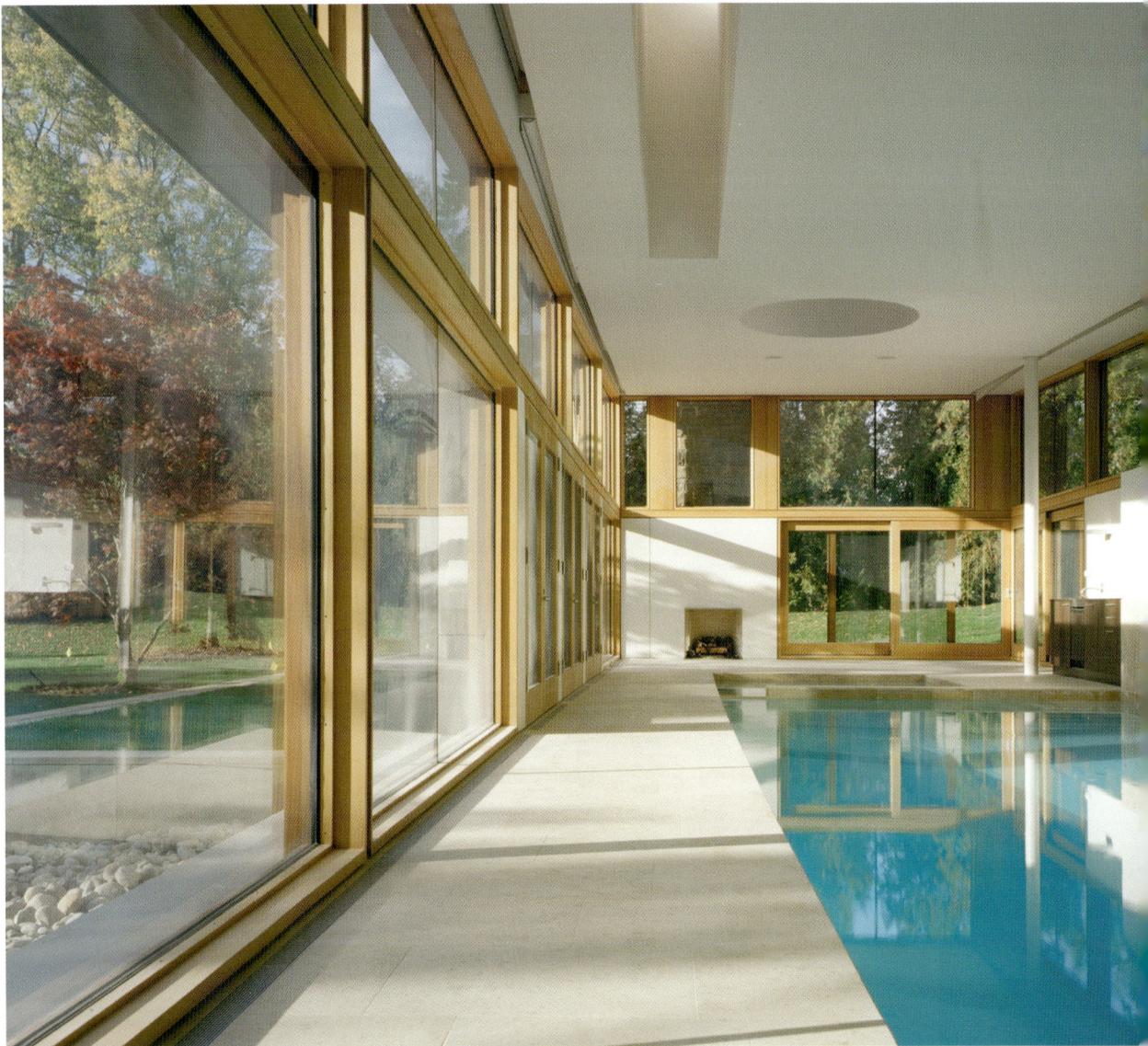

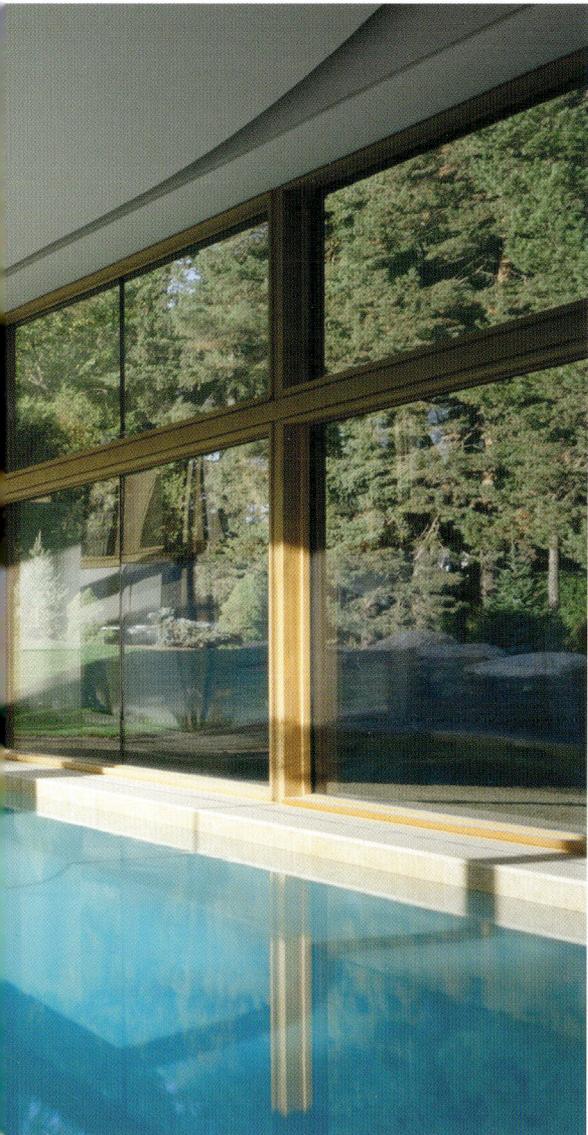

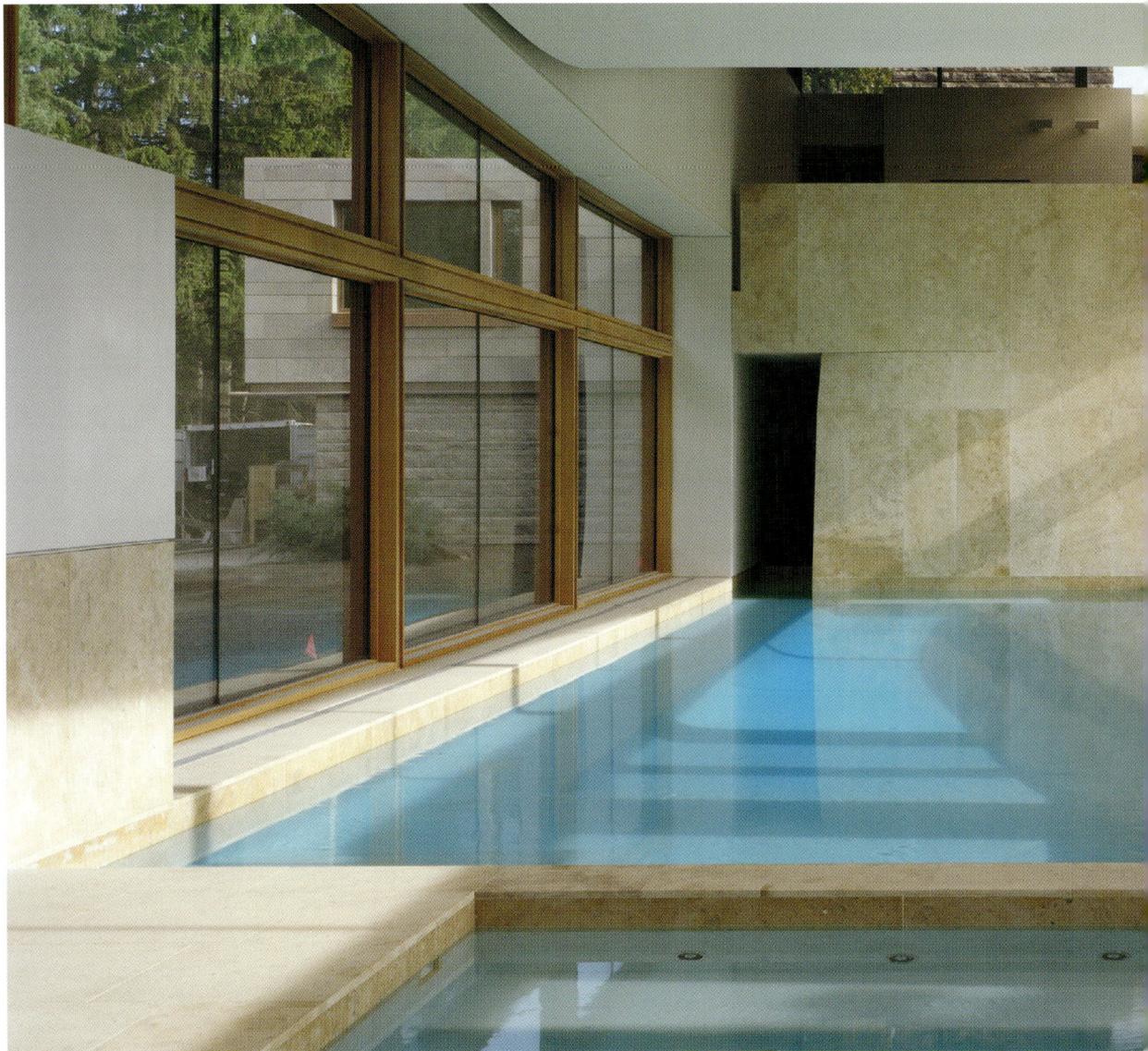

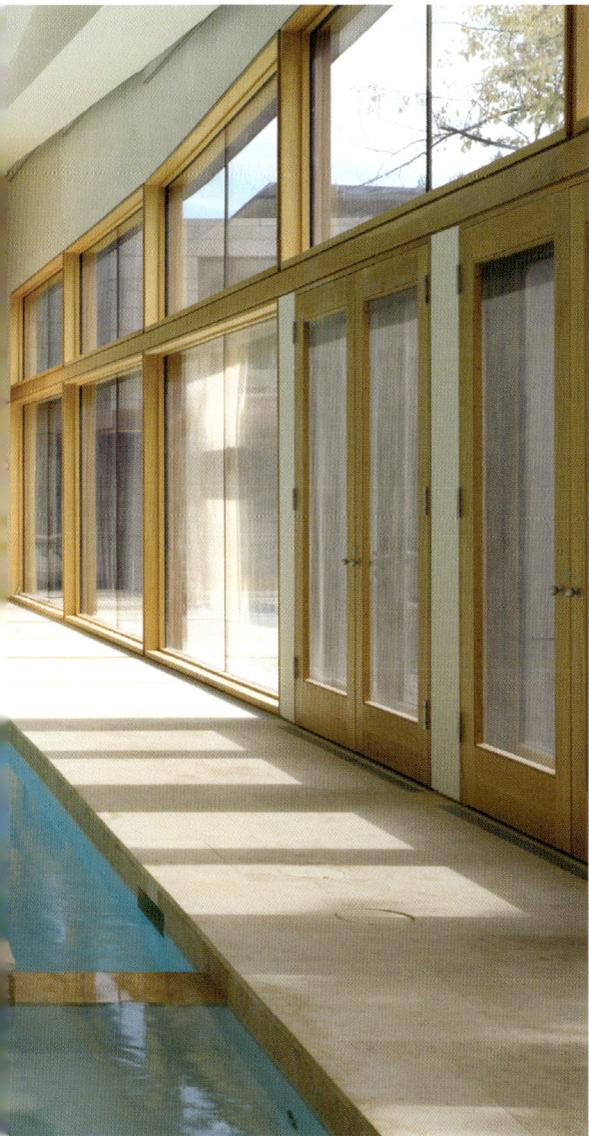

Hertl Architekten | Steyr, Austria
Pool am Hof
Pöch, Austria | 2001

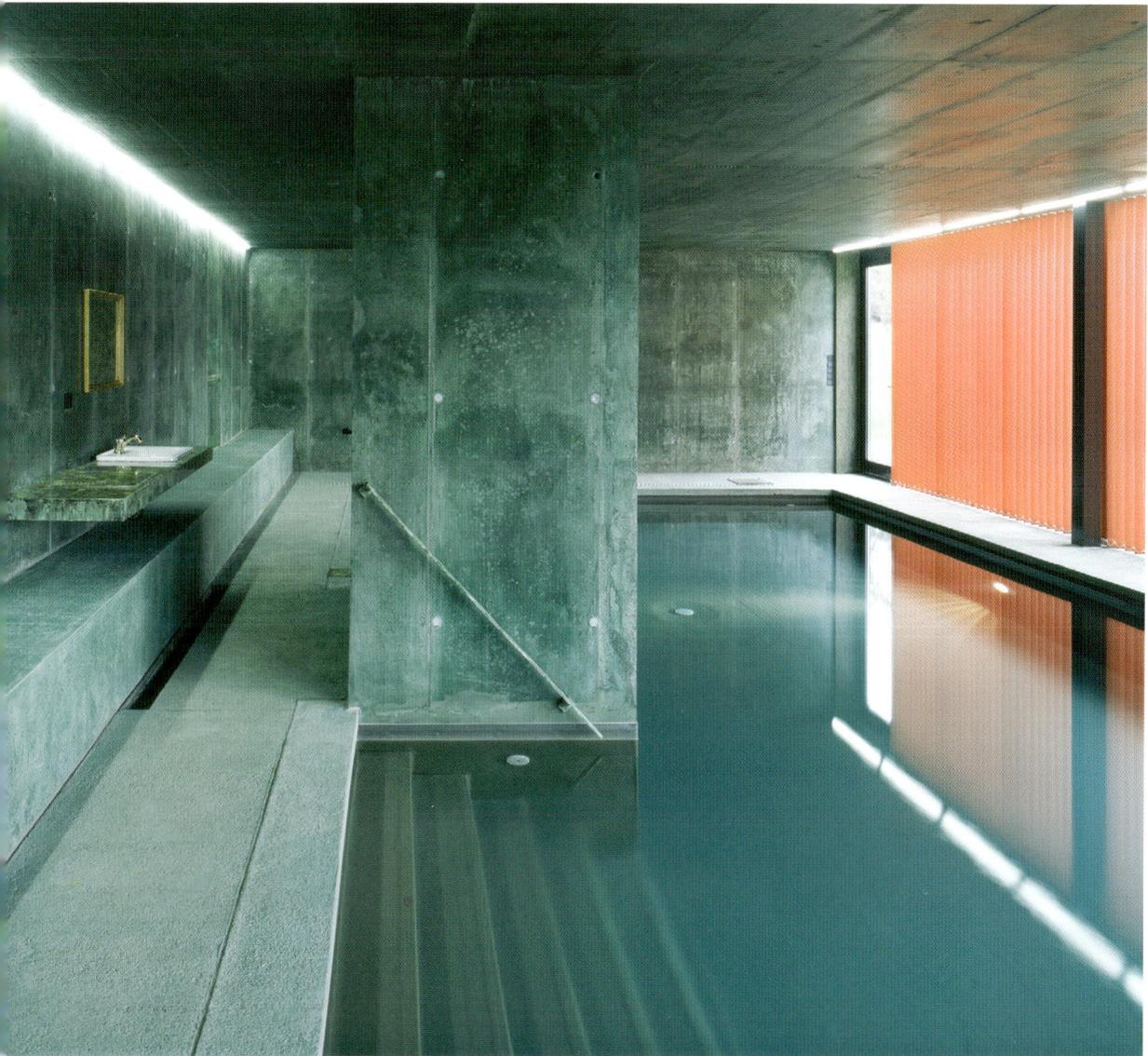

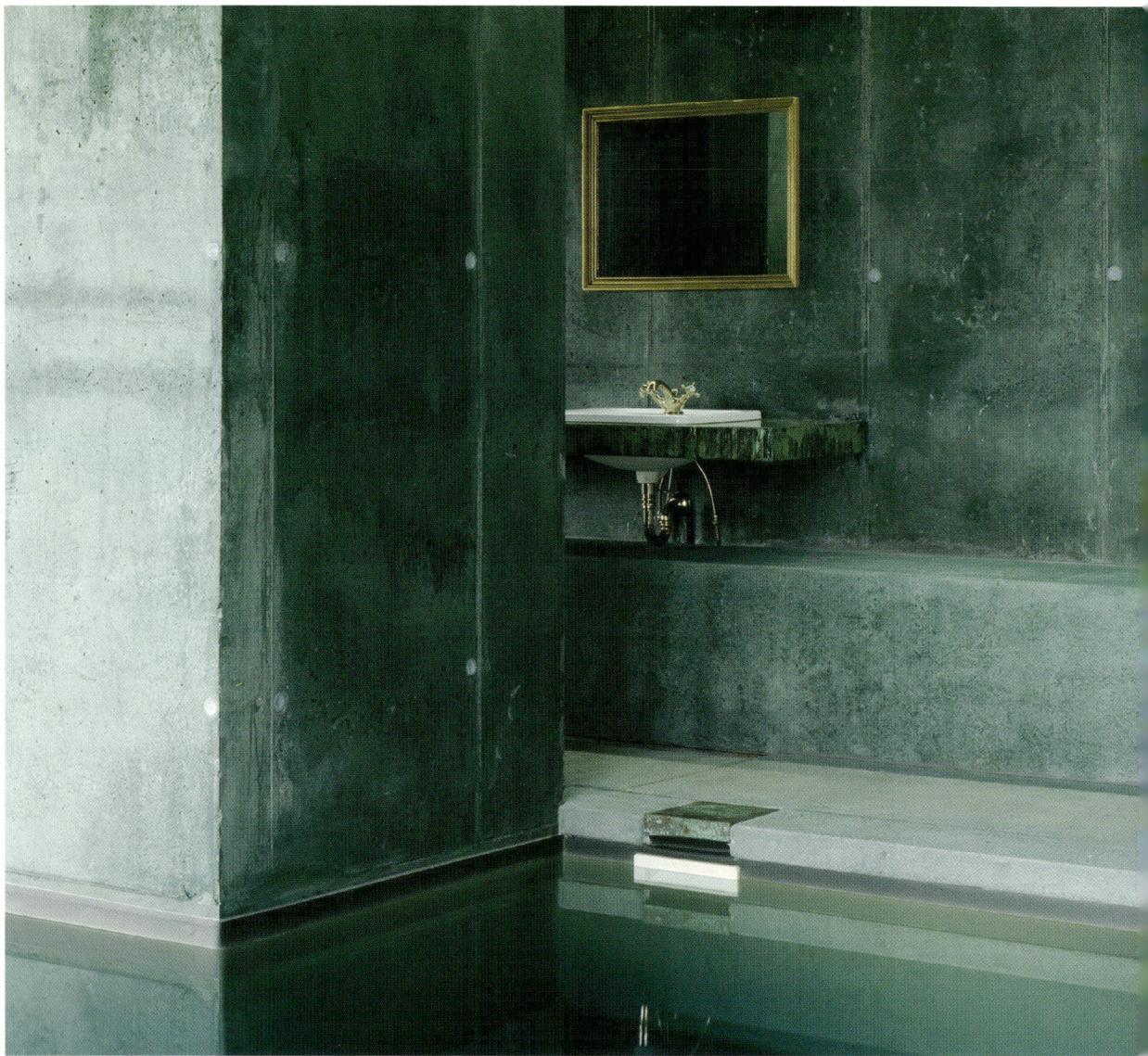

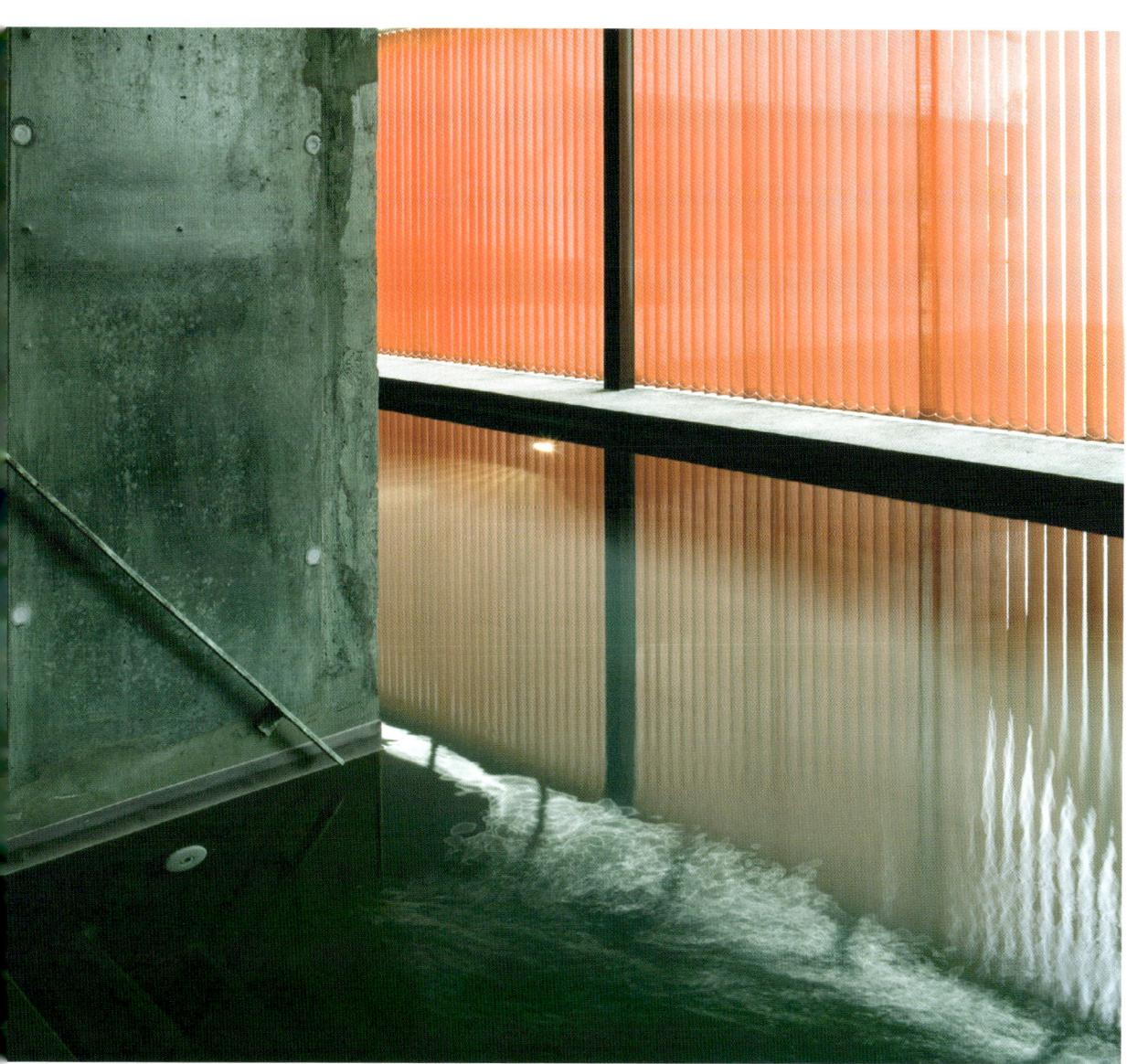

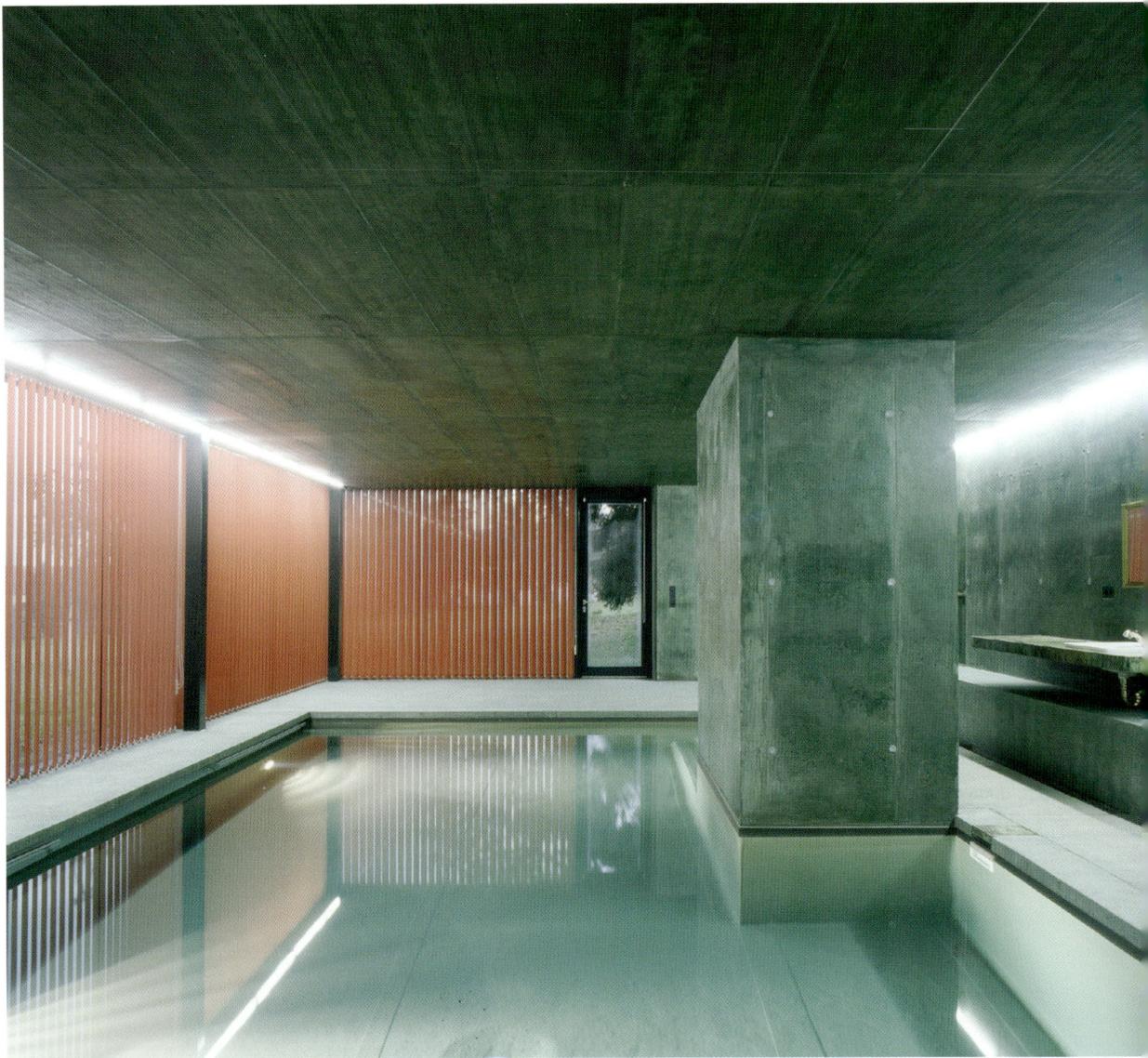

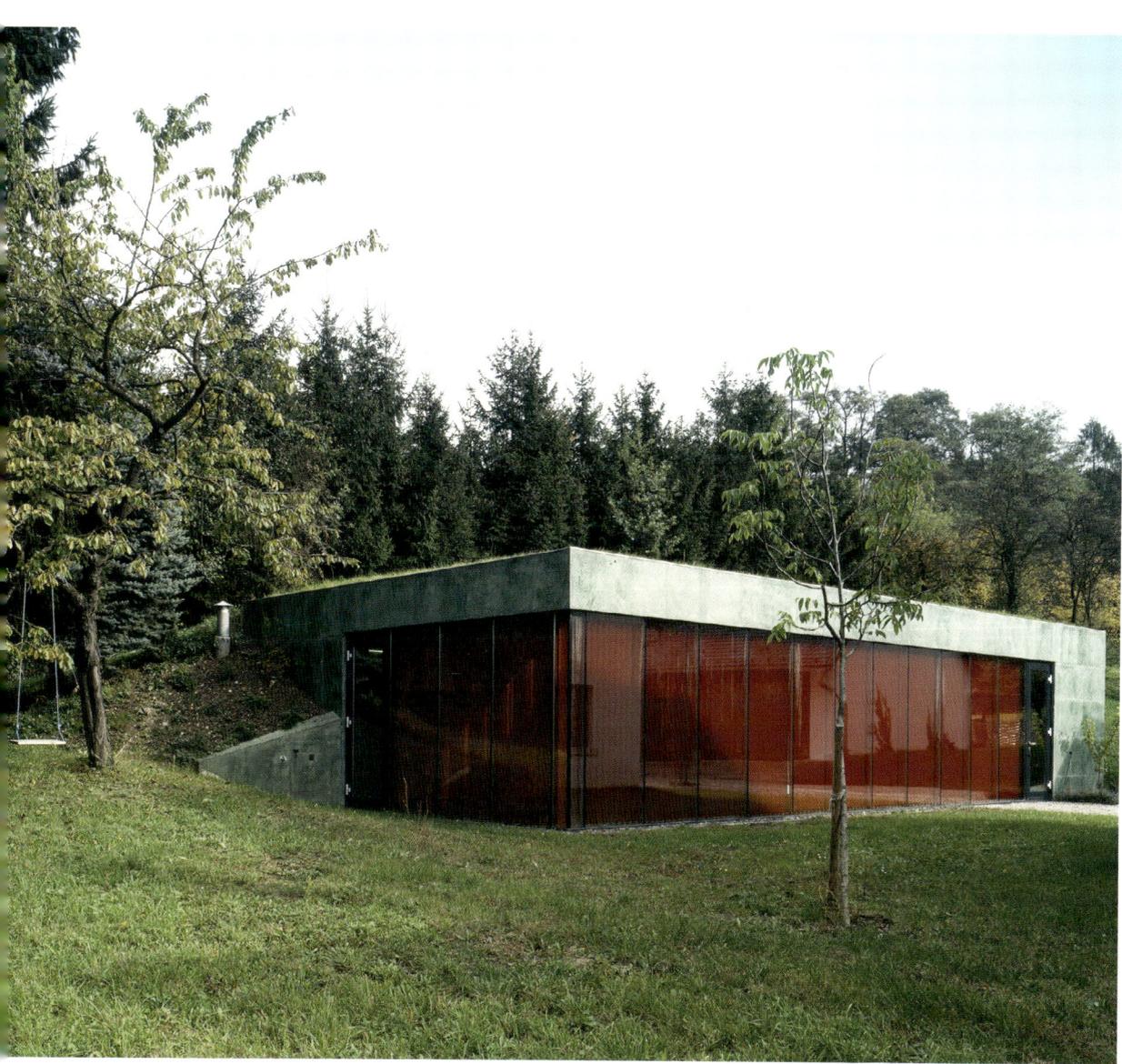

Herzog & De Meuron | Basel, Switzerland
Wohnhaus Ruff
Düsseldorf, Germany | 2004

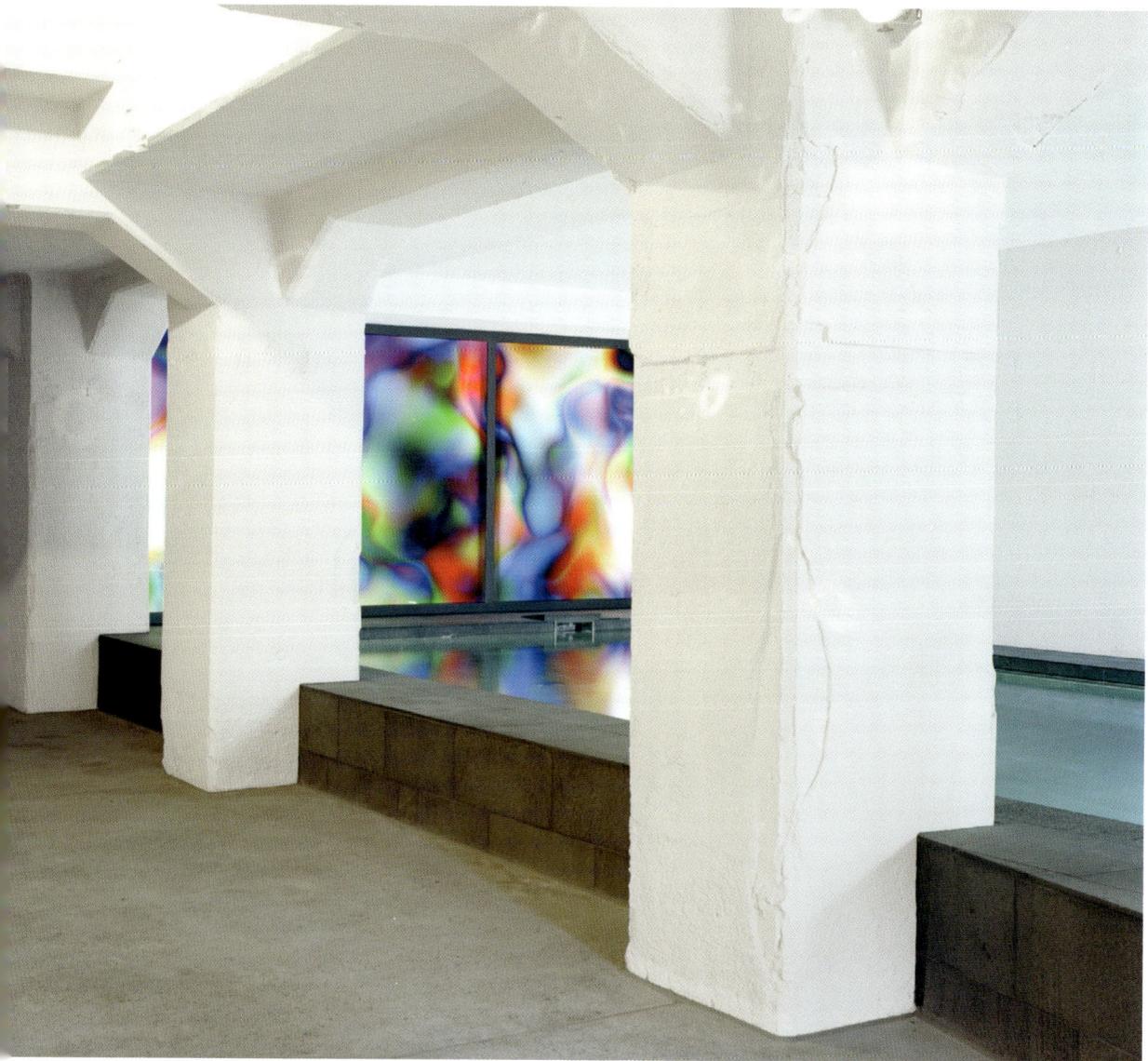

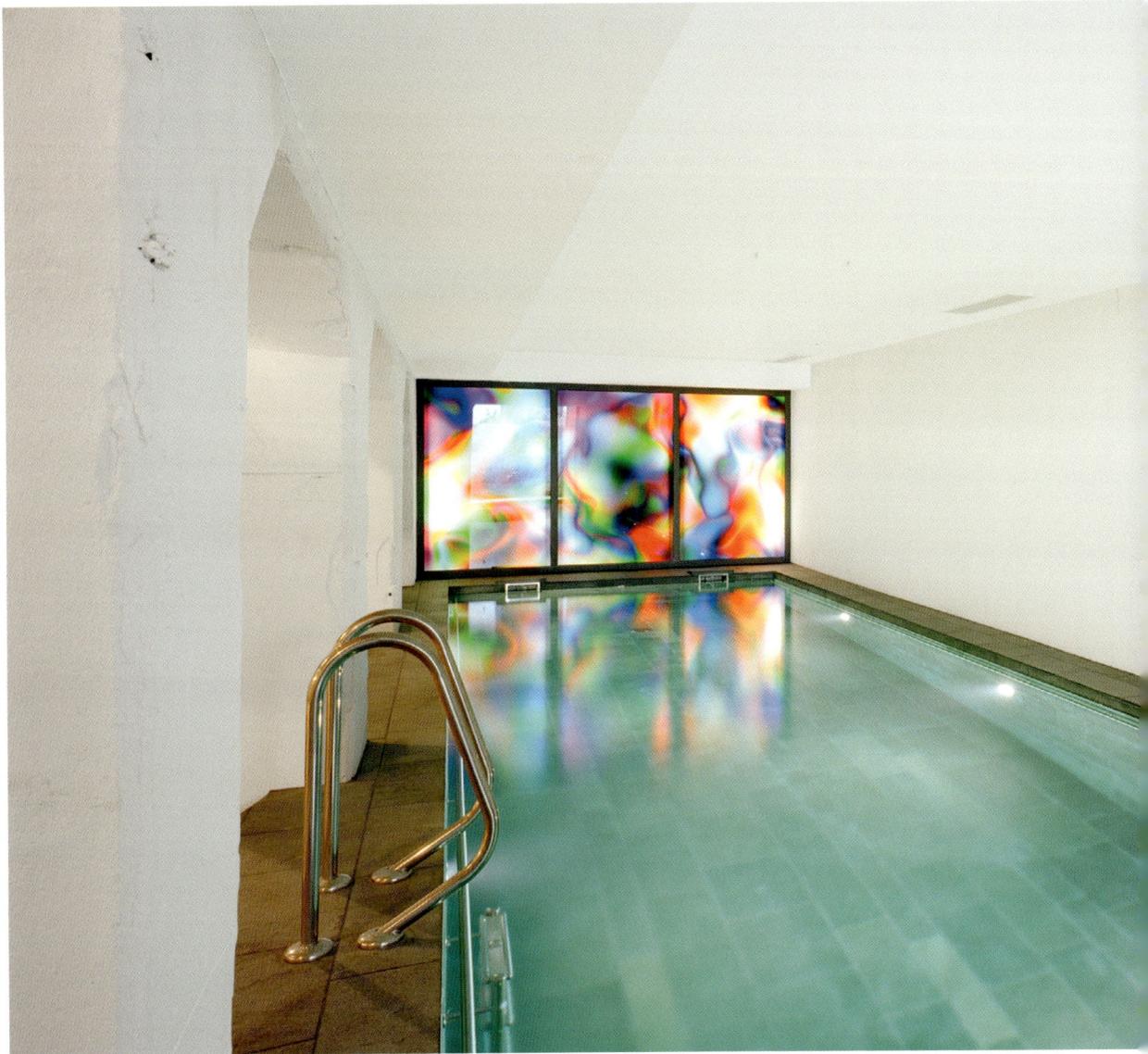

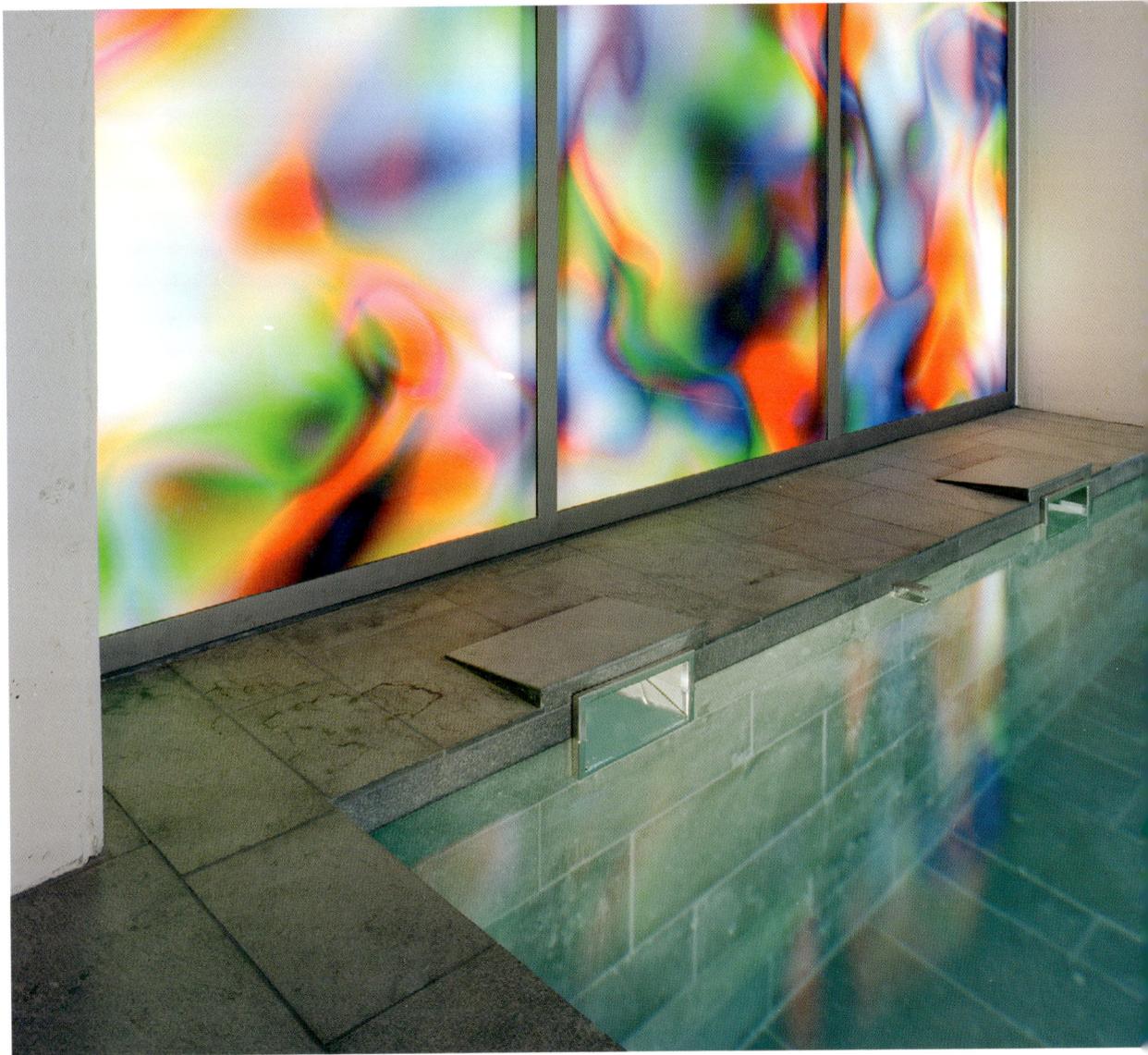

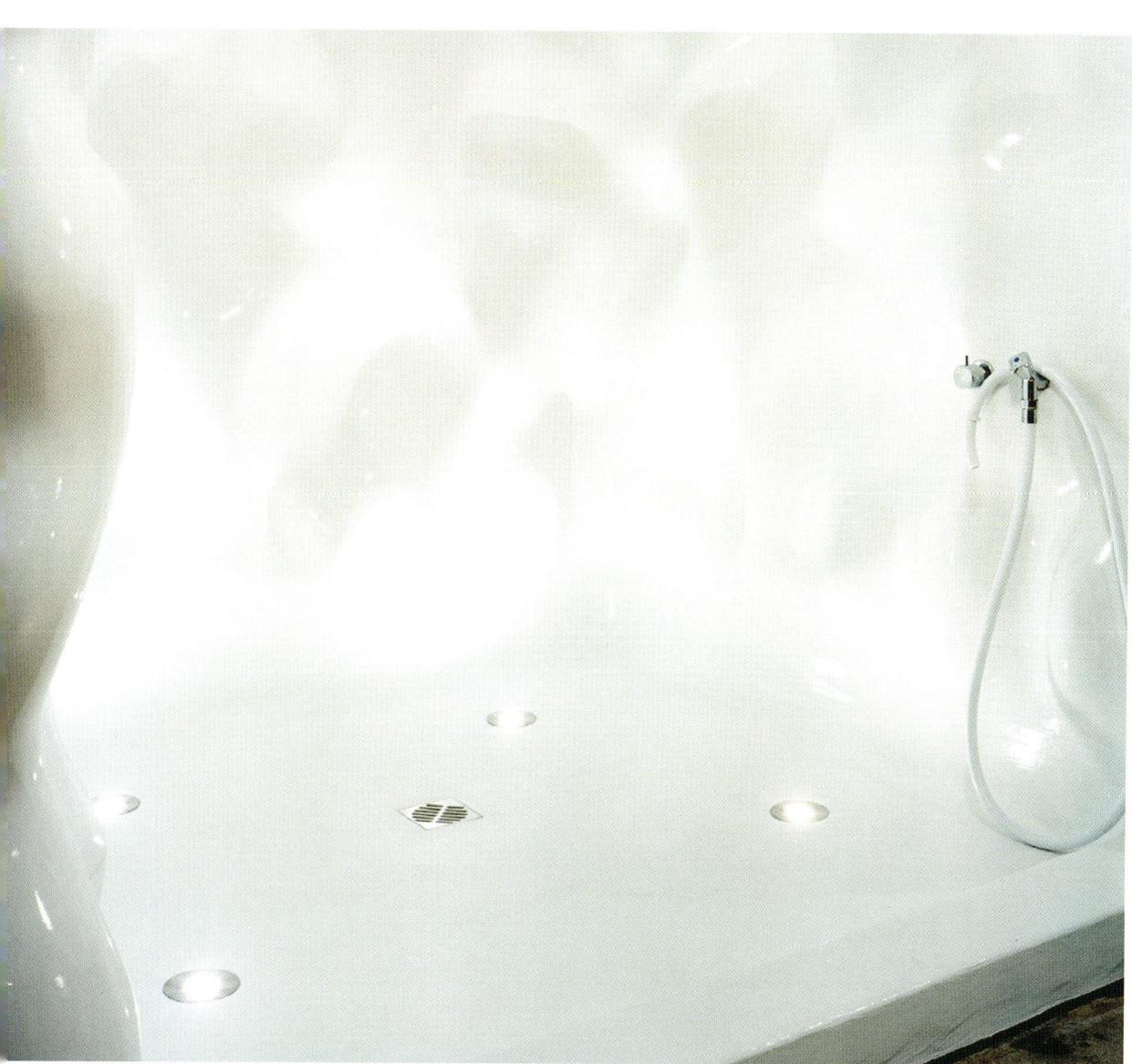

KVA–Kennedy and Violich Architecture | Boston, USA
Residence and Gallery of Contemporary Art
Western, Massachusetts, USA | 1998

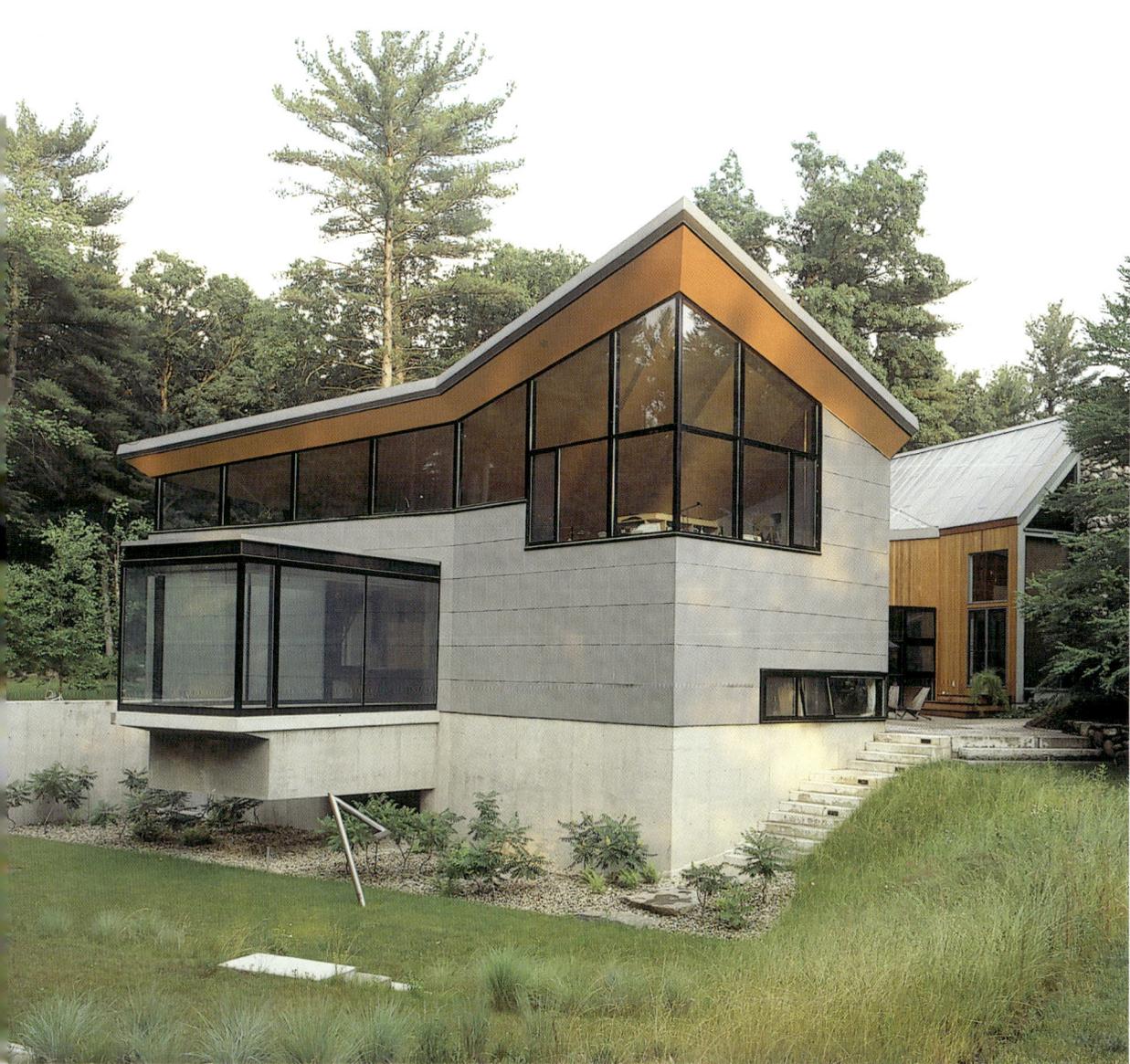

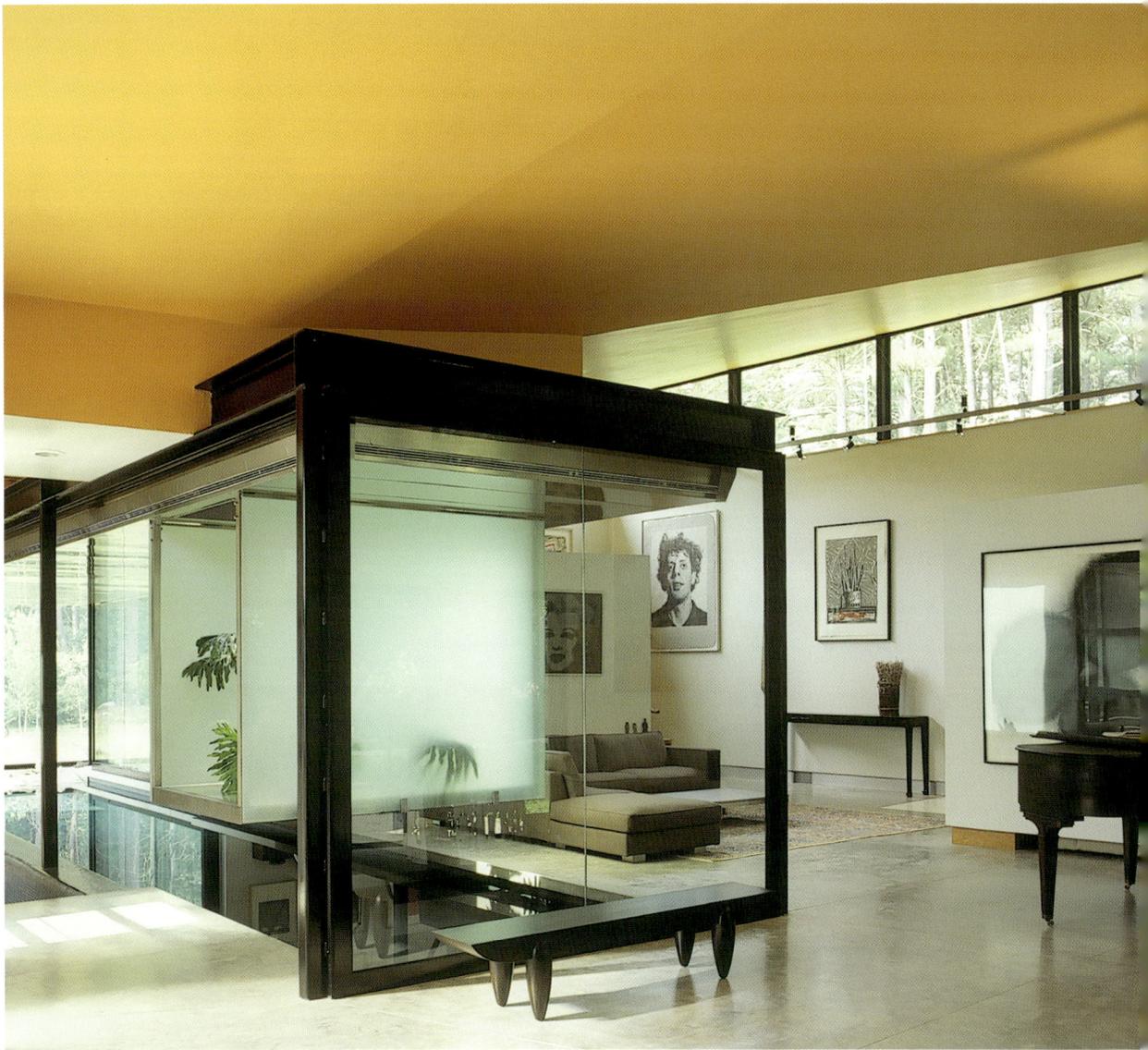

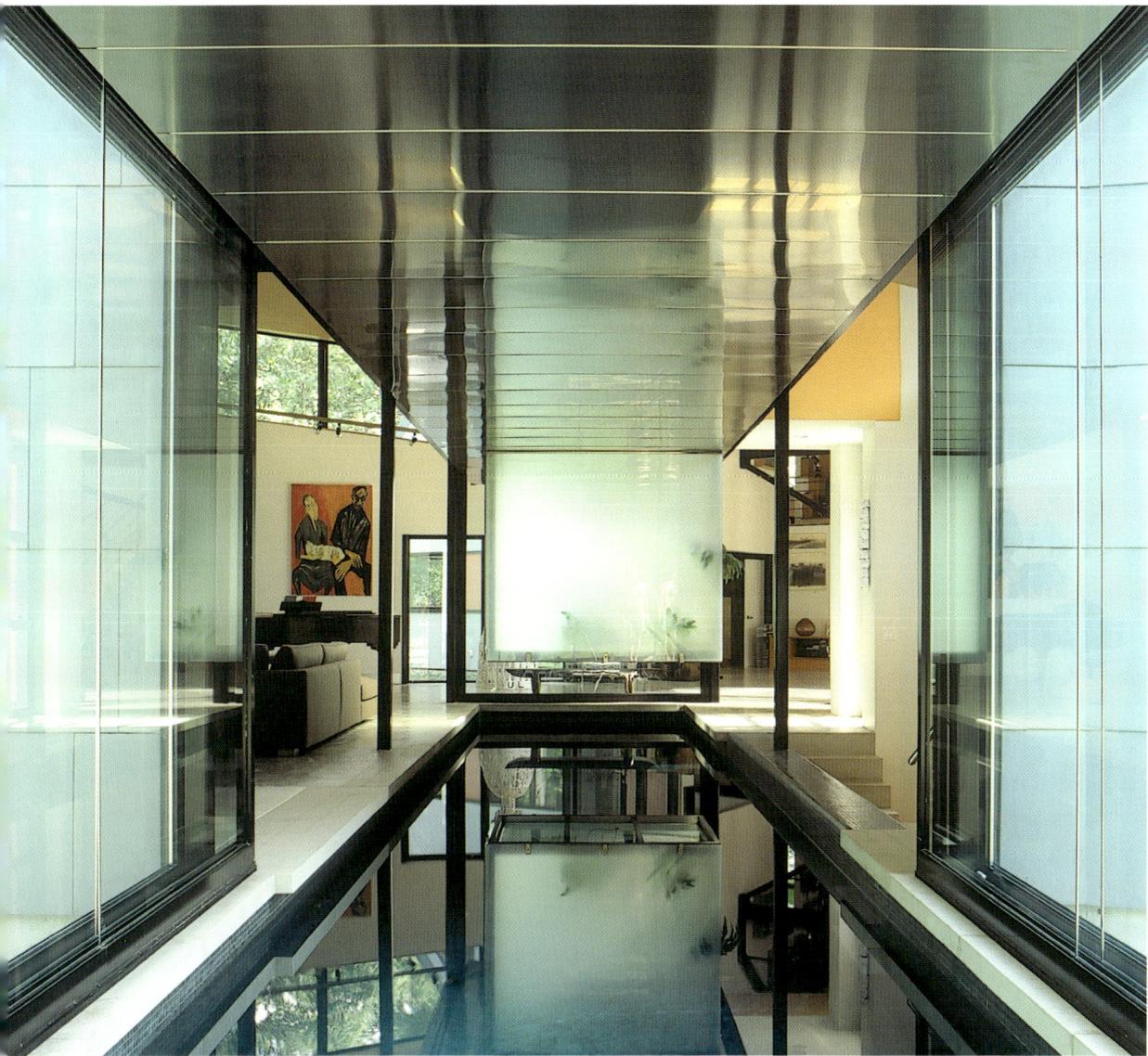

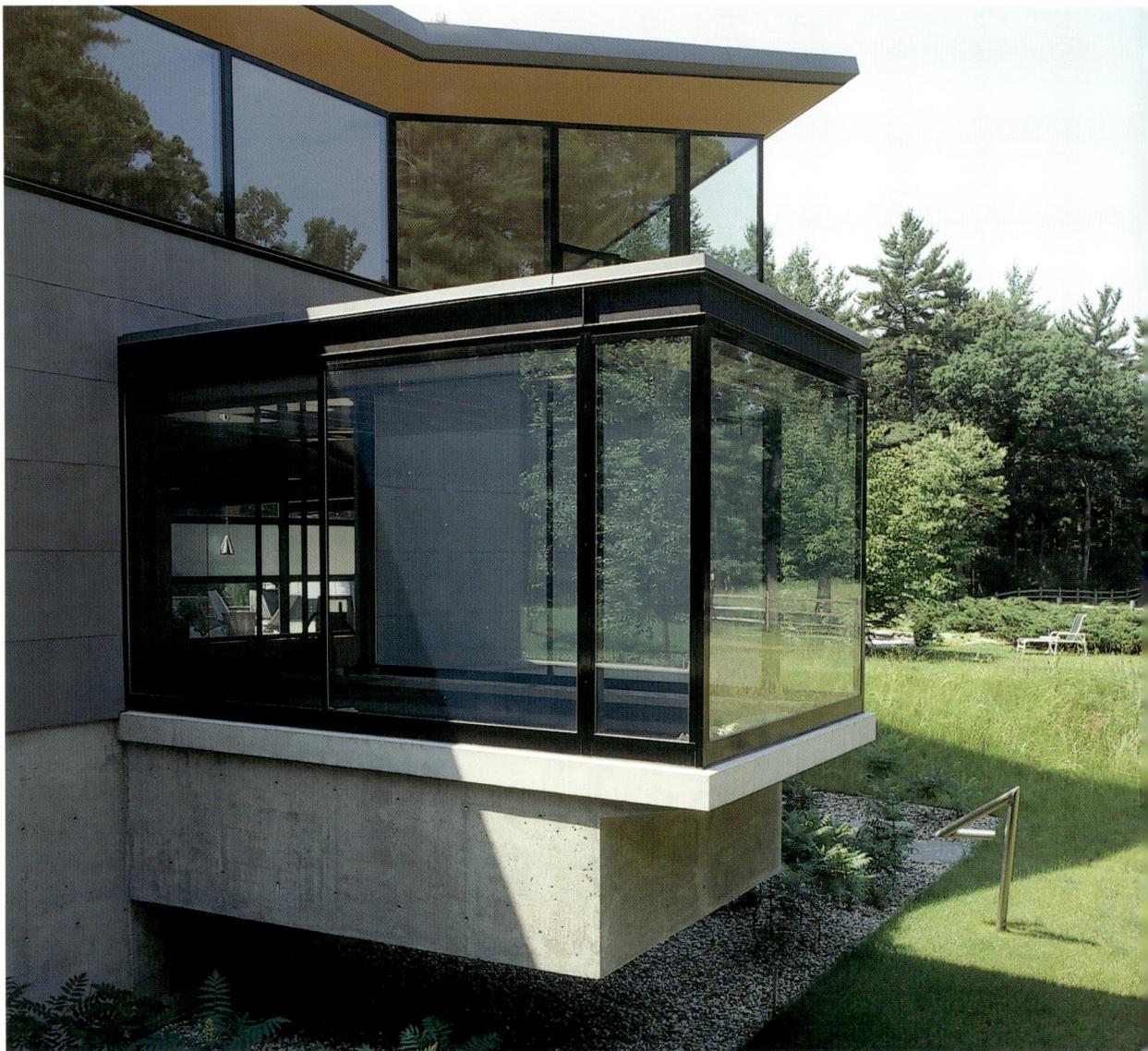

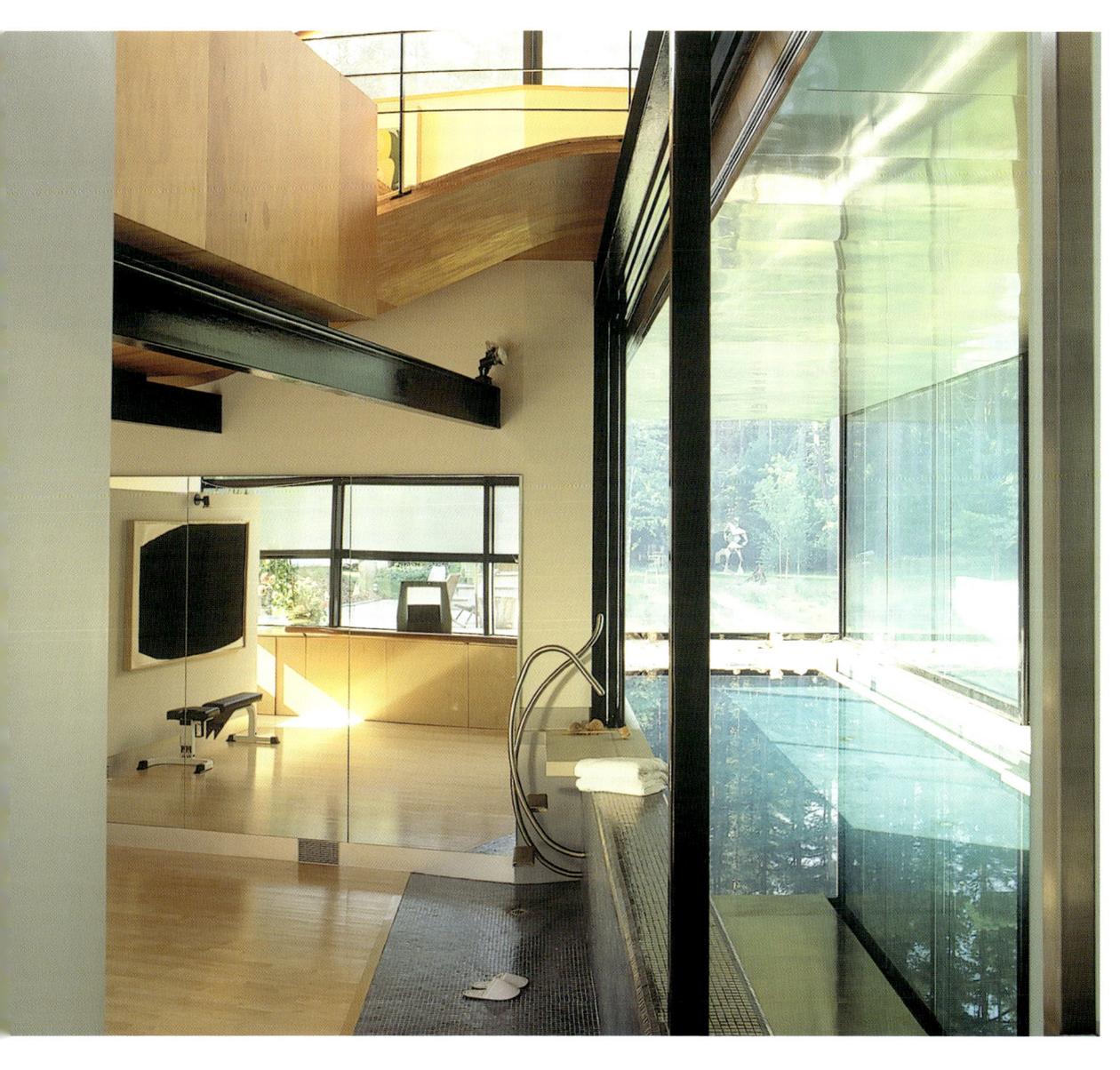

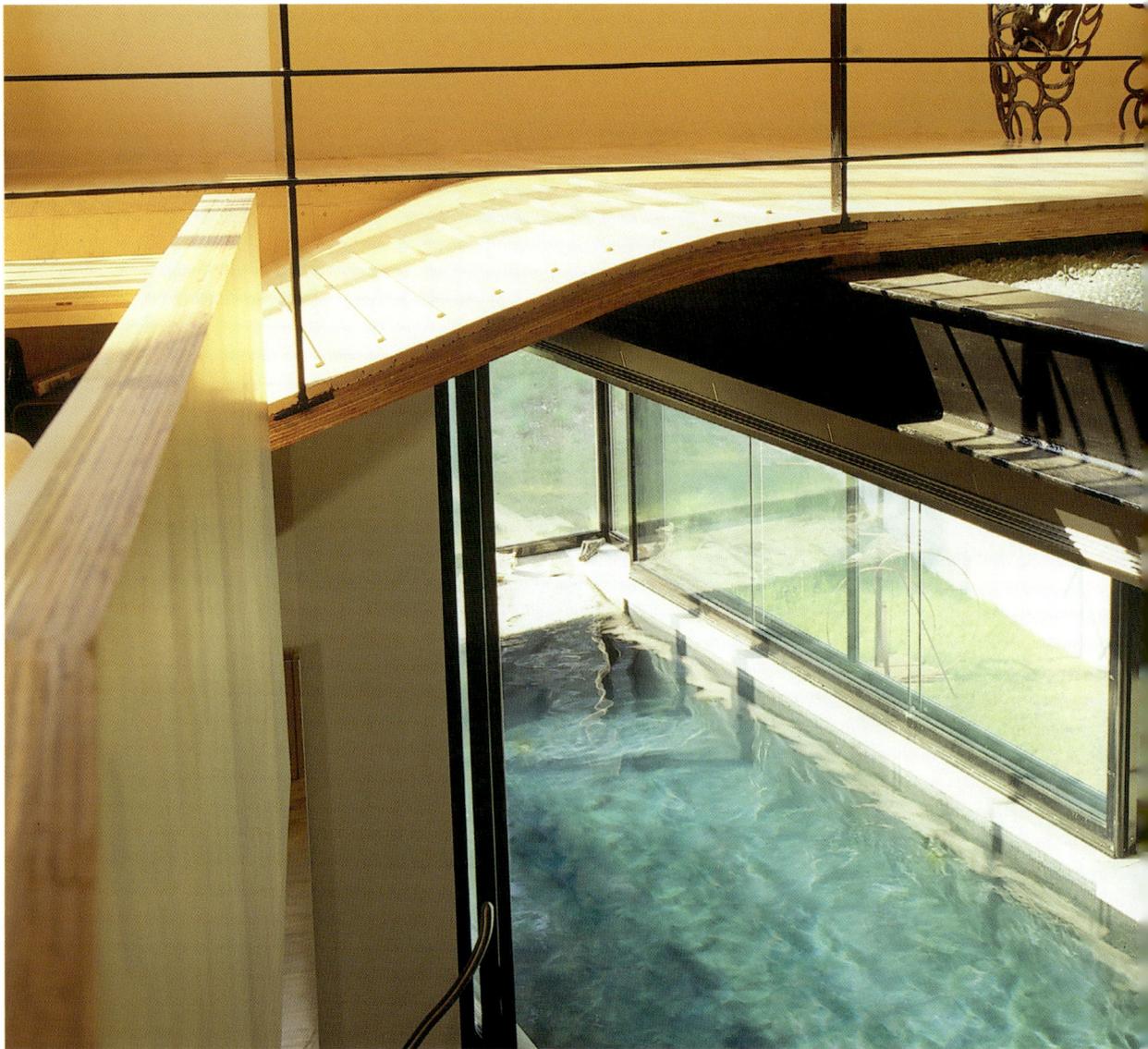

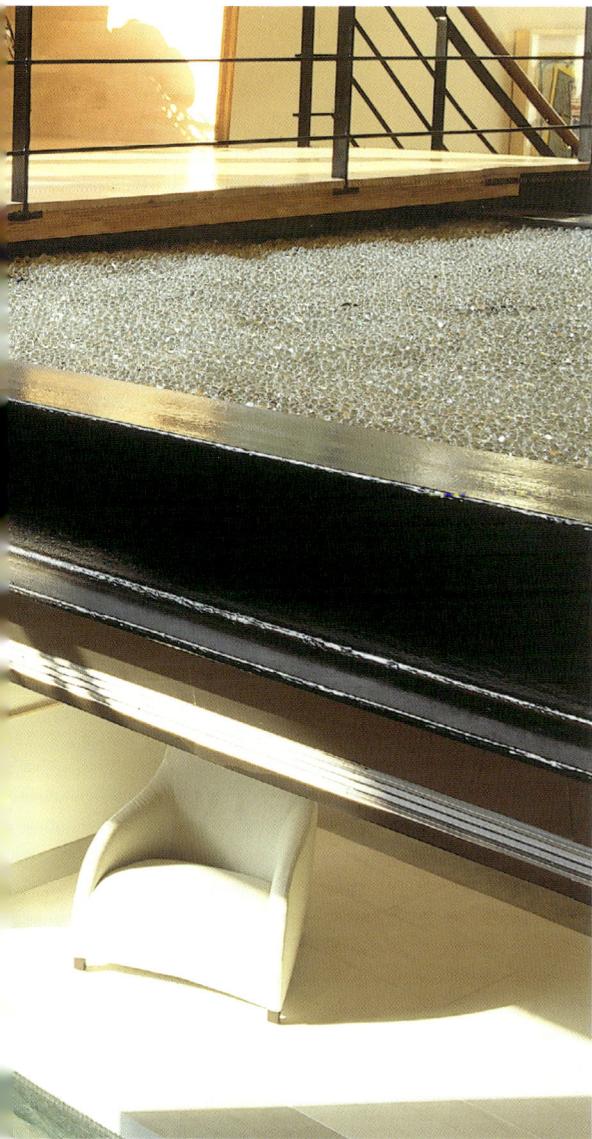

LKD Concepts | Zurich, Switzerland
House in Gordes
Gordes, France | 2001

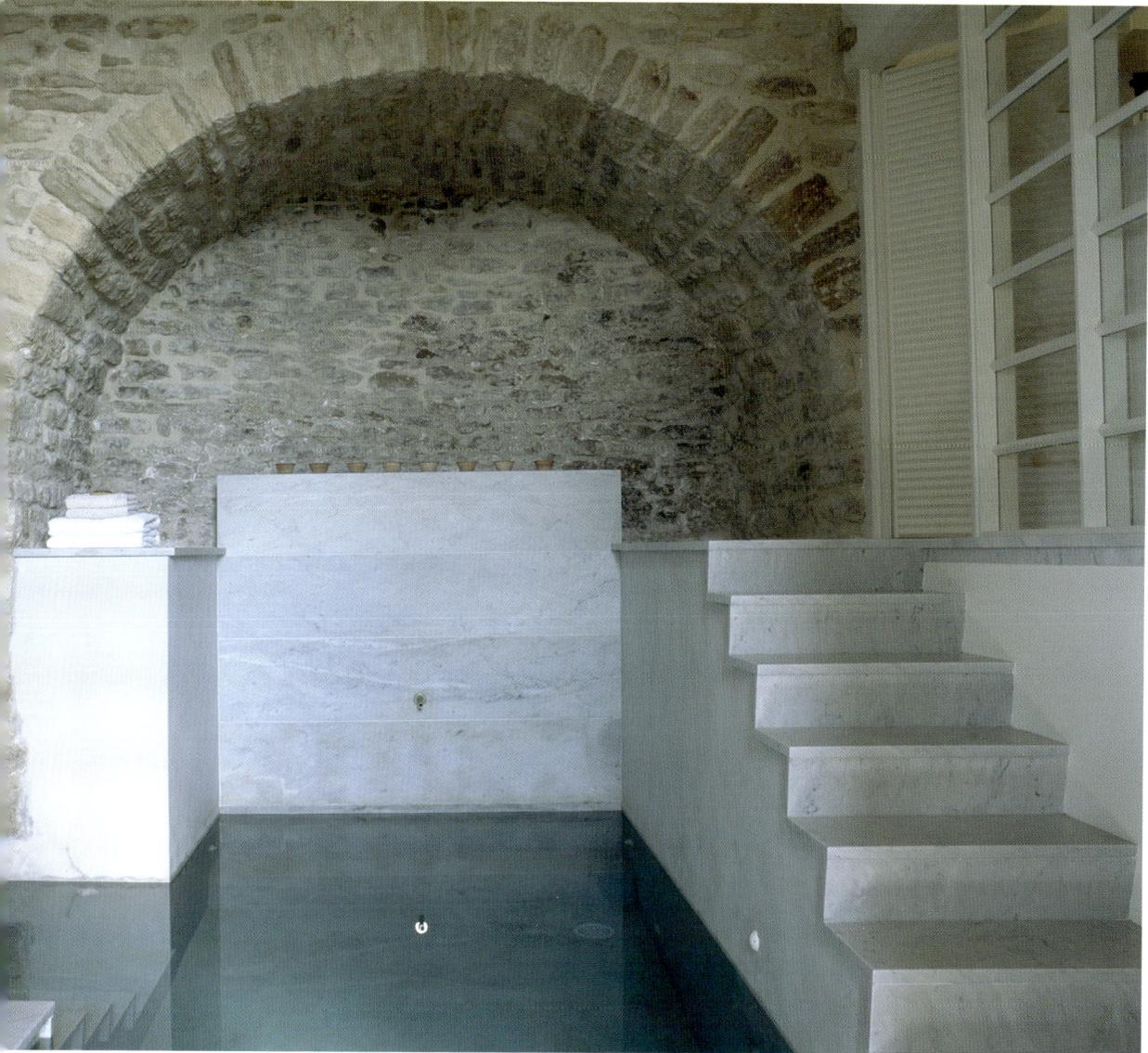

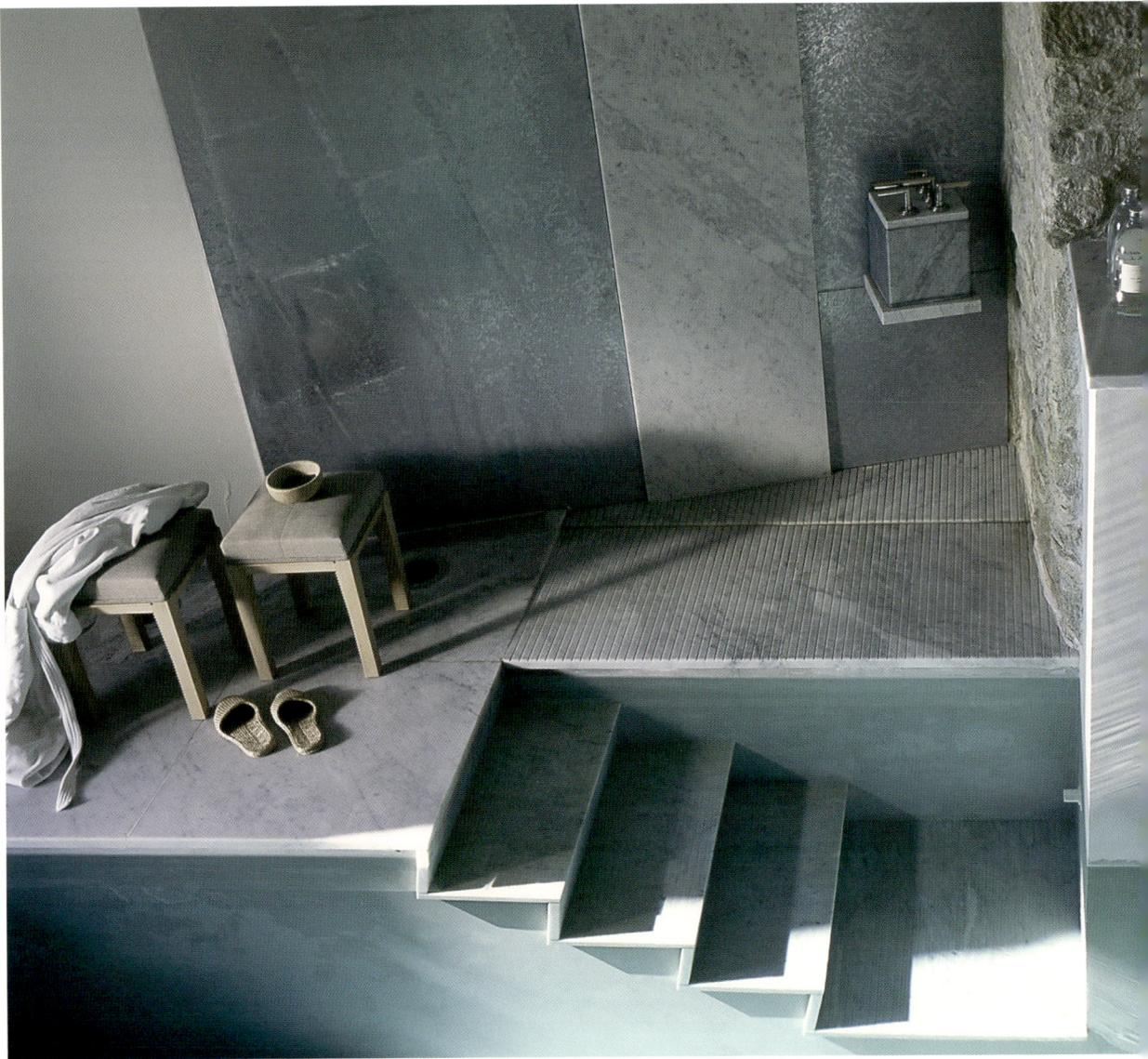

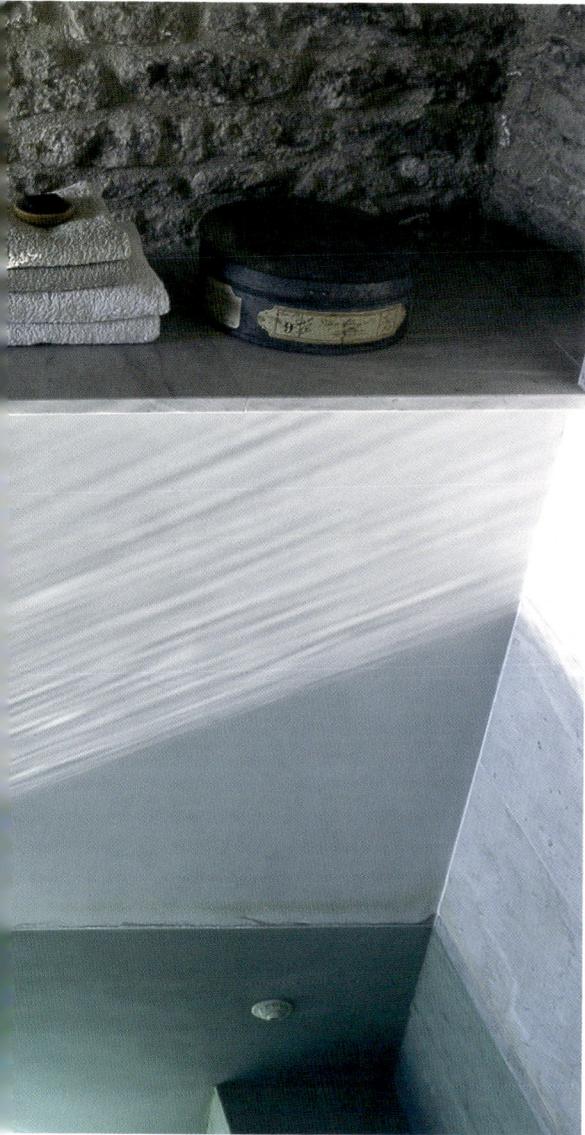

Manuel Serrano Arquitectos | Madrid, Spain
Loft
Madrid, Spain | 2004

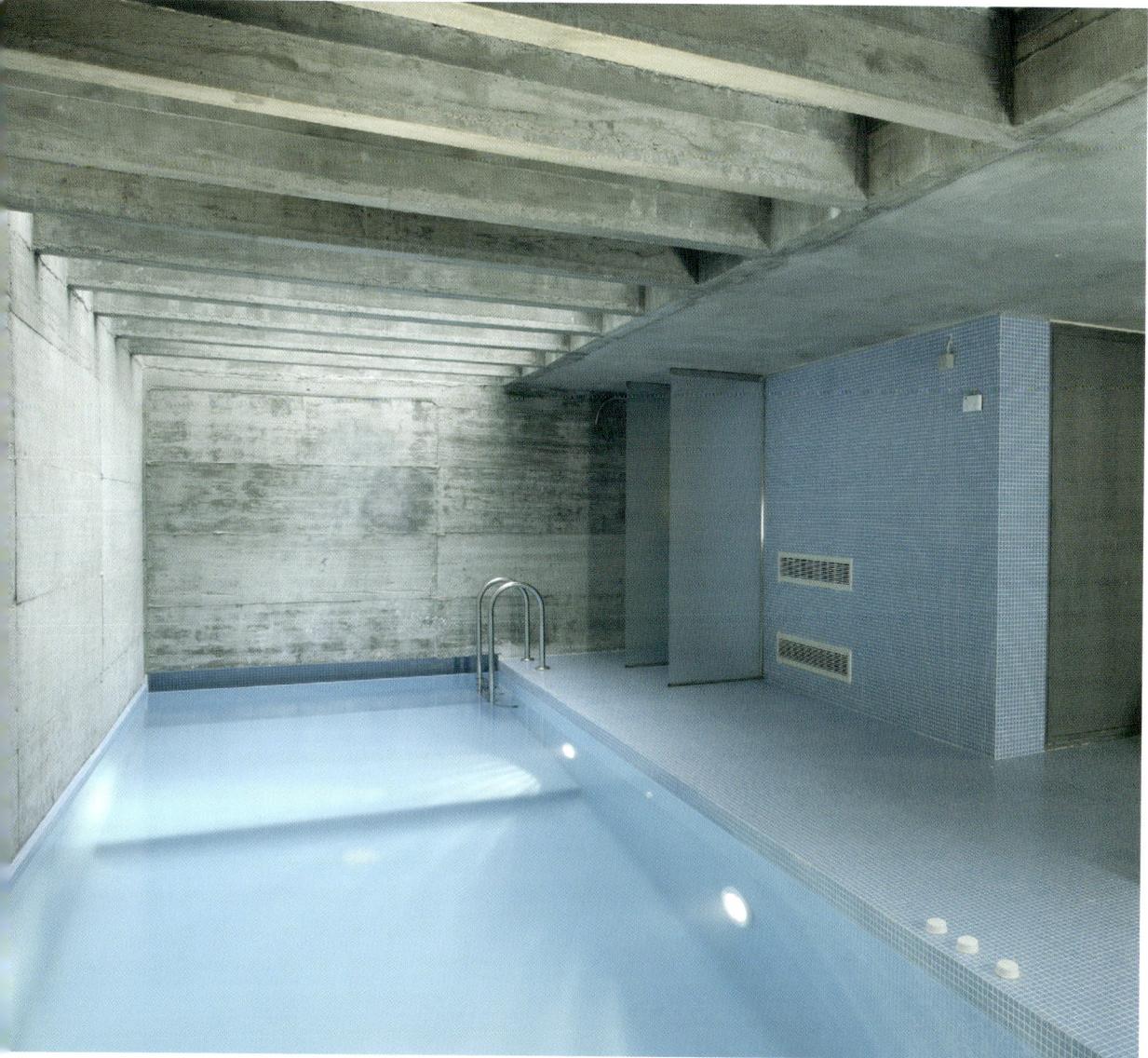

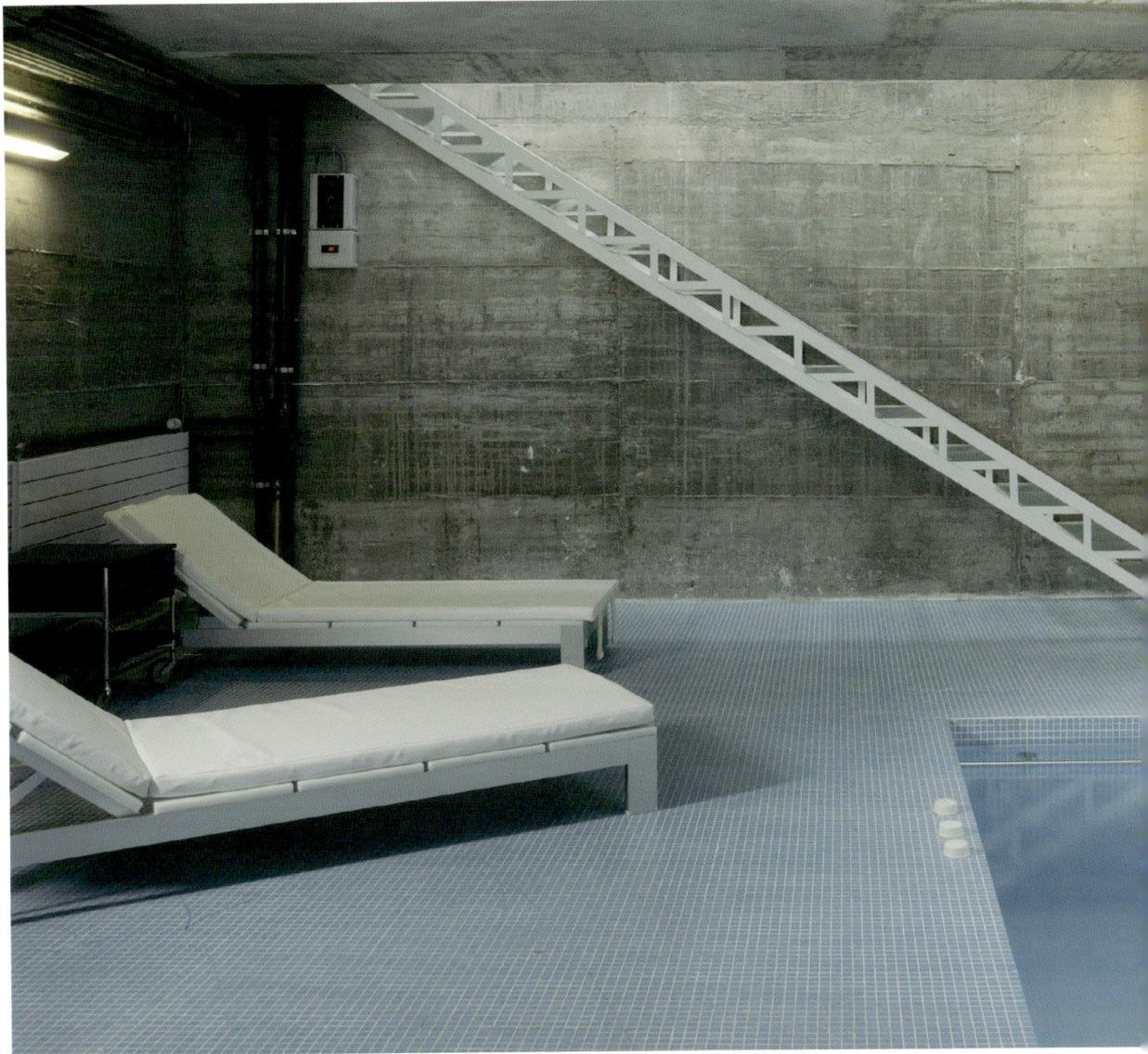

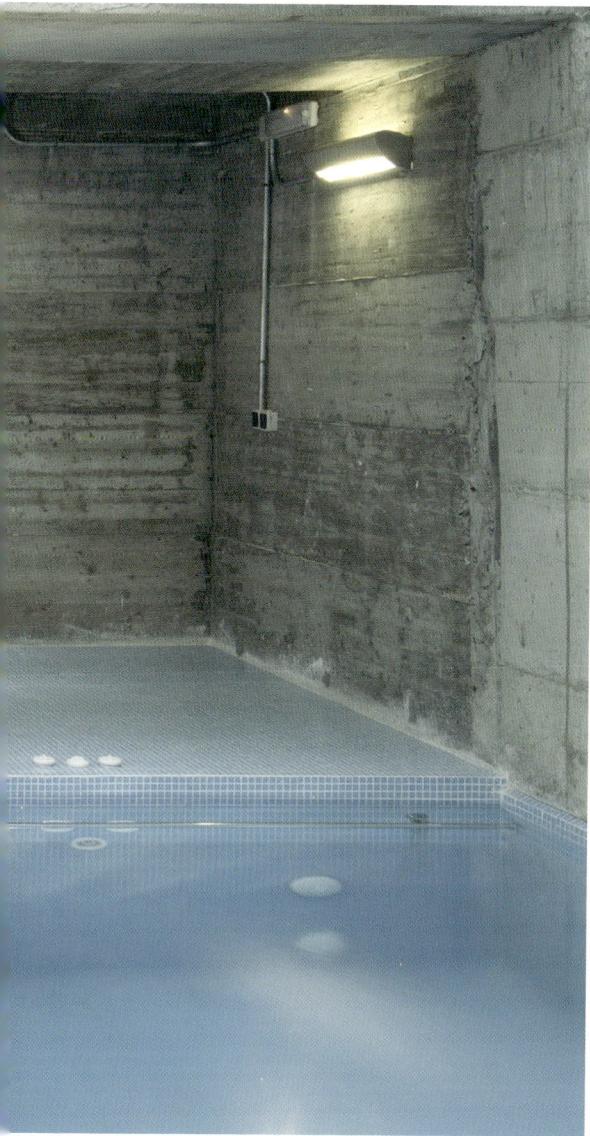

Marcio Kogan Architects | São Paulo, Brazil
BR House
Araras, Brazil | 2004

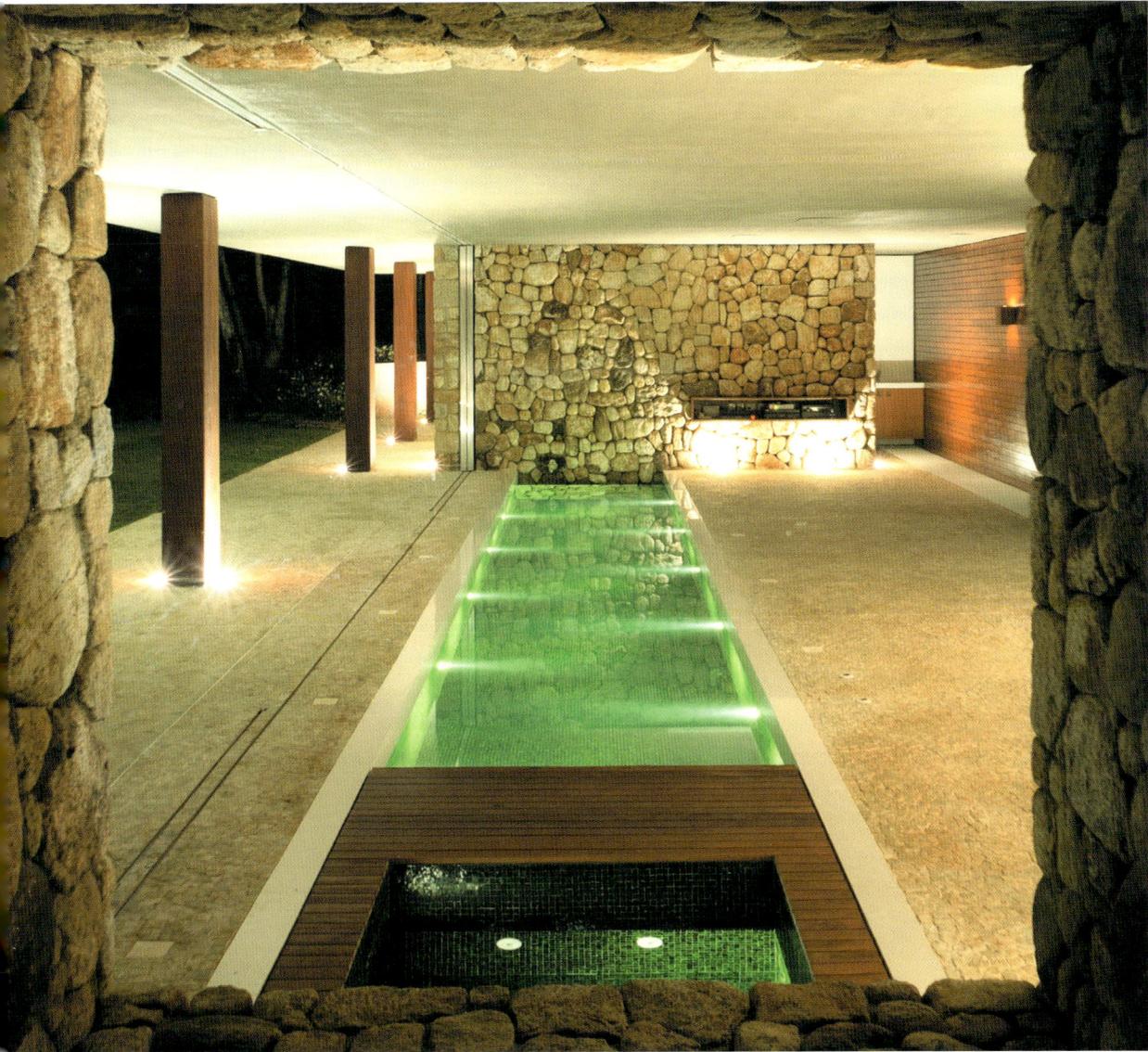

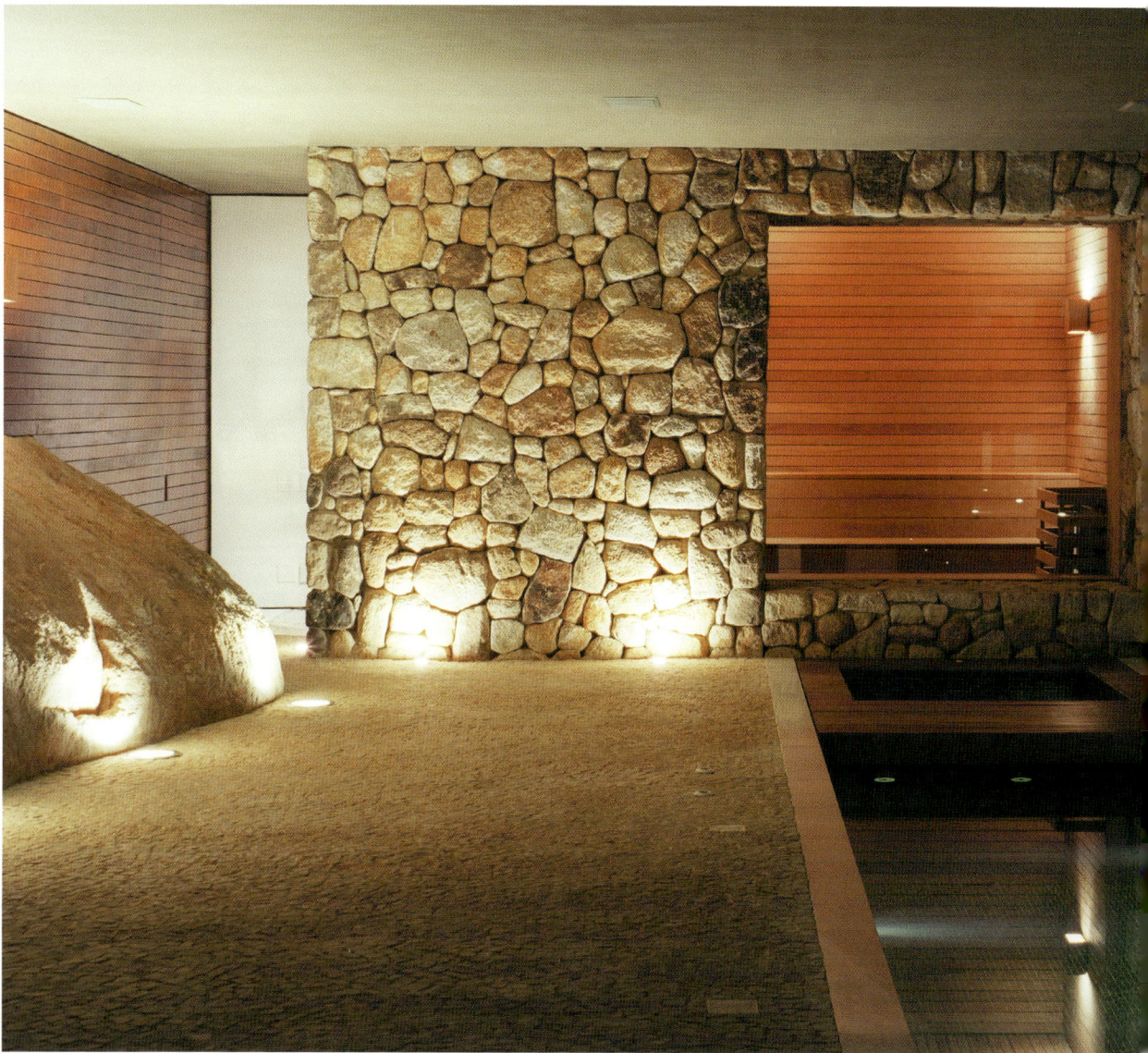

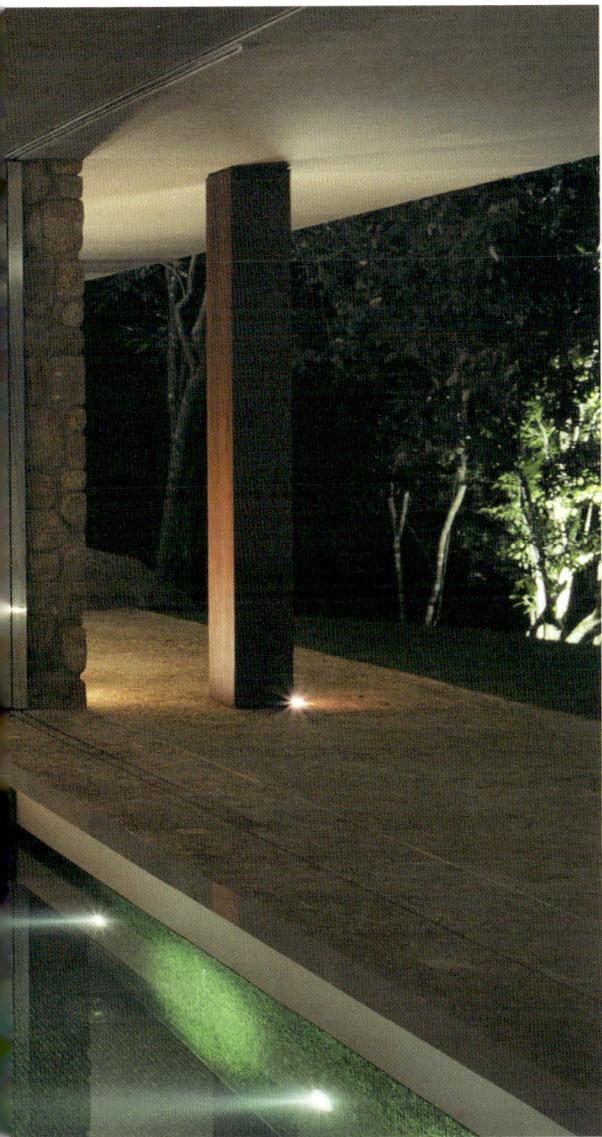

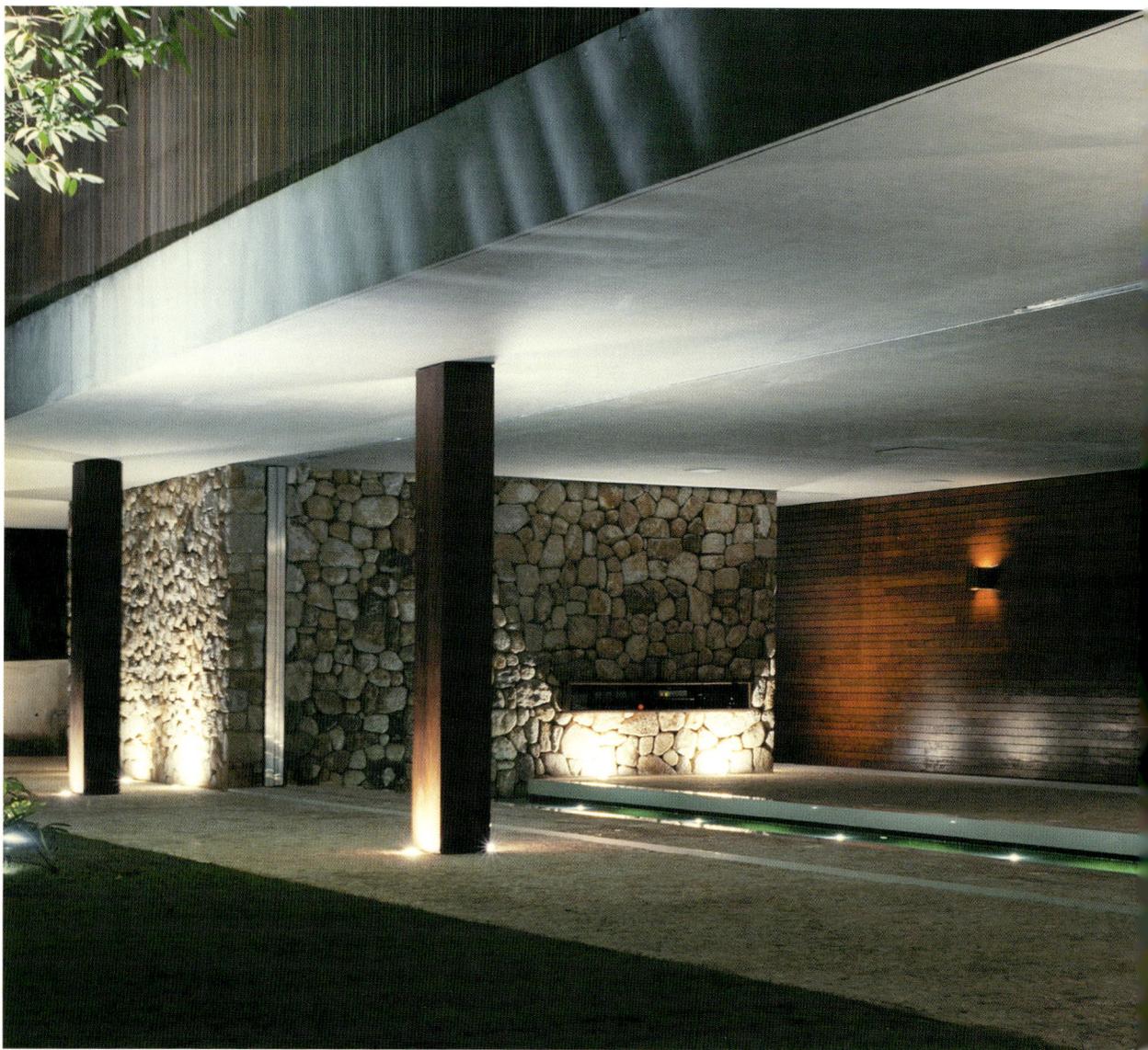

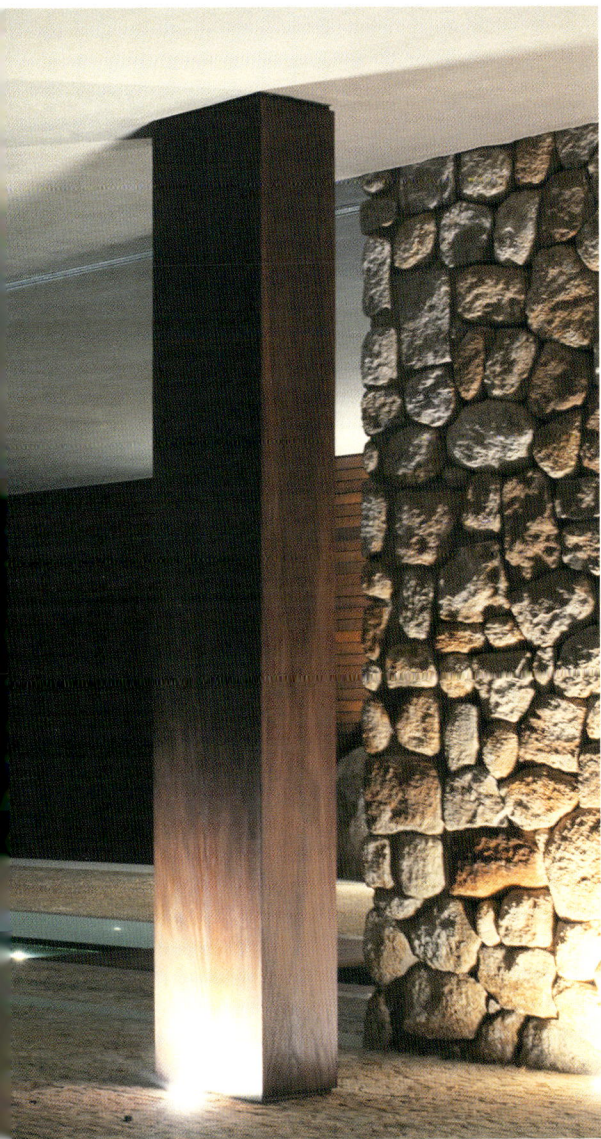

Pichler & Traupmann Architekten | Vienna, Austria
House Hofbauer
Vienna, Austria | 2001

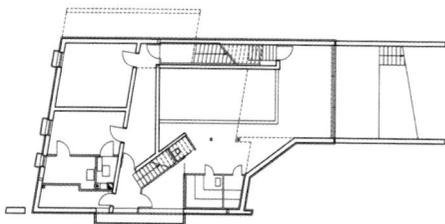

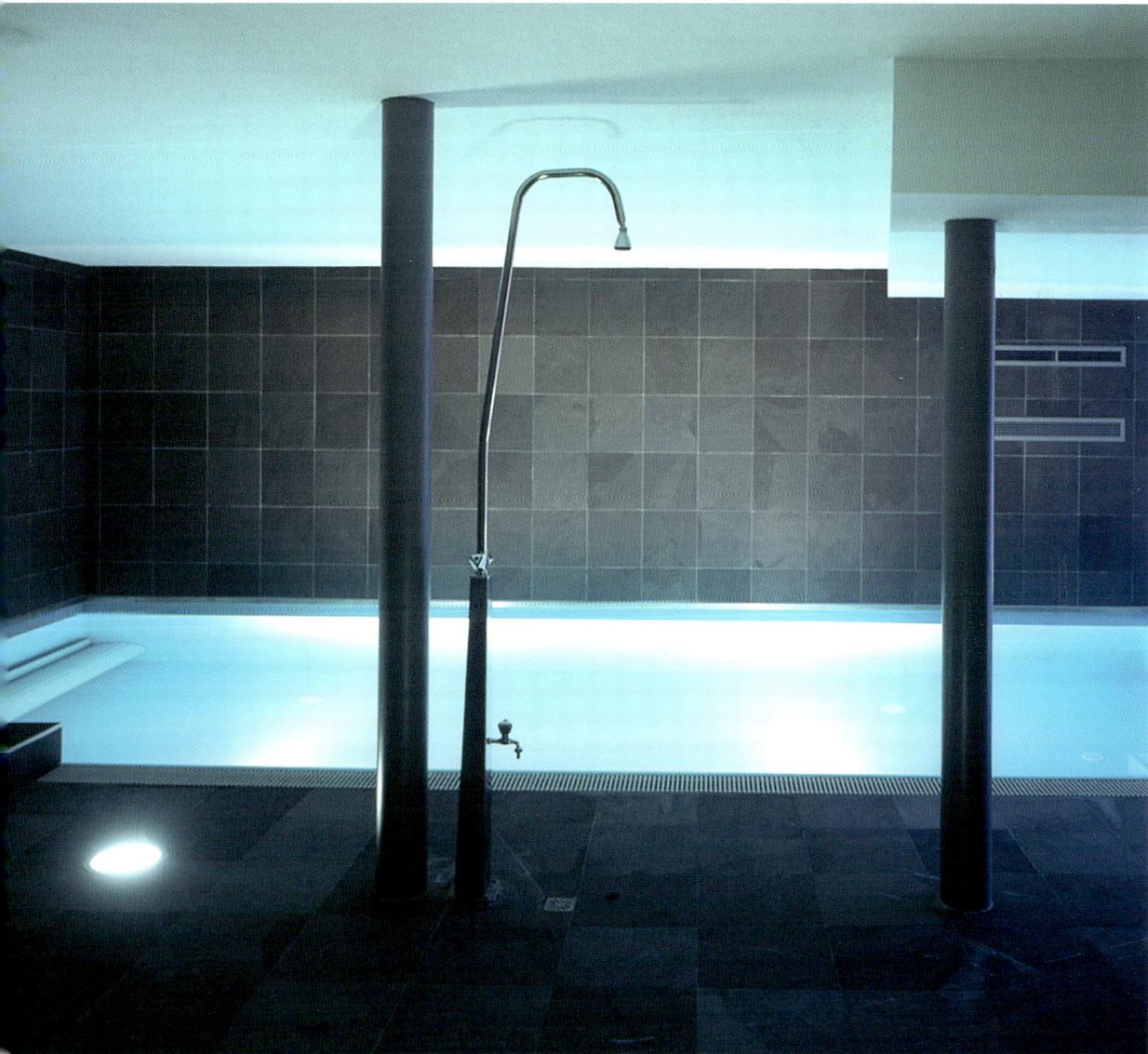

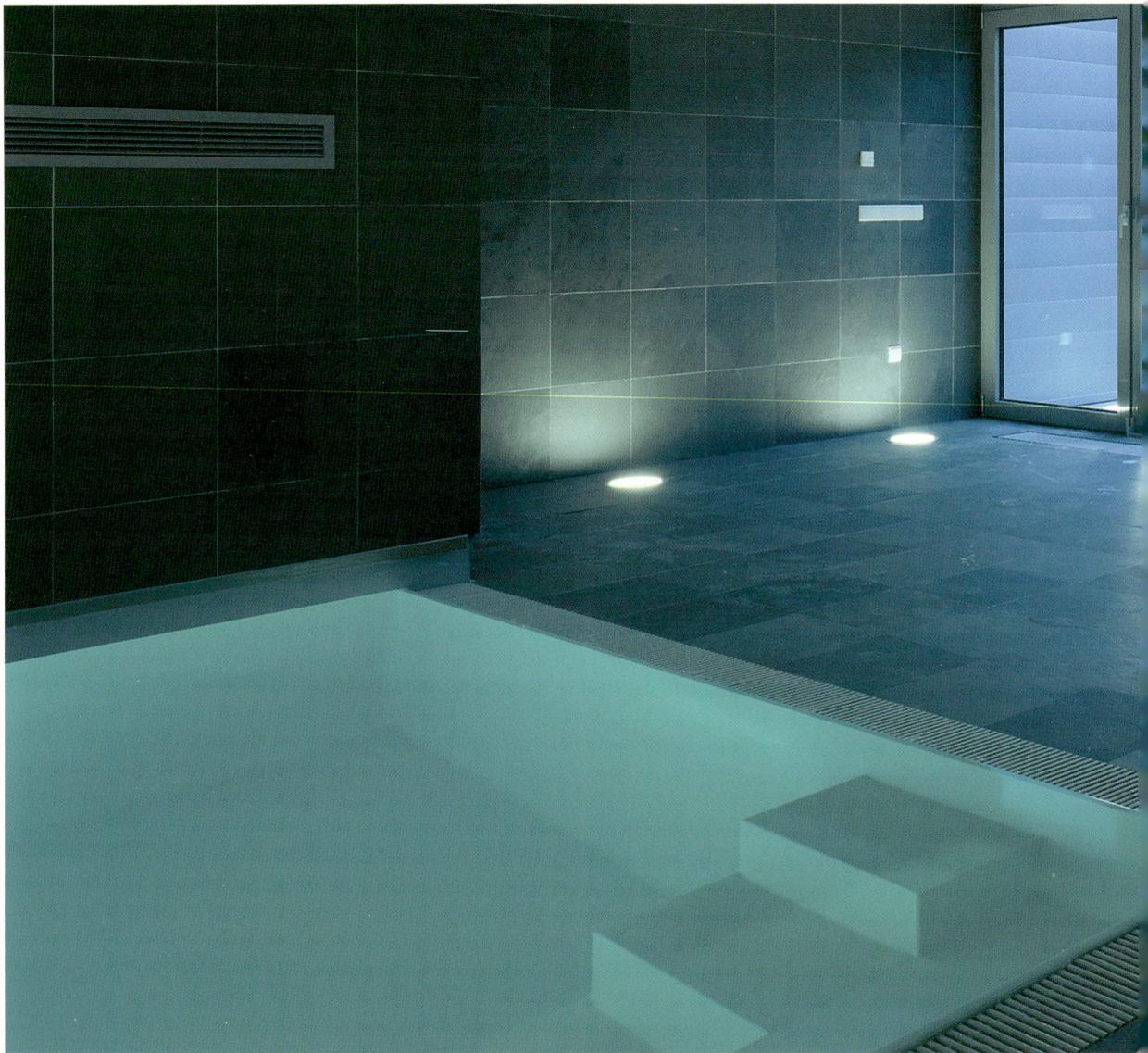

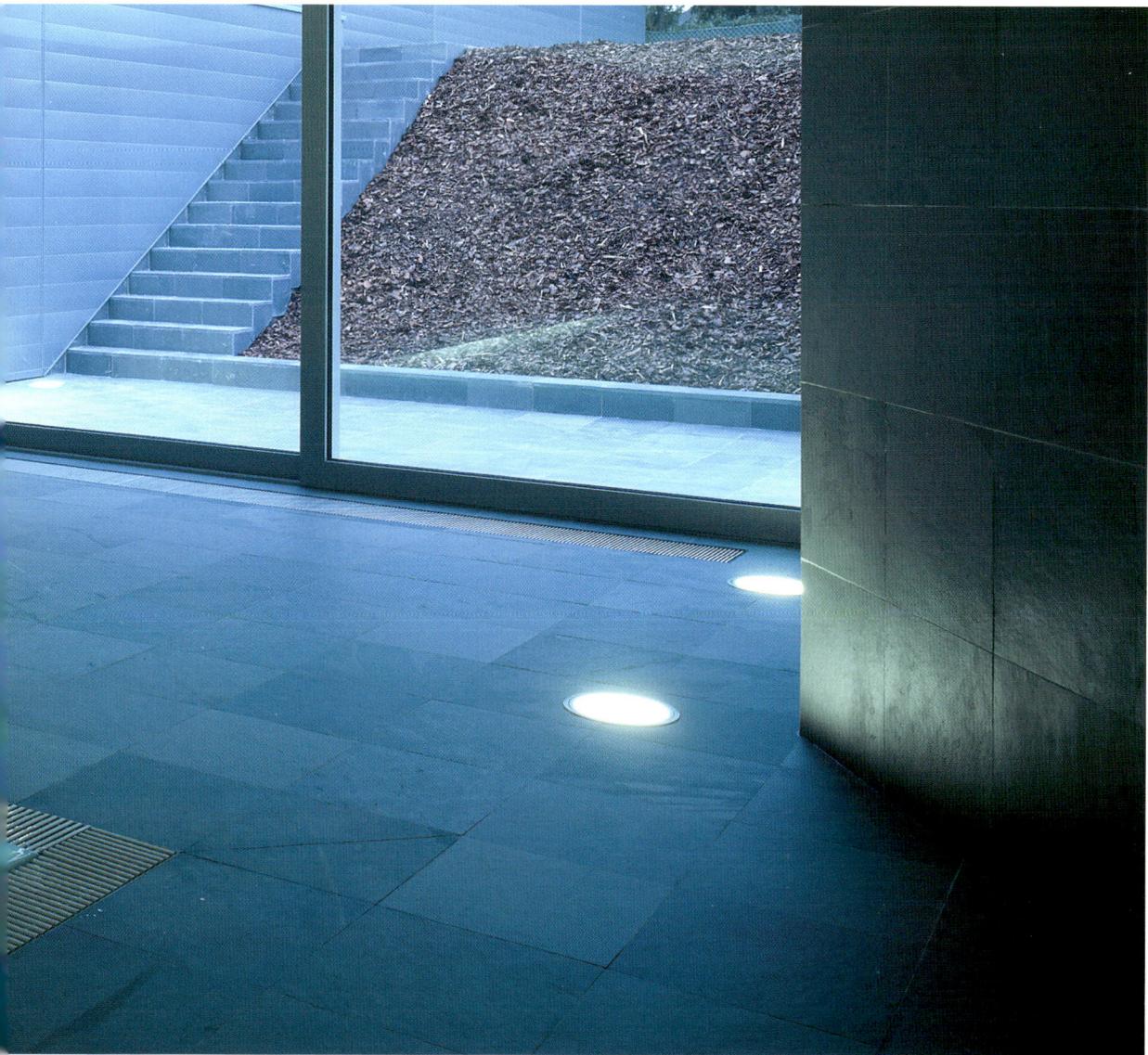

Ramon Esteve Estudio de Arquitectura | Valencia, Spain
Family House
Valencia, Spain | 2000

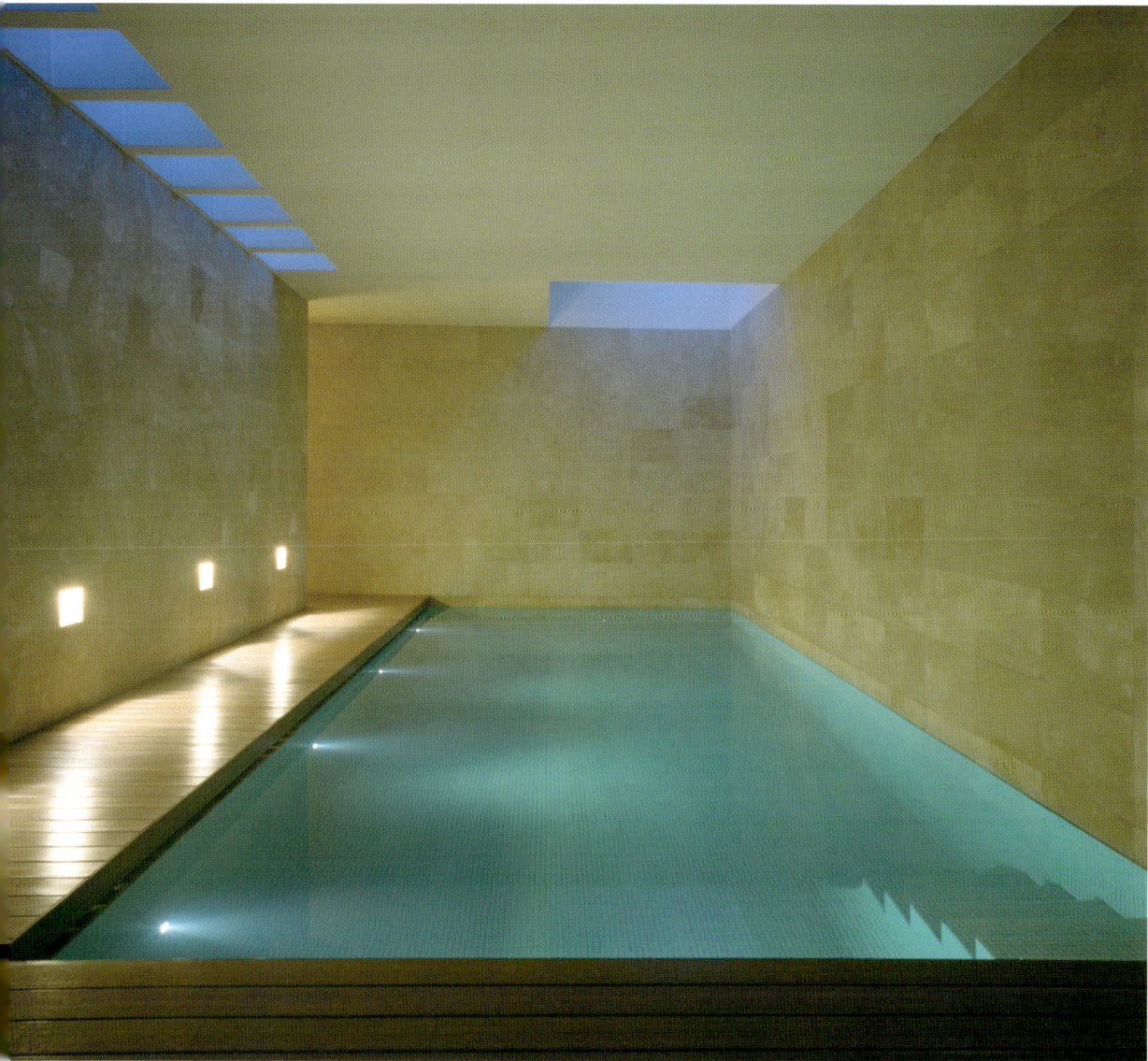

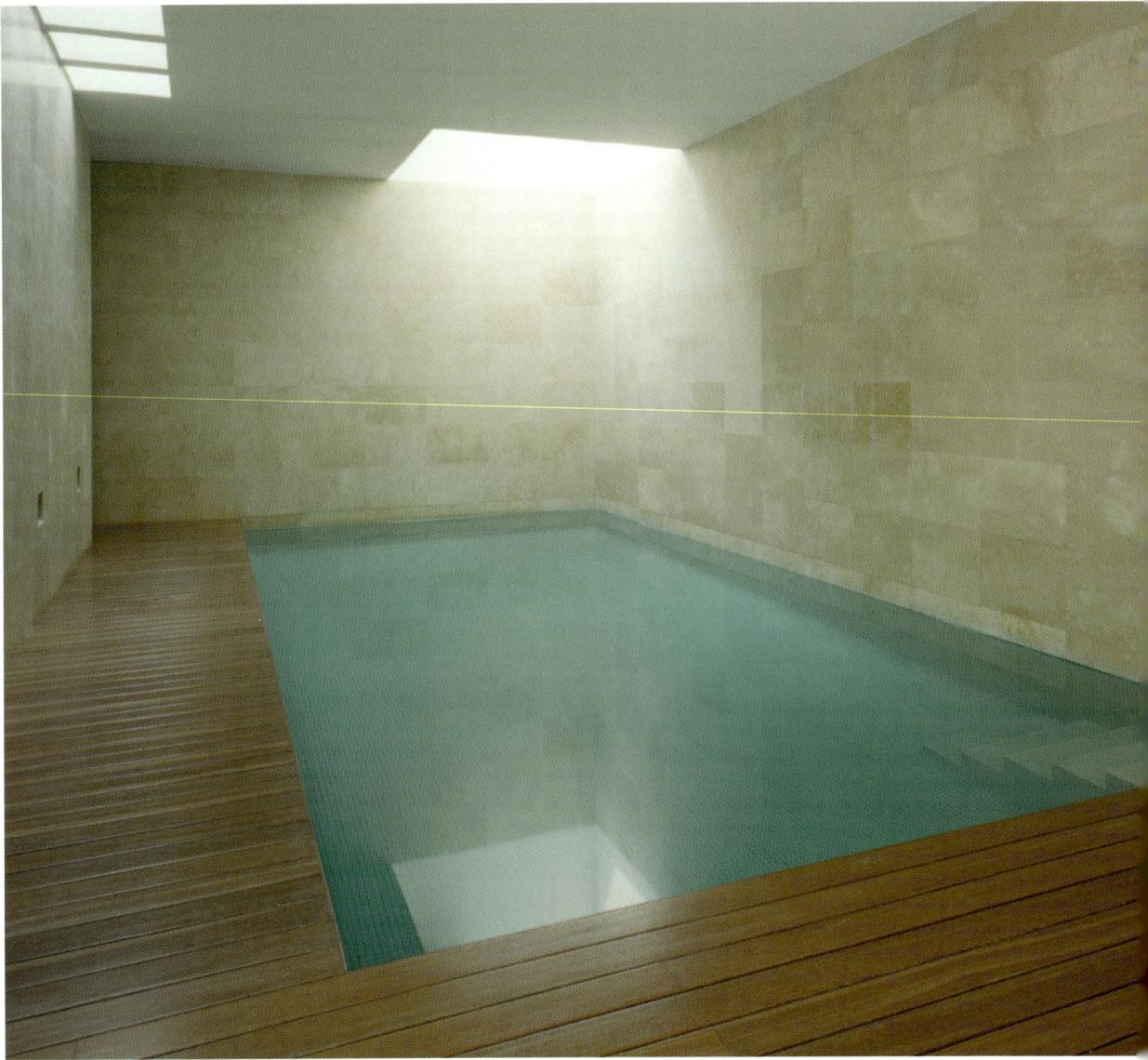

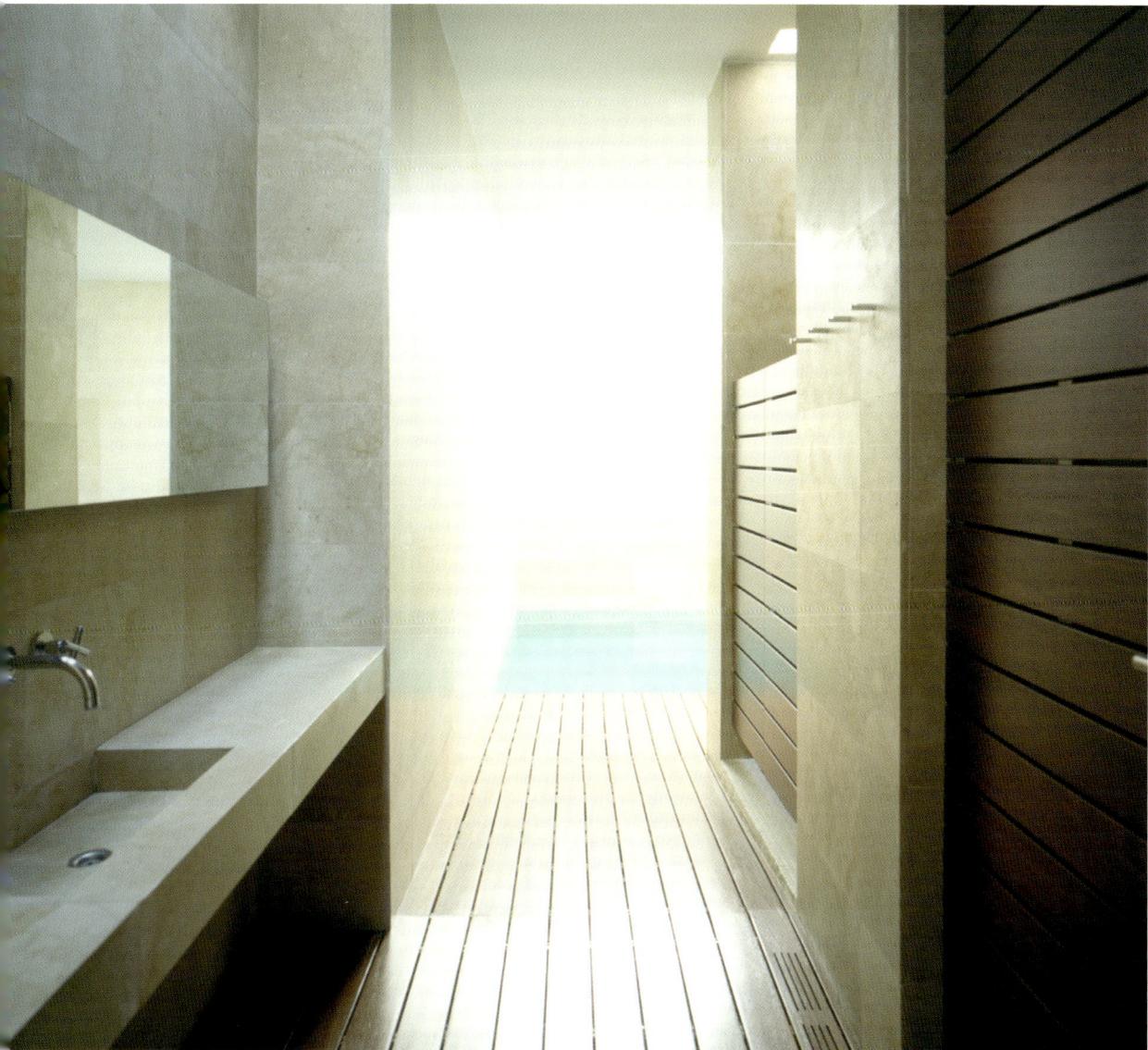

Smith Caradoc Hodgking Architects | London, UK
St. Saviours Pool
London, UK | 2001

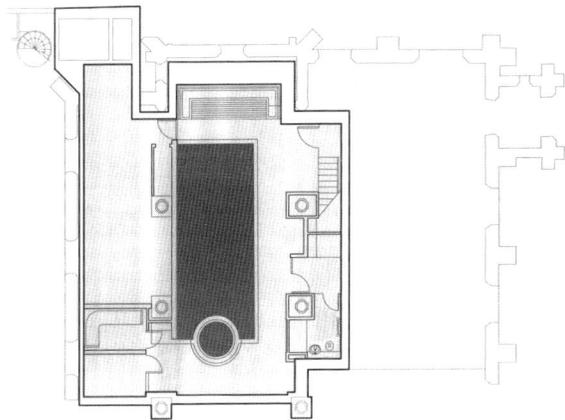

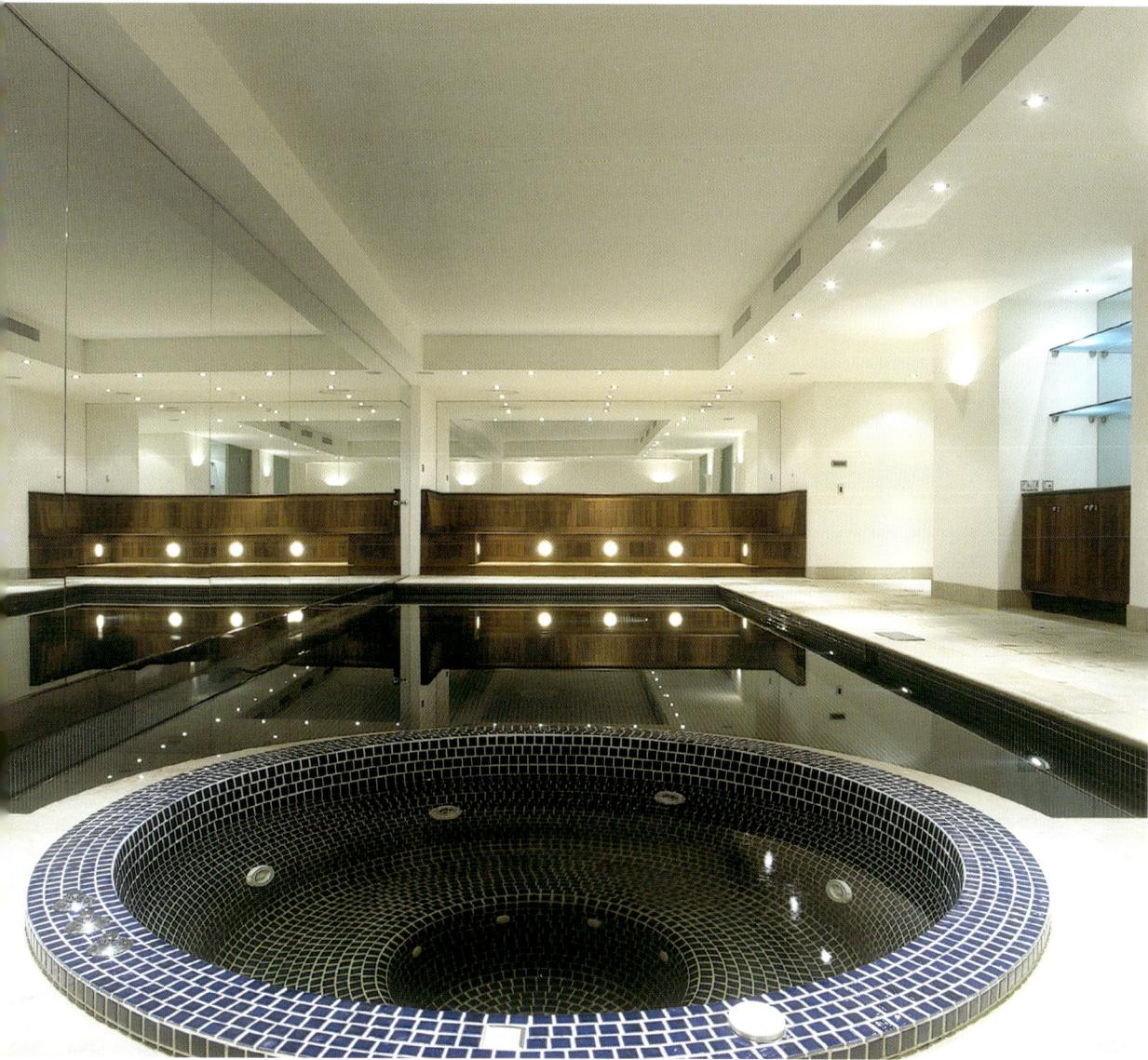

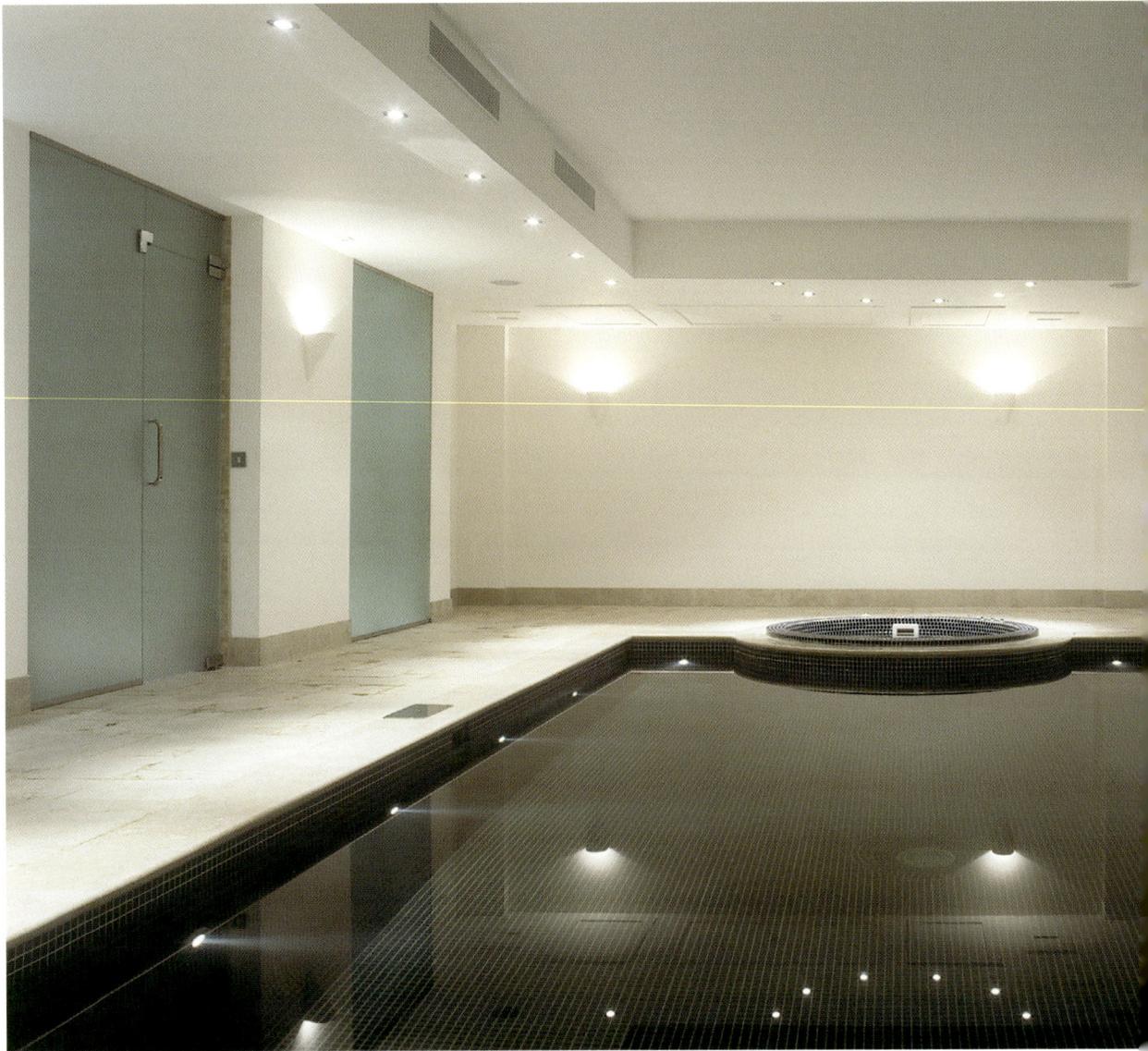

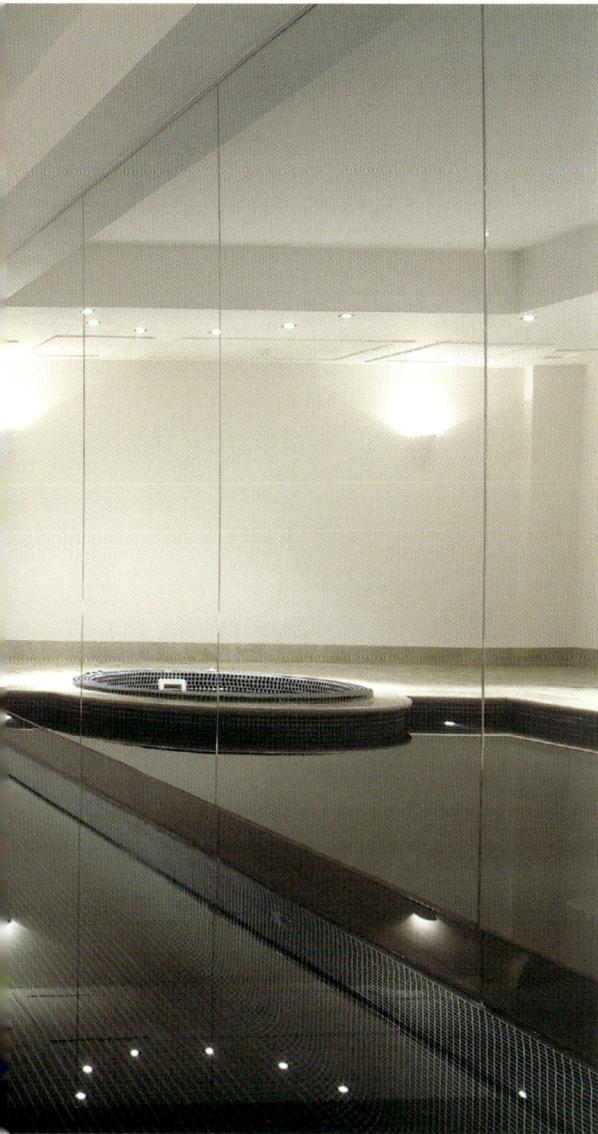

Uwe Bernd Friedemann | Cologne, Germany
Villa Cologne
Cologne, Germany | 2001-2003

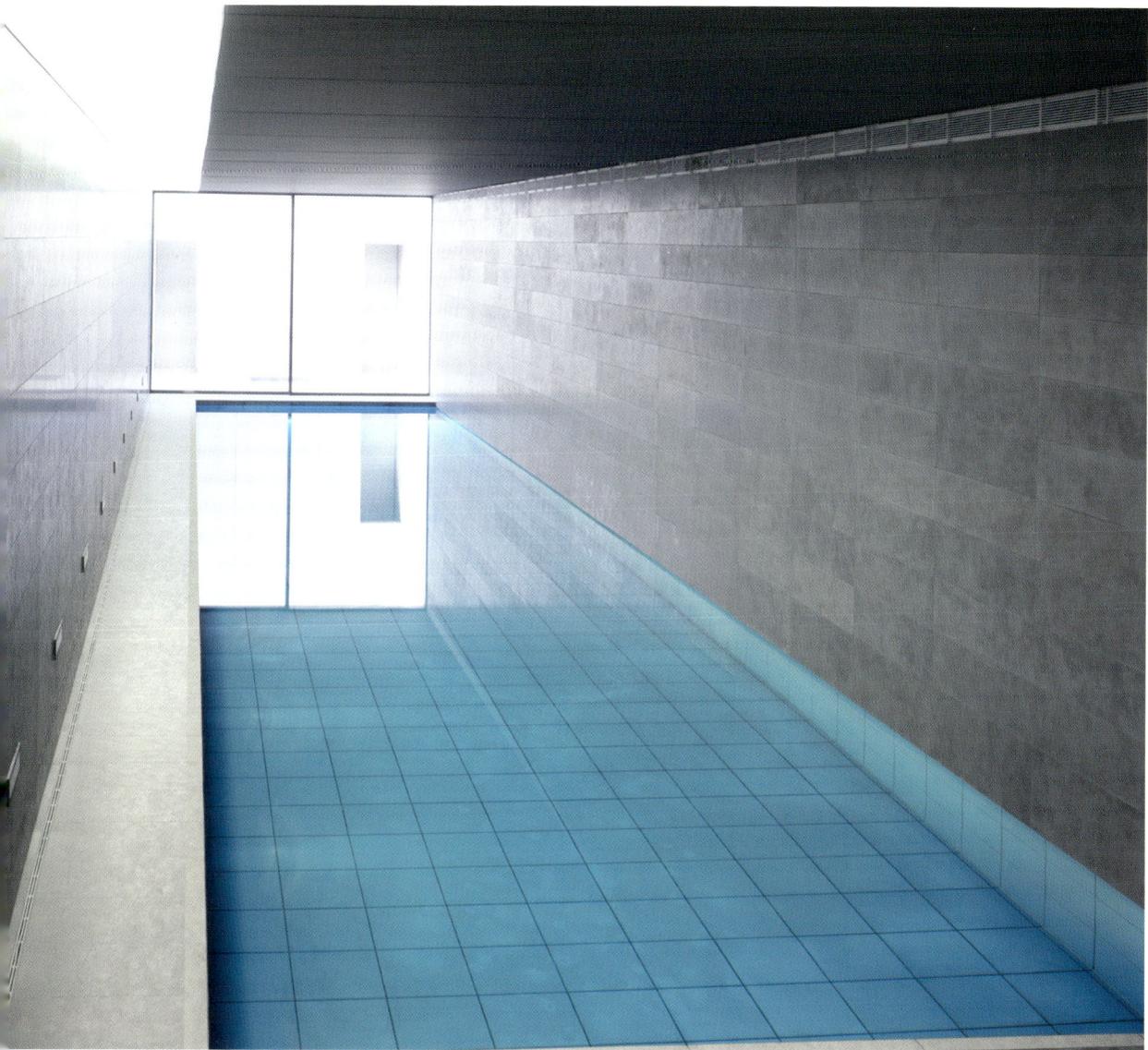

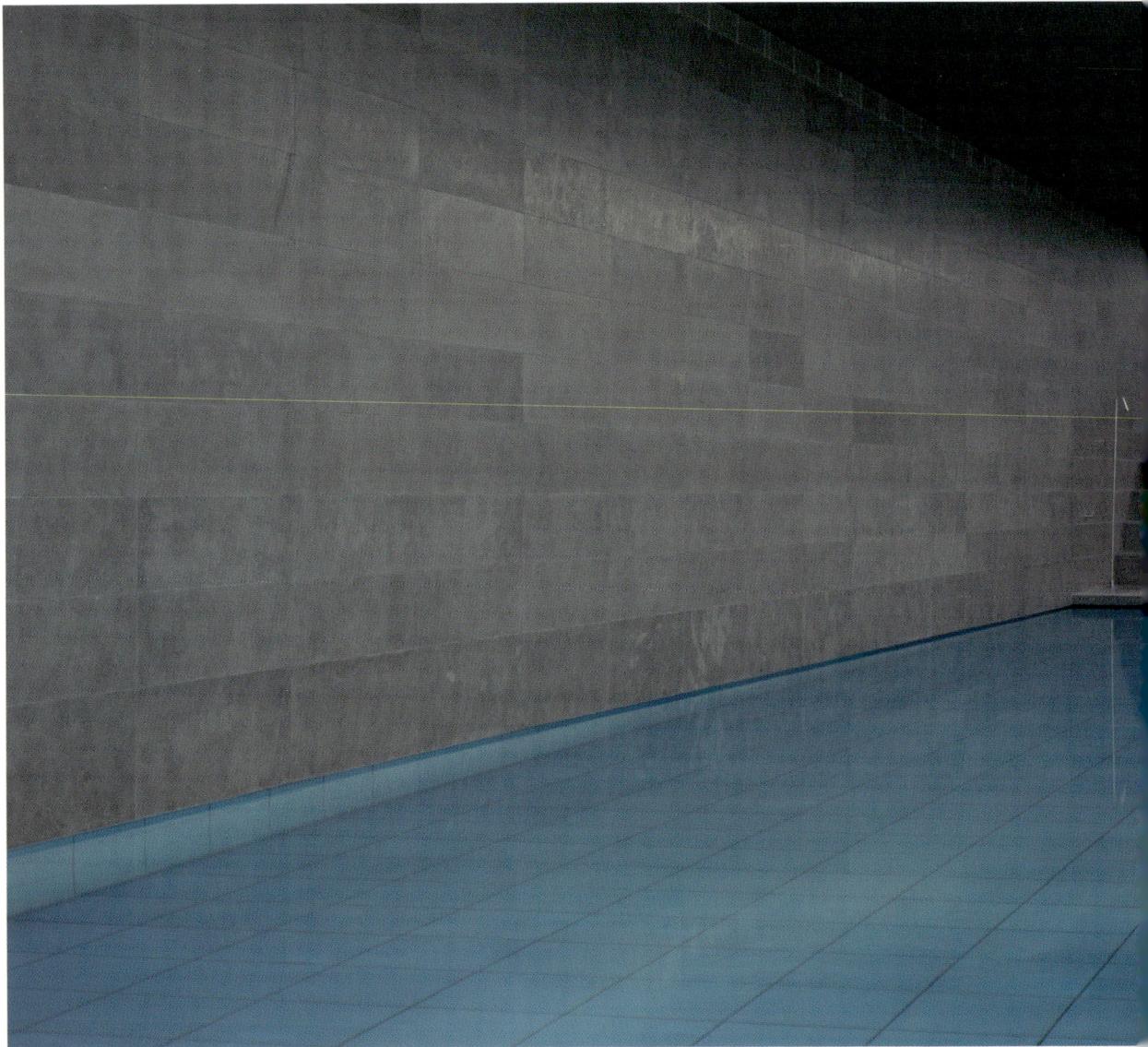

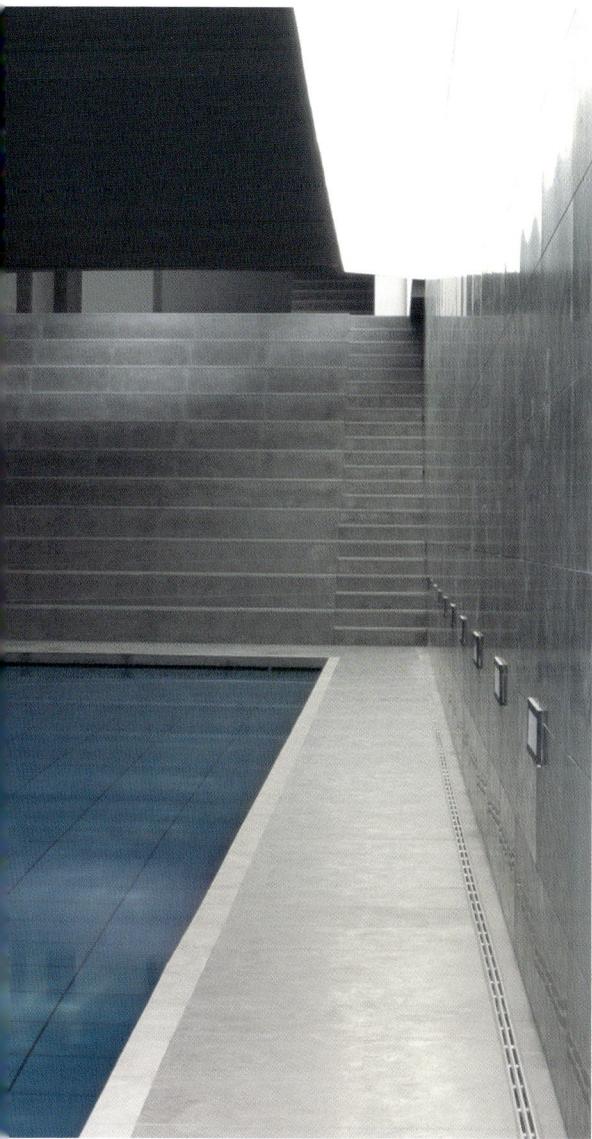

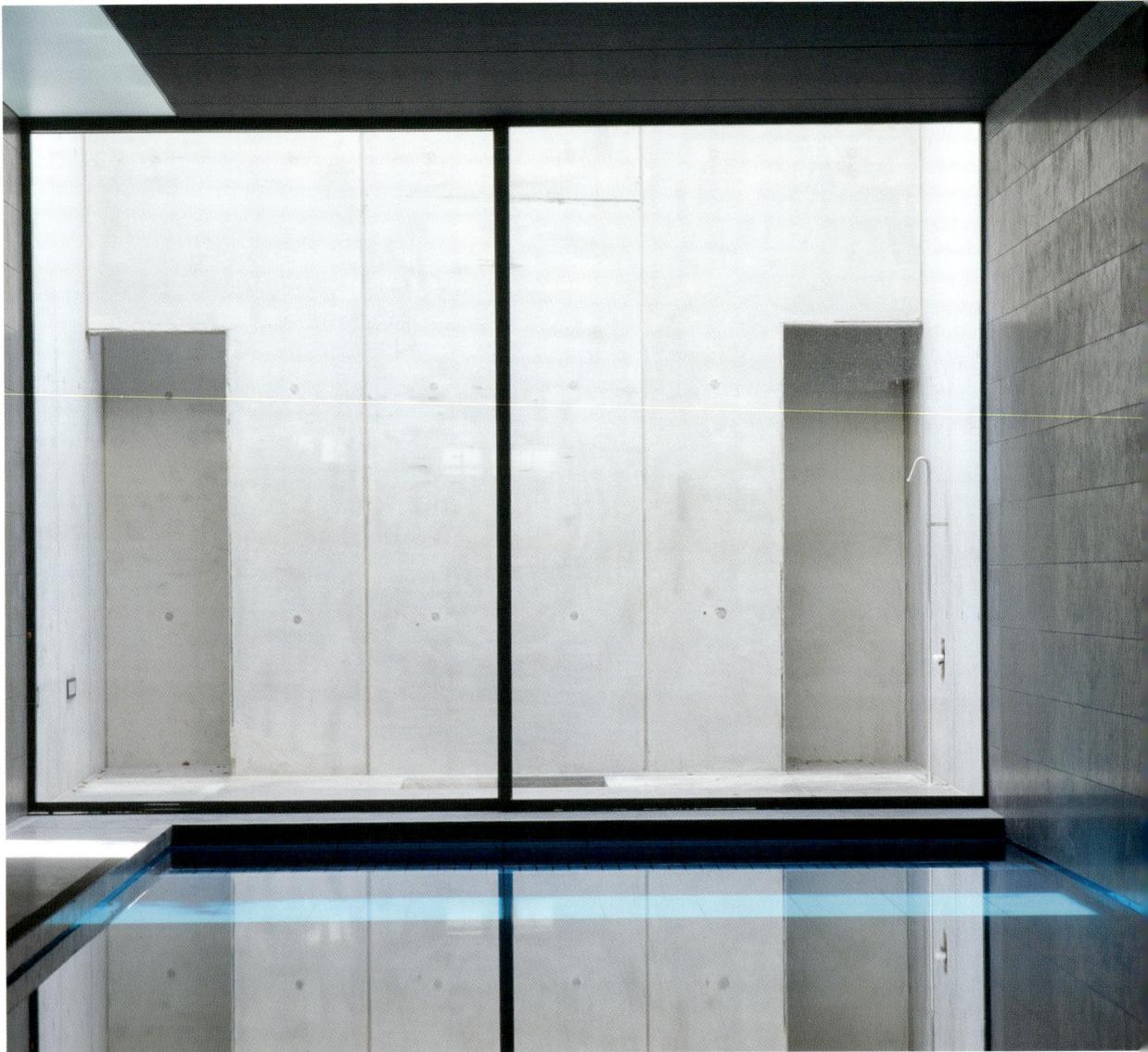

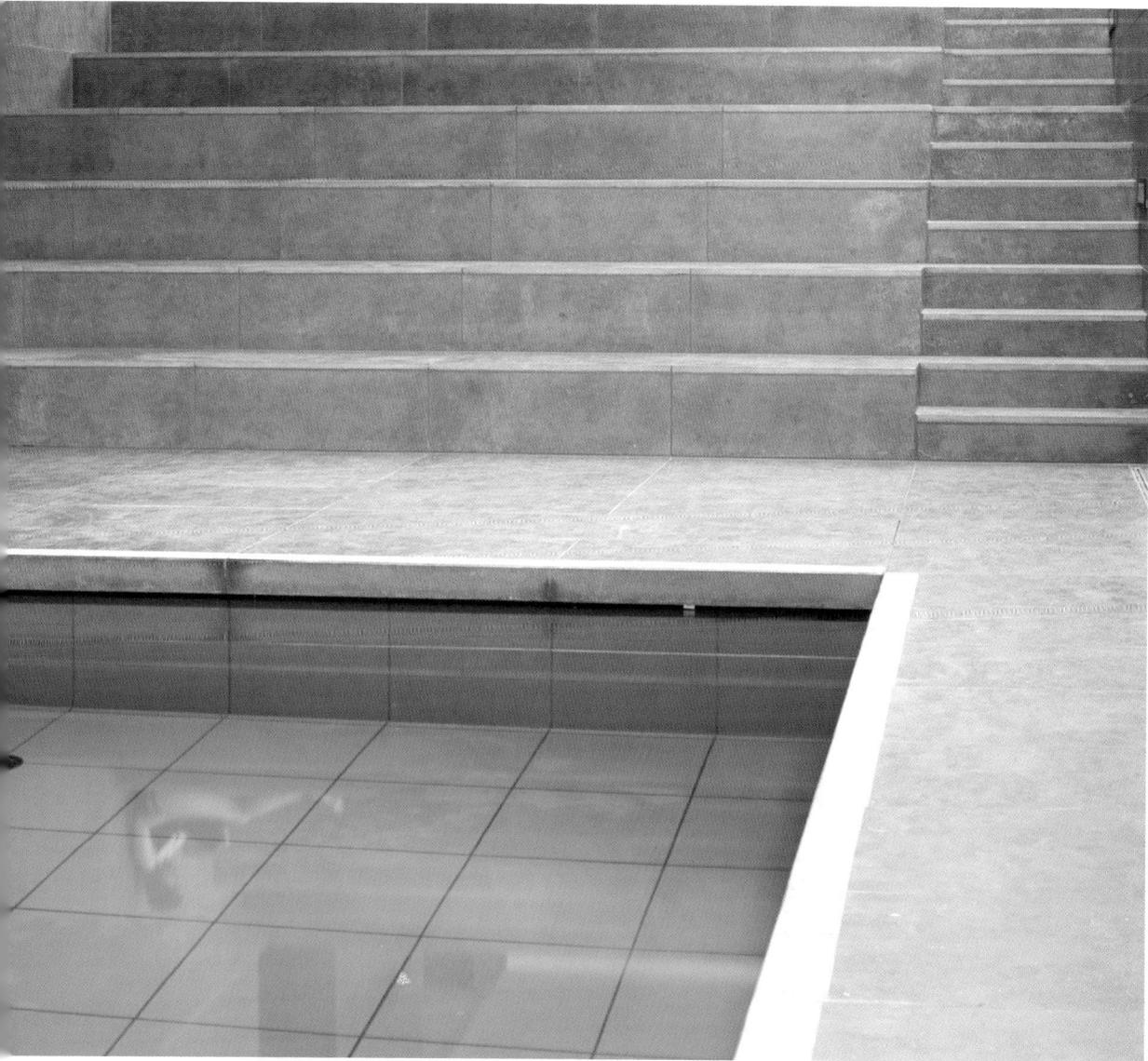

Vicens & Ramos Estudio de Arquitectura | Madrid, Spain
Las Encinas House
Pozuelo de Alarcón, Madrid, Spain | 2003

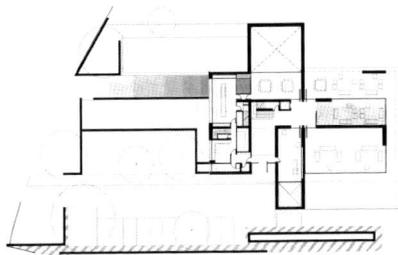

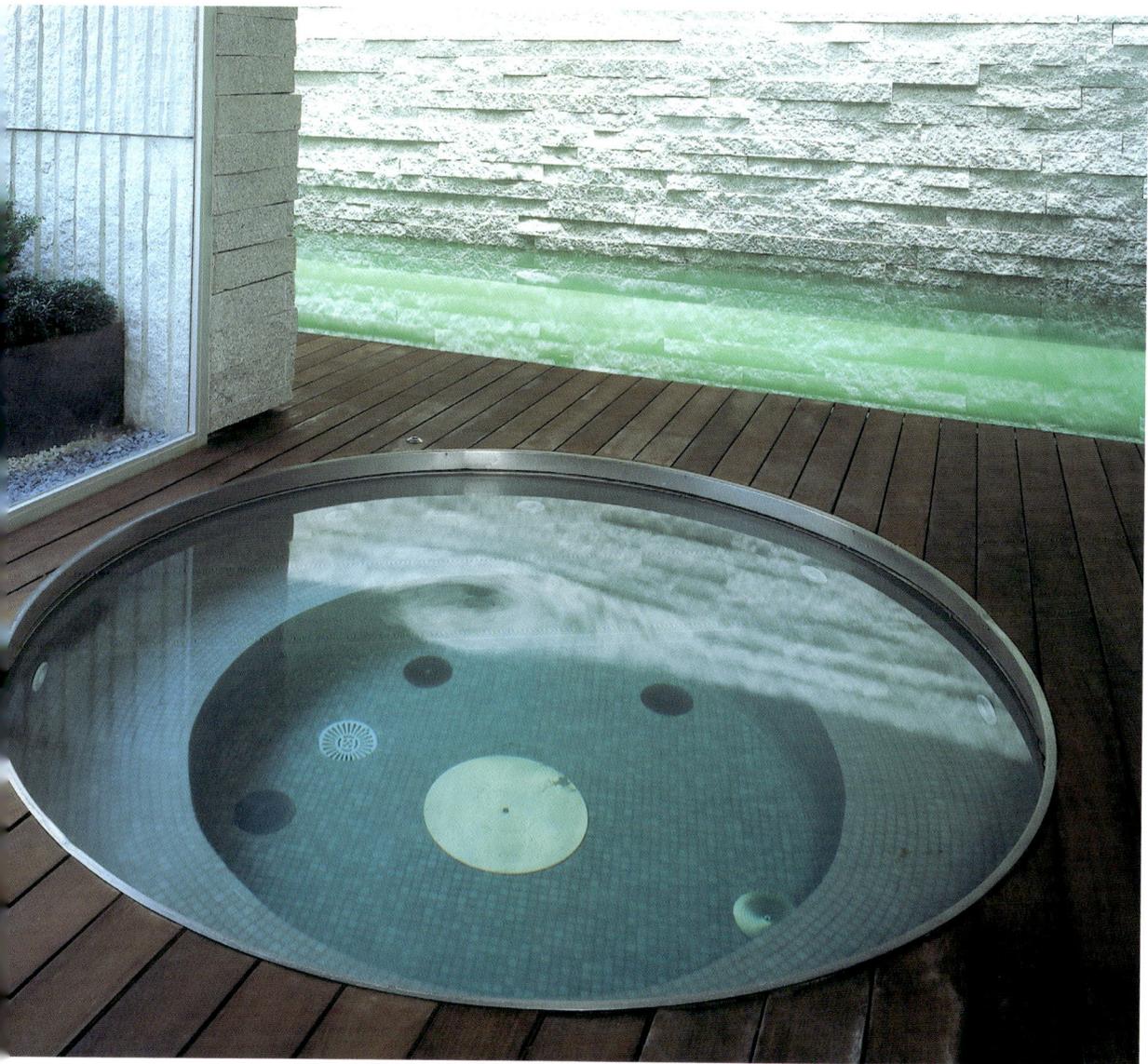

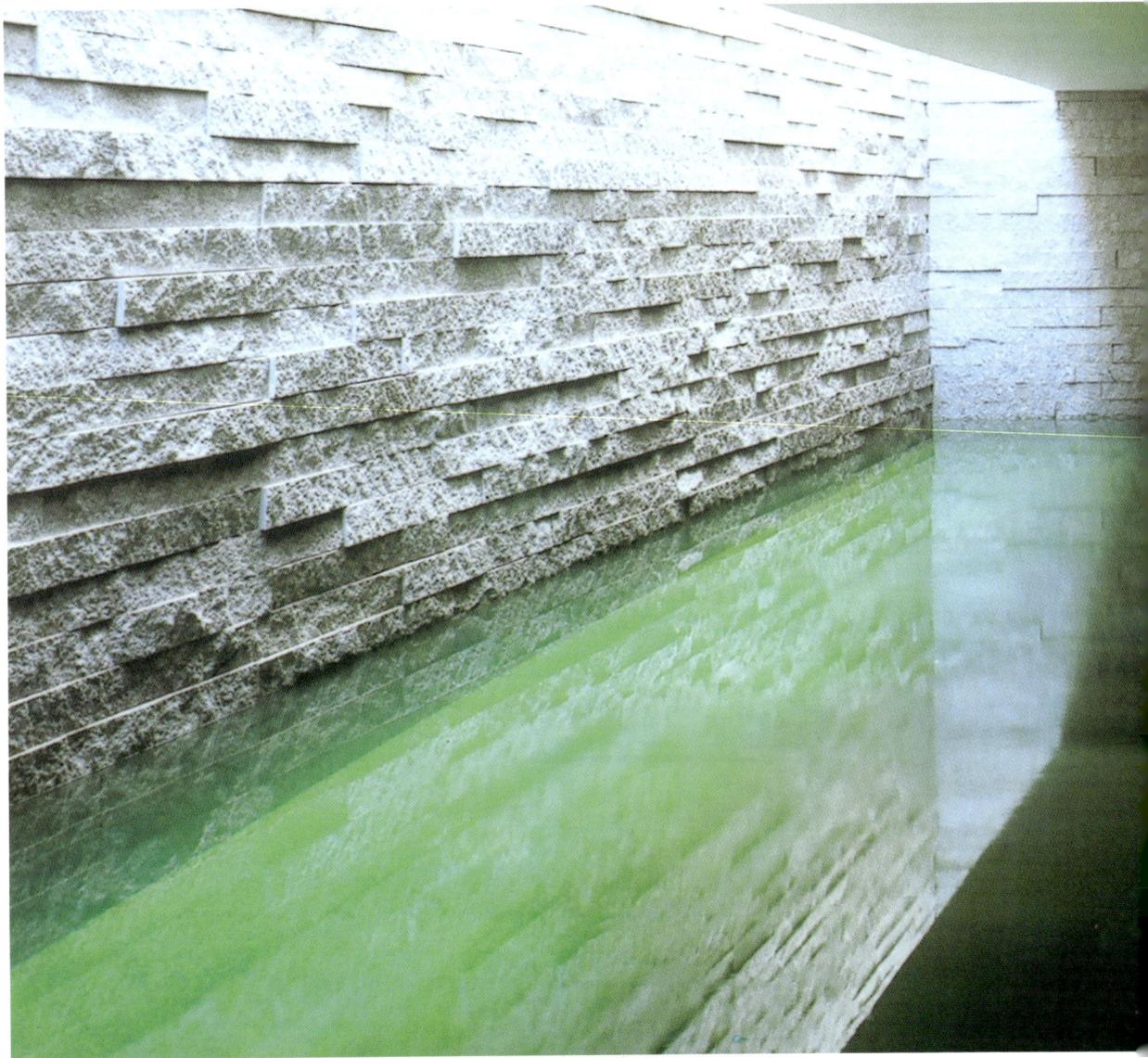

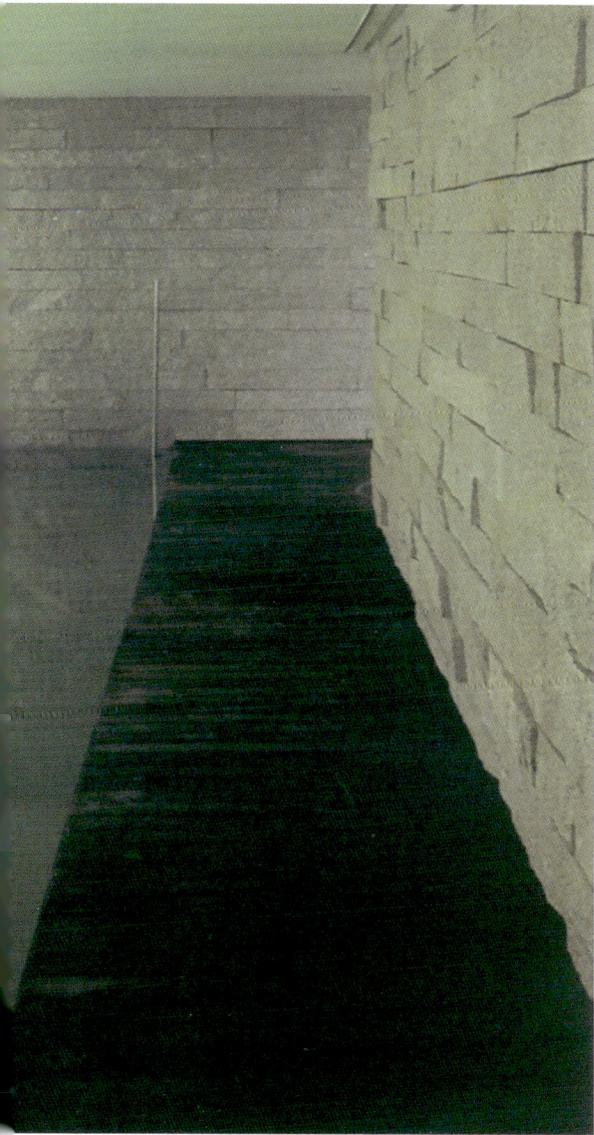

Wood & Zapata/Carlos Zapata | New York, USA
Klein House
Miraville, Ecuador | 2002

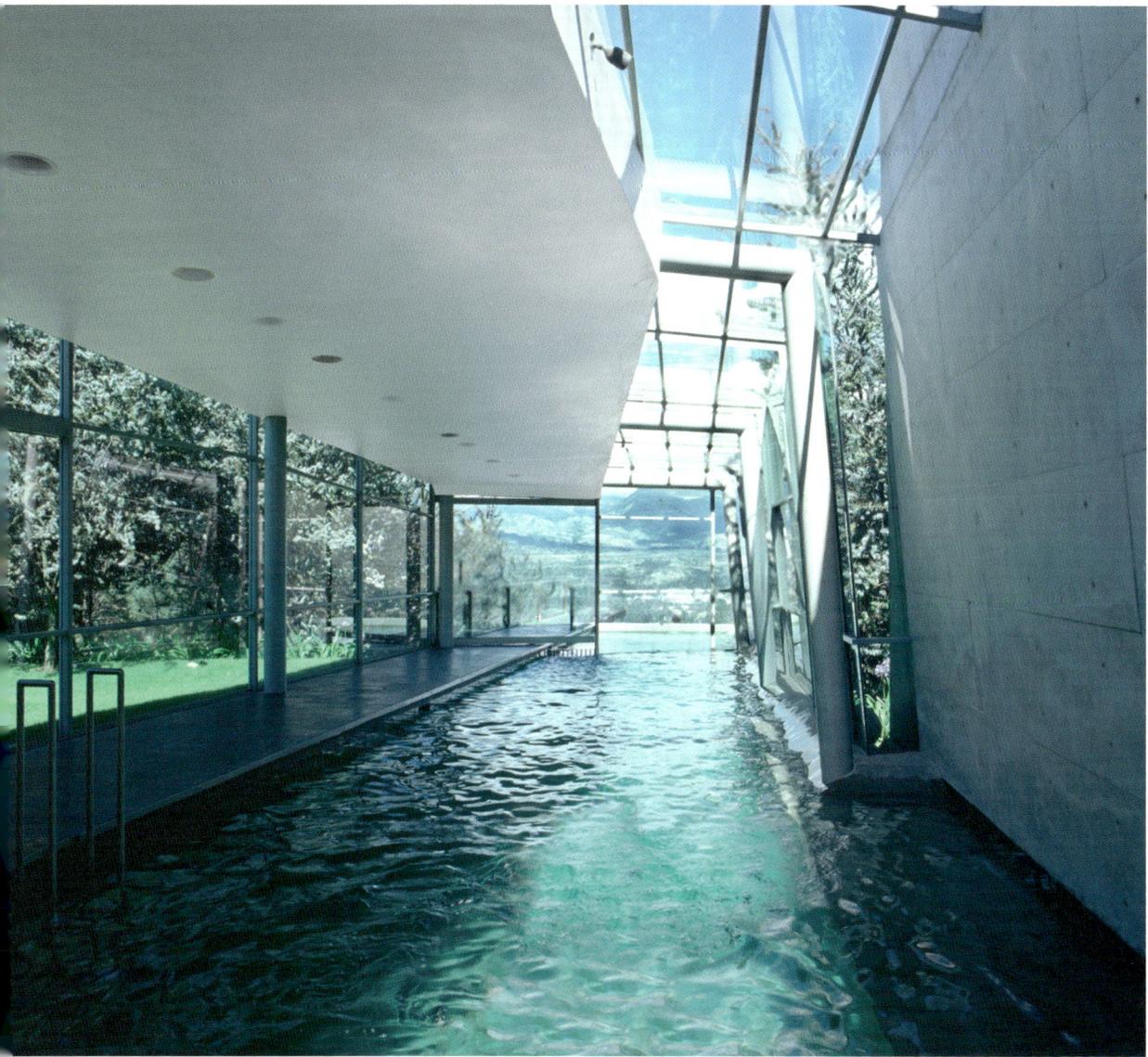

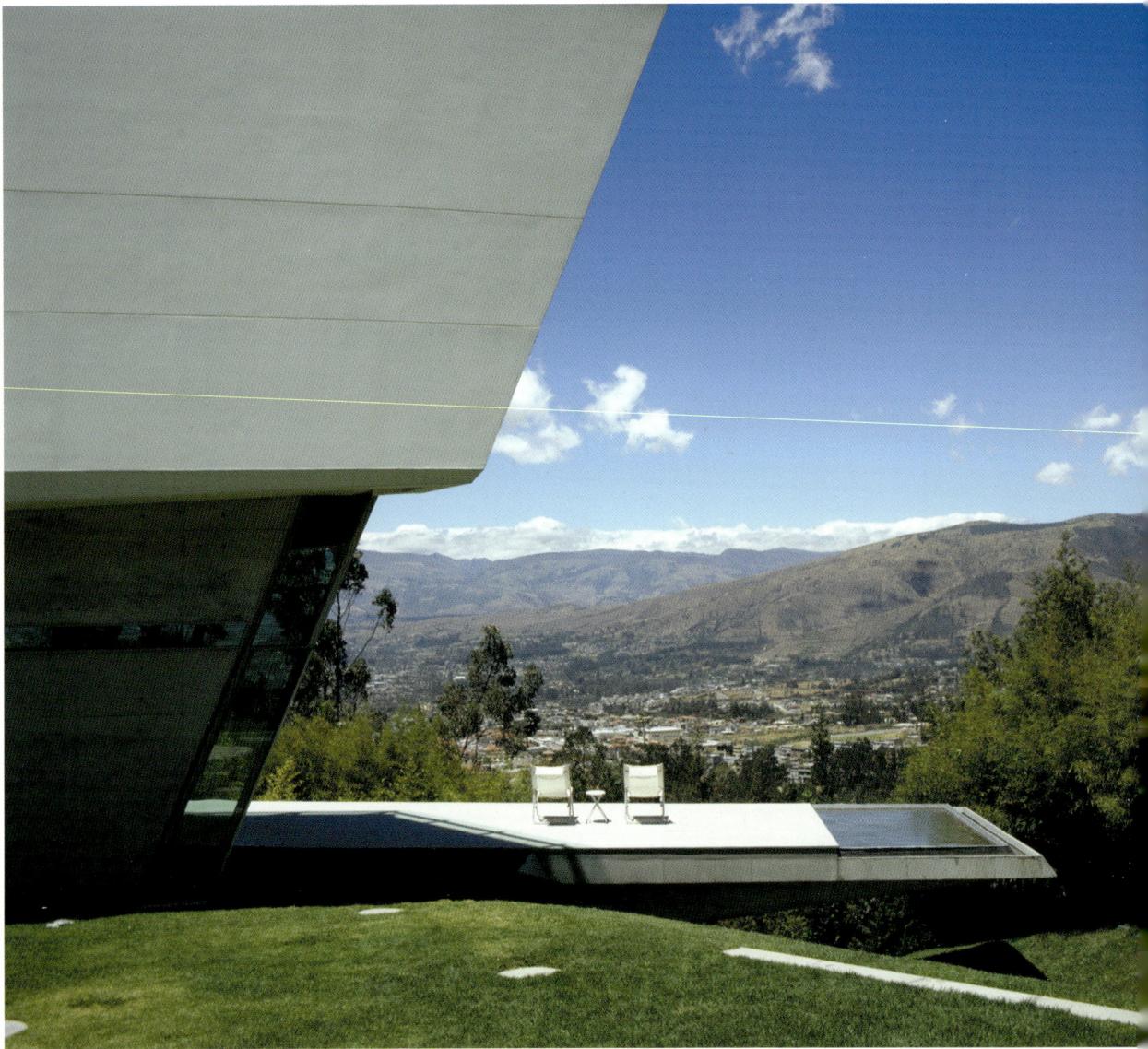

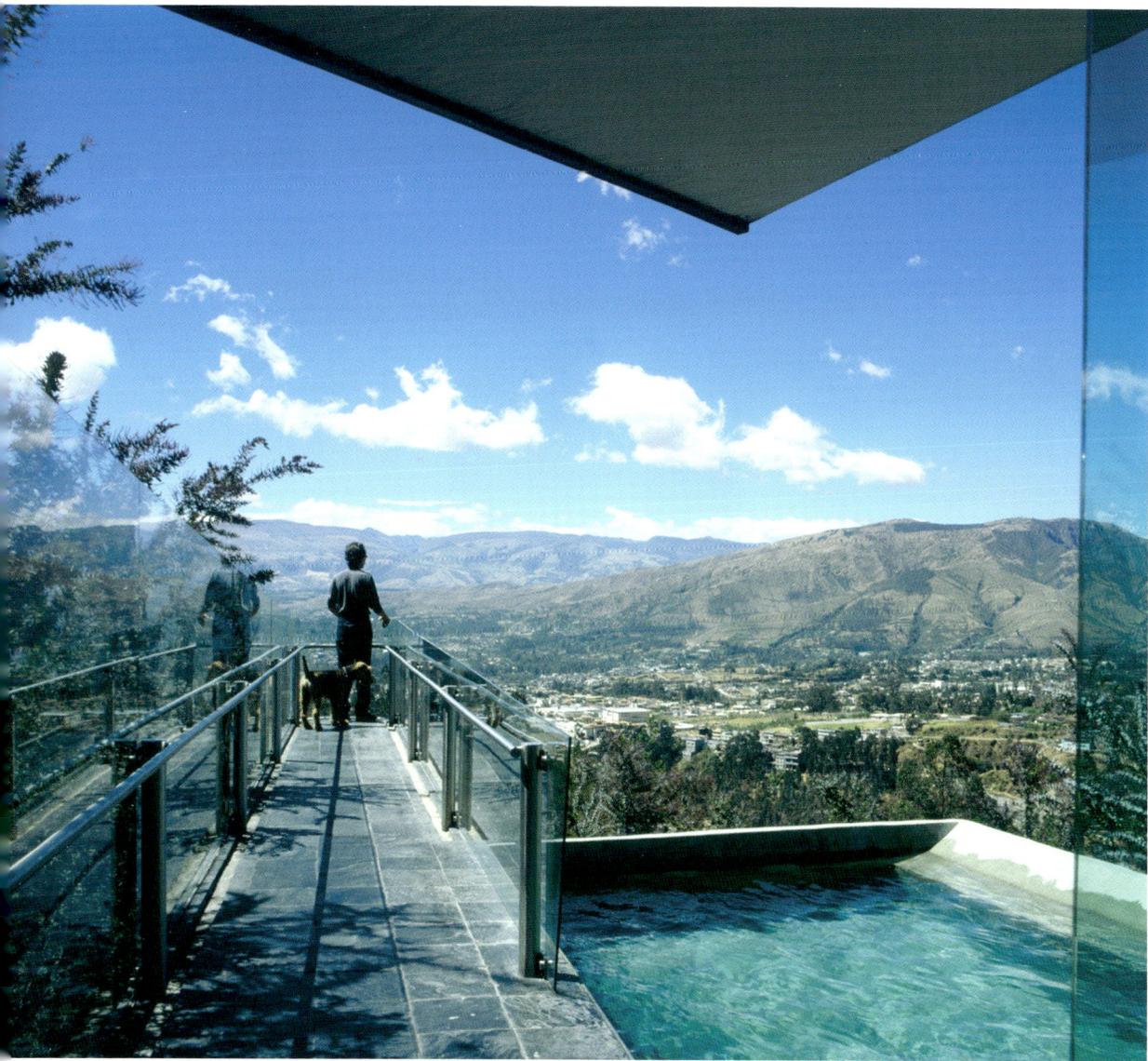

A-Cero Estudio de Arquitectura y Urbanismo S. L.
Falperra 7 bajos 15005 A Coruña, Spain
P +34 981 154 178
F +34 981 154 565
Arriaza, 6 bajos 28008 Madrid, Spain
P +34 915 489 656
F +34 915 489 657
www.a-cero.com
House in Madrid
Photos: © Hisao Suzuki

A-LDK–Anabela Leitao, Daiji Kondo
Rua Luís Fernández 20, 4 Esq. 200-244 Lisbon, Portugal
P / F +351 91 408 0177
www.a-ldk-studio.com
daiji.kondo@mail.telepac.pt
Beloura House
Photos: © Rui Morais de Sousa

Alonso Balaguer y Arquitectos Asociados
Bac de Roda 40 08019 Barcelona, Spain
P +34 933 034 160
F +34 933 034 161
www.alonsobalaguer.com
Modernist House
Musitu Residence
Photos: © Pere Peris

Álvaro Siza
Rua do Aleixo 53-2 4150-043 Porto, Portugal
P +351 22 616 7270
F +351 22 616 7279
www.alvarosiza.com
Quinta Santo Ovidio
Photos: © Luis Ferreira Alves

Architectenbureau Paul de Ruiter bv
Leidsestraat 8-10 NL-1017 PA Amsterdam, Netherlands
P +31 20 626 32 44
F +31 20 623 70 02
www.paulderuiter.nl
info@paulderuiter.nl
Villa Deys
Photos: © Rien van Rijthoven

Architektur Consult ZT GmbH
Körblergasse 100 A-8010 Graz, Austria
P +43 316 32 31 00 0
F +43 316 32 31 00 30
www.eisenkoeck.com
office@archconsult.com
Pool Lannach
Photos: © Paul Ott

Arthur Casas Arquitetura e Design
Rua Capiravi 160 01246-020 São Paulo, Brazil
P +55 113 664 7700
F +55 113 663 6540
www.arthurcasas.com.br
casas@arthurcasas.com.br
P. M. Home
Photos: © Tuca Reines

Atonis Stasinopoulos
10 Angelikis Chatzimichali Str. Plaka 10558 Athens, Greece
P +30 210 347 3259
antstas@otonet.gr
House Galani
House Nikolakopoulou
House Symeonidi
Photos: © B@W Art Studio Athens

bammp
Del Vall 59 08221 Terrassa, Barcelona, Spain
P +34 937 332 973
F +34 937 331 912
www.bammp.com
bcsl@bammp.com
Xiol House
Photos: © Miquel Tres

Caña y Caña
Florida 6-8 08120 La Llagosta, Barcelona, Spain
Lloreda House
Photos: © Thomas Wagner

Carlo Donati
Viale Monte Grapa 6 20124 Milan, Italy
P/F +39 0229 00 61 38
www.carlodonati.it
carlodon@tiscall.it
Casa a Patio
Loft A
Photos: © Matteo Piazza

Comercial Blautec S. L.
Lecco 9 08700 Igualada, Barcelona, Spain
www.blautec.com
info@blautec.com
ArcsLlacuna
Photos: © Comercial Blautec S. L.

Corsin S. L. (Coordinación de Servicios Inmobiliarios)
Paseo de l'Esquirol 10 43008 Tarragona, Spain
P +34 977 658 065
M +34 629 333 290
corsin@gmail.com
House in Cala Tamarit
Photos: © Jordi Miralles

De Vita e Fici Architetti Associati
Via Fra' Giovanni Angelico 71 50121 Florence, Italy
P/F +39 0552 47 74 64
www.devitaefici.it
info@devitaefici.it
Old Glasshouse
Photos: © De Vita e Fici Architetti Associati

Donald Billinkoff Architects
310 Riverside Drive Suite 202-1
New York, NY 10025 USA
P +1 212 678 7755
F +1 212 678 7743
www.billinkoff.com
dba@billinkoff.com
Old Branchville Road
Photos: © Elliot Kaufmann

Espinet & Ubach Arquitectes i Associats S. L.
Camp 63 08022 Barcelona, Spain
P +34 934 187 833
F +34 934 172 122
www.espinet-ubach.com
espinet-ubach@espinet-ubach.com
V House
Photos: © Joan Mundó

Estudi PSP Arquitectura
Roca i Batlle 30 planta Pasaje 08023 Barcelona, Spain
P +34 934 181 999
F +34 934 184 900
www.estudipsp.com
estudi@estudipsp.com
House in Les Corts
Photos: © Estudi PSP Arquitectura

Estudio de Arquitectura Mangado y Asociados

Vuelta del Castillo 5 ático 31007 Pamplona, Spain

P +34 948 276 202

F +34 948 176 505

www.fmangado.com

House in Gorraiz

Photos: © Roland Halbe / Artur

Guilhem Roustan

22 rue de la Folie Méricourt 75011 Paris, France

P +33 014 355 8004

F +33 014 021 6914

www.roustanarchitecture.com

gr@roustanarchitecture.com

Levallois Pool

Photos: © Daniel Moulinet

Habitación 8

Princesa 75 28008 Madrid, Spain

P +34 915 440 462

gonzaloconcheiro@habitacion8.co

Concheiro House

Photos: © Xurxo Lobato

Hariri Pontarini Architects

245 Davenport Road 3rd floor M5R 1K1 Toronto, Canada

P +416 929 4901

F +416 929 8924

www.hariripontarini.com

Art Collector's Residence

Photos: © Steven Evans Photography

Hertl Architekten ZT Keg

Zwischenbrücken 4 4400 Steyr, Austria

P +43 72 524 6944

F +43 72 524 7363

www.hertl-architekten.com

Pool am Hof

Photos: © Paul Ott, Graz

Herzog & De Meuron

Rheinschanze 6 CH-4056 Basel, Switzerland

P +41 61 385 5757

info@herzogdemeuron.com

Wohnhaus Ruff

Photos: © Manos Meise

KVA—Kennedy and Violich Architecture Ltd.

160 North Washington Street 8th floor

Boston, MA 02114, USA

P +1 617 367 3784

F +1 617 367 3727

www.kvarch.net

info@kvarkch.net

Residence and Gallery of Contemporary Art

Photos: © Undine Pröhl

LKD Concepts

Neuhausstrasse 3 6318 Zug, Switzerland

P / F +41 41 758 2249

House in Gordes

Photo: © Zapaimages / Reto Guntli

Manuel Serrano Arquitectos
Padilla 54 bis 28006 Madrid, Spain
P +34 913 093 635
F +34 913 093 633
serrano-arquitectos@serrano-arquitectos.e.telefonica.net
Loft
Photos: © Manuel Serrano

Marcio Kogan Architects
Al. Tietê 505 04616-001 São Paulo, Brazil
P +55 11 3081 3522
F +55 11 3063 3424
www.marciokogan.com.br
BR House
Photos: © Nelson Kon

Pichler & Traupmann Architekten
Kundmanngasse 39/12 1030 Vienna, Austria
P +43 1 713 32 03
F +43 1 713 32 03
www.pxt.at
office@pxt.at
House Hofbauer
Photos: © Rupert Steiner

Ramon Esteve Estudio de Arquitectura S. L.
Plaza Pere Borrego/Galindo 7 46003 Valencia, Spain
P +34 963 510 434
F +34 963 155 534
www.ramonesteve.com
media@ramonesteve.com
Family House
Photos: © Xavier Mollá

Smith Caradoc Hodgking Architects
43 Tanner Street London SE 1 3PL, United Kingdom
P +44 020 7407 0717
F +44 020 7407 0792
mail@sch-architects.com
St. Saviours Pool
Photos: © Carlos Domínguez

Uwe Bernd Friedemann
Rathenauplat 21 D50674 Cologne, Germany
P +49 221325883
www.uweberndfriedemann.de
UBF@UweBerndFriedemann.de
Villa Cologne
Photos: © Lukas Roth

Vicens & Ramos Estudio de Arquitectura
Barquillo 29 2.º izq. Madrid, Spain
P +34 915 210 004
vicensramos@arquired.es
Las Encinas House
Photos: © Eugeni Pons

Wood & Zapata
444 Brodway 3rd floor New York NY 10013, USA
P + 1 212 966 9292
F + 1 212 966 9242
www.cz-studio.com
mkoff@cz-studio.com
Klein House
Photos: © Undine Prohl

© 2006 daab
cologne london new york

published and distributed worldwide by
daab gmbh
friesenstr. 50
d - 50670 köln

p + 49 - 221 - 94 10 740
f + 49 - 221 - 94 10 741

mail@daab-online.com
www.daab-online.com

publisher ralf daab
rdaab@daab-online.com

creative director feyyaz
mail@feyyaz.com

editorial project by loft publications
© 2006 loft publications

editor isabel artigas
layout elisabet rodríguez
english translation jay noden
french translation michel ficerai / lingo sense
italian translation maurizio siliato
german translation susanne engler
copy editing alicia capel tatjer

printed in spain
gràfiques ibèria, spain

isbn 3 - 937718 - 27 - 3
d.l. B - 21949 - 06